# AMERICAN ARTIST GUIDE TO
# PAINTING
# TECHNIQUES

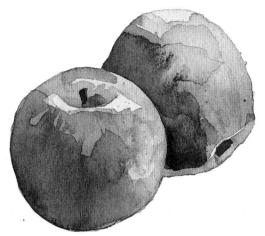

# AMERICAN ARTIST GUIDE TO
# PAINTING
# TECHNIQUES

Elizabeth Tate

Hazel Harrison

INTERWEAVE.
interweave.com

A QUARTO BOOK

INTERWEAVE.
interweave.com

Copyright © 2011 Quarto Inc

Published in North America by

Interweave Press LLC
201 East Fourth Street
Loveland, CO 80537-5655
www.interweave.com

Conceived, designed, and produced by
Quarto Publishing plc
The Old Brewery
6 Blundell Street
London N7 9BH

QUAR.EPAR

Library of Congress Cataloging-in-Publication Data
Tate, Elizabeth.
  American artist guide to painting techniques / Elizabeth
Tate, Hazel Harrison.
     p. cm.
  Includes bibliographical references and index.
  ISBN 978-1-59668-279-5 (pbk.)
1.  Painting--Technique.  I. Harrison, Hazel. II. Title. III. Title:
Guide to painting techniques.
  ND1500.T265 2011
  751.4--dc22

                              20100460435

Project Editor: Victoria Lyle
Art Editor: Joanna Bettles
Designer: Karin Skånberg
Art Director: Caroline Guest
Proofreader: Linda Crosby
Indexer: Helen Snaith
Picture Researcher: Sarah Bell
Creative Director: Moira Clinch
Publisher: Paul Carslake

Color separation in Hong Kong by Modern Age
Repro House Ltd
Printed in China by 1010 Printing International Ltd

10 9 8 7 6 5 4 3 2 1

# CONTENTS

# FOREWORD

Elizabeth Tate's *Encyclopedia of Painting Techniques* was first published in 1986, and since then has transformed into many new editions. And rightly so; it was a ground-breaking work and quite a new departure at the time. There have been many "how-to" painting books since then, but this was the first.

But times move on, and new things appear on the horizon. You only have to think about the progress in the world of computing just in the last ten years. And painting is no exception: although old values still hold true, and will forever, artists are continually experimenting with their chosen media, whether it be oils, acrylics, watercolor, or pastel, and finding new ways of exploiting them. Manufacturers have also played a big part, coming up with new devices to help artists express their ideas and create interesting effects. The eighteenth-century watercolor painters might have perhaps found masking fluid helpful? I doubt that they would have despised it.

I am honored to have been asked to update this book, and in doing so have included several techniques and methods that were not featured in the original book. I have also omitted certain media, notably egg tempera which is seldom used, and played up that wonderful "do everything" medium, acrylic, which is the choice of many painters today.

But bear in mind that techniques are only a means to an end; it is fun trying them out, but you have to rely on your own vision to make them work for you in the context of a painting. My advice is to play about with methods of working, commit them to memory, and then paint with confidence and assurance.

**Hazel Harrison**

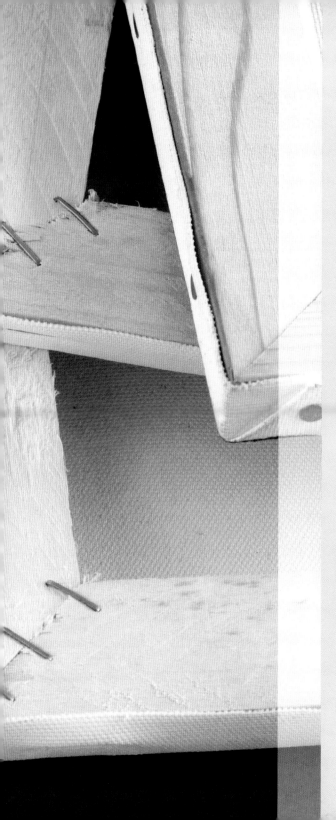

# PREPARING TO PAINT

In this short section you will discover how to prepare your papers or canvases before painting. This may sound dull, but the type of "ground" you work on has a considerable influence on your work. For example, many new painters have found that the commercially available canvas boards are less than sympathetic, but you can easily make your own as quickly as you can color grounds to your own requirements.

# STRETCHING CANVAS

STRETCHING YOUR OWN CANVAS IS NOT ONLY ECONOMICAL BUT IT ALSO ALLOWS YOU TO PREPARE THE CANVAS IN ACCORDANCE WITH YOUR OWN SPECIFICATIONS.

Canvas is stretched over a frame made from mitered wooden stretcher bars, available from art stores in a range of lengths, widths, and profiles. Only stretcher bars of the same width and profile will fit together. Stretcher pieces are usually classified as economical, mid-quality, or professional quality, and are made from various species of kiln-dried pine or tulip wood. The highest-quality stretchers are jointed using a dovetail joint; others use a mortise and tenon. Many stretchers incorporate two slots into the corner joint to allow a triangular wooden wedge to be inserted; this can be used after priming to push the wood apart and apply lateral pressure to the canvas, stretching it taut.

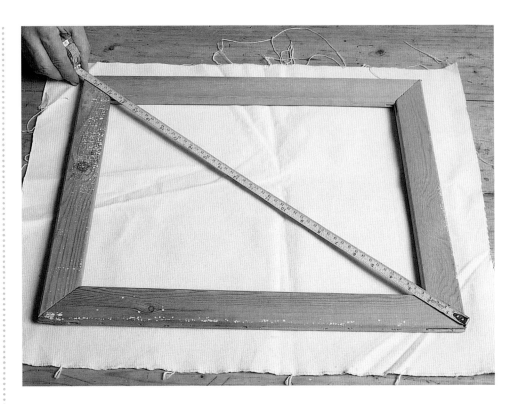

1 Cut the canvas so that it is about 2" (5 cm) larger than the stretcher frame. Assemble the stretcher and make sure it is square by measuring diagonally from corner to corner: if the measurements are the same, the frame is square.

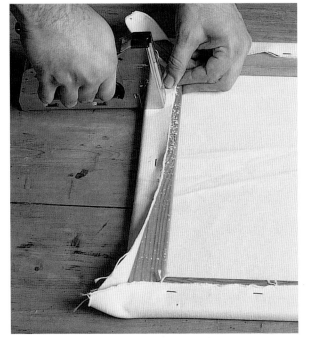

2 Pull the canvas overlap up the sides and over onto the back of the stretcher frame. Secure at even 2" (5 cm) intervals with staples.

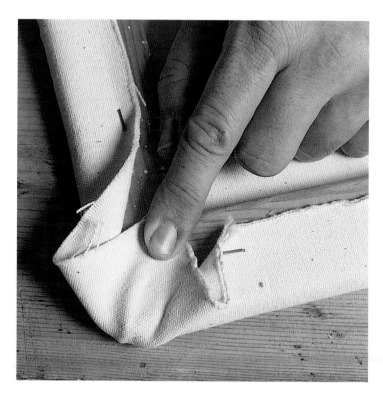

**3** Working one corner at a time, pull the corner of the canvas tightly across the back of the stretcher toward the center. Fold one of the canvas wings in and over.

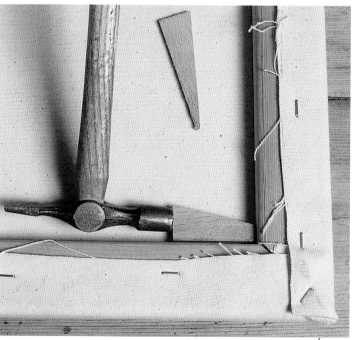

**4** Secure the fold to the stretcher frame using a single staple.

**5** If the canvas remains limp when dry, it can be made taut by forcing the stretcher bars apart using wooden wedges hammered into the slots at each corner.

# STRETCHING PAPER

IT IS NECESSARY TO
STRETCH PAPER BECAUSE,
WHEN WET, PAPER FIBERS
ABSORB MOISTURE LIKE A
SPONGE AND SWELL, CAUSING
THE PAPER TO BUCKLE. WHEN THE
FIBERS DRY, THEY SHRINK AGAIN BUT
NOT ALWAYS TO THE ORIGINAL SIZE,
AND THE BUCKLING CAN REMAIN.

The application of watery acrylic over such an uneven, "wavy" surface can be difficult. Stretching the paper helps to solve this problem by ensuring that the sheet dries flat each time it is wetted. You will need a sheet of paper, a wooden board that is larger than the paper, adhesive paper tape, a sponge, a craft knife, and clean water.

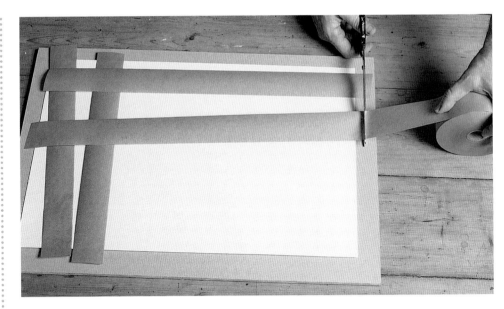

**1** Prepare four strips of adhesive paper tape, cutting each strip approximately 2" (5 cm) larger than the paper.

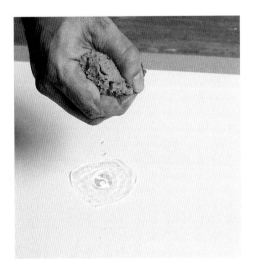

**2** Lay the sheet of paper centrally on the wooden board and wet it thoroughly, squeezing water from the sponge. Alternatively, the paper can be wetted by holding it under a running tap or by dipping it into a water-filled tray or sink.

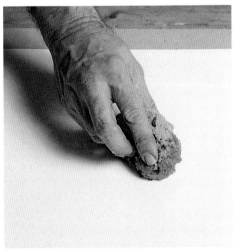

**3** Wipe away any excess water with the sponge, taking care not to distress the paper surface.

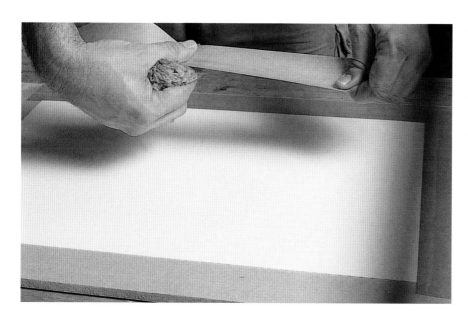

**4** Beginning on the longest side of the paper, wet a length of tape using the sponge, and lay it down along one edge. Ensure that about one-third of the tape surface is covering the paper, with the rest on the board.

## ARTIST'S TIP

Staples can be used to secure mediumweight and heavyweight papers. Wet the paper and position it on the board, as left. Secure the edges by placing staples about ½" (1.3 cm) in from each edge at ½"–1" (1.3–2.5 cm) intervals. Work quickly, before the paper buckles. Allow to dry as right.

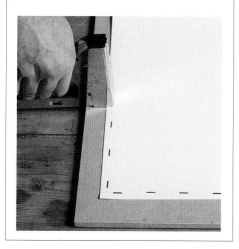

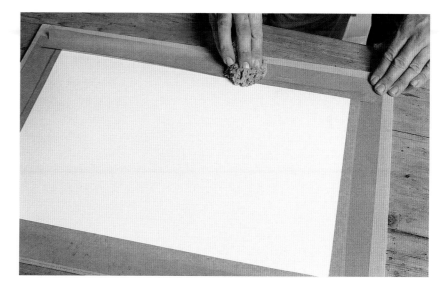

**5** Smooth the tape down with the sponge. Apply the tape in the same way along the opposite edge and then along the other two edges. Place the board and paper aside to dry for a few hours; you can also use a hairdryer to speed up the drying process, but keep the dryer moving so that the paper dries evenly. Do not hold the dryer too close to the paper's surface.

# HOME-MADE CANVAS BOARDS

SUITABLE THIN FABRICS LIKE CANVAS, HESSIAN, MUSLIN, AND CALICO CAN BE GLUED TO A BOARD, SUCH AS MASONITE, TO GIVE IT A TEXTURED SURFACE.

This method, called marouflaging, is an extremely inexpensive and effective way of using up fabric and off-cuts from boards and results in a support that is excellent for use on location.

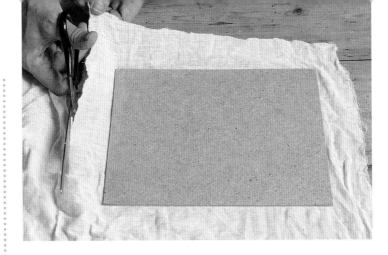

**1** Rub the board thoroughly with a damp cloth to remove any dust and then place it face down onto the fabric. Cut the fabric to size, leaving a 2" (5 cm) overlap on all four edges.

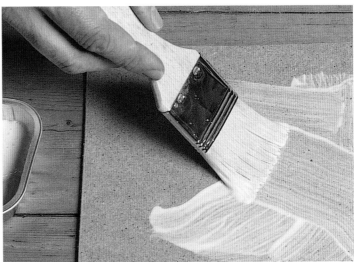

**2** Turn the board face up and liberally paint the surface with a coat of acrylic matte medium.

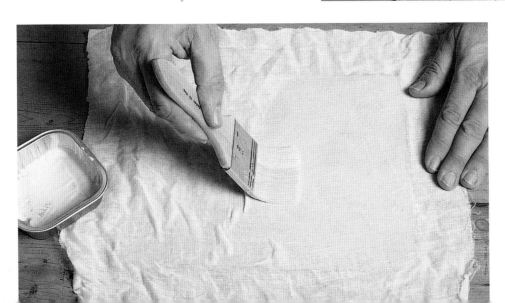

**3** Place the fabric square onto the board and brush on more medium. Start from the middle and work out to the edges, applying enough pressure to make sure no air bubbles or thick pockets of glue or medium are left. Continue until the fabric is completely flat.

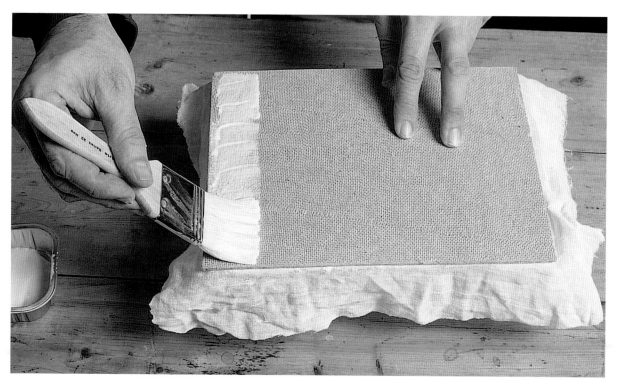

**4** When dry, turn the board over and place it on a block of wood. Apply acrylic matte medium around all four edges.

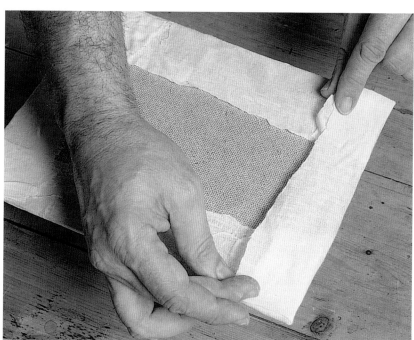

**5** Fold the fabric over the sides and onto the back of the board. Smooth down using more acrylic matte medium. If the medium has raised the grain of the fabric, rub down lightly with sandpaper.

# PRIMING AND STAINING

BOTH OILS AND ACRYLICS CAN BE APPLIED TO RAW CANVAS, BUT THE CANVAS WILL ABSORB THE FIRST LAYER OF PAINT, SO IT IS CUSTOMARY TO APPLY A COAT OF PRIMER. THIS ACTS AS A BARRIER BETWEEN THE PAINT AND THE CANVAS. PAPER, WHICH CAN BE USED FOR BOTH ACRYLICS AND OILS, CAN BE PRIMED IN THE SAME WAY.

## PRIMING WITH GESSO

Gesso gives an inflexible, slightly absorbent surface. Traditional gesso is made by mixing whiting with warm glue size and white pigment. Black gesso is also available; another alternative is to tint acrylic gesso with black acrylic paint. Acrylic gesso has one clear advantage over traditional gesso: it is flexible, and so it can be used on stretched canvas. Smooth boards are usually given several thin coats of gesso, with each coat painted at a right angle to the previous coat. Each coat is allowed to dry and then sanded using fine-grit sandpaper before the next coat is applied. The number of coats required depends on the degree of surface smoothness desired.

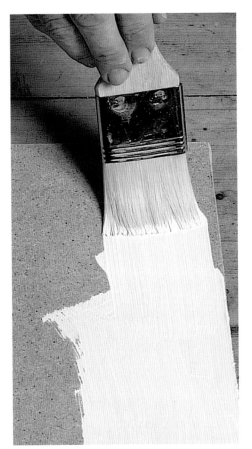

## PRIMING

**1** Using a soft bristle brush, apply a layer of gesso to the surface of the board.

**2** When the gesso is dry, sand the surface to remove any brushmarks.

**3** Repeat steps 1–2 using brushstrokes painted at right angles to the previous ones. Always sand between coats.

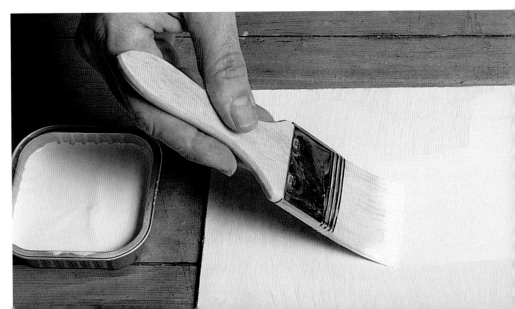

## STAINING

Acrylic paint contains no corrosive ingredients that might degrade paper or fabric, making it possible to work directly onto canvas without any prior sizing or priming. Acrylic paint applied to unsized canvas will soak into the surface, staining the fabric fibers; this stained layer can be sized and then worked on in a conventional manner or worked on without sizing. Always work dark over light, allowing each stain to dry before applying the next. Too many stained paint layers will dull the colors. Raw canvas repels paint, while a flow medium added to a thin-color mix improves absorption. The support should be placed flat, or the thin paint will run. Once the paint has soaked into the fibers, it is impossible to remove, even when wet.

**WORKING OVER A GROUND COLOR**

**1** Because the dominant color in the painting will be green, the artist has chosen a red ground; red and green are complementary, or opposite, colors. He is working with acrylics, but the same procedure can be used for oils. He begins by painting the dark blue-green of the hills, using the color thinly so that it does not obliterate the red.

**2** Next, he starts to build up the foliage with a variety of greens, using the paint unthinned. The contrast between the thin and thick paint creates an impression of space and depth, because the more full-bodied paint "advances" to the front of the picture.

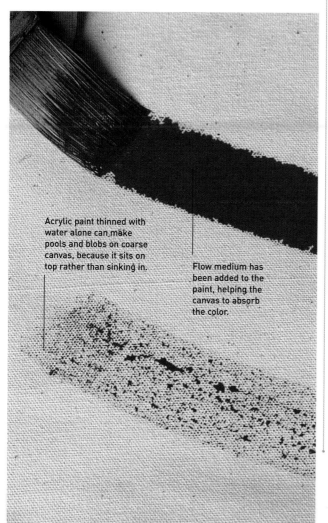

Acrylic paint thinned with water alone can make pools and blobs on coarse canvas, because it sits on top rather than sinking in.

Flow medium has been added to the paint, helping the canvas to absorb the color.

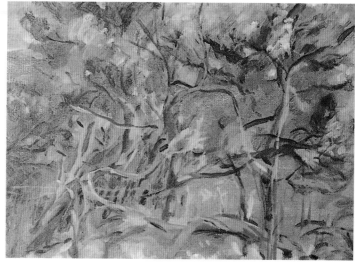

**3** The finished painting has a lively sense of movement, and the red-green contrast makes a strong impact.

# TEXTURING

WATERCOLORS WILL NORMALLY HAVE A SLIGHT TEXTURE WHICH COMES FROM THE GRAIN OF THE PAPER. OILS WILL ALSO HAVE A SLIGHT TEXTURE IF YOU WORK ON A FAIRLY HEAVY CANVAS, BUT MORE DRAMATIC EFFECTS CAN BE ACHIEVED BY CREATING TEXTURES OF YOUR OWN DEVISING. SUCH METHODS ARE SUITABLE FOR PASTEL, OIL, AND ACRYLIC BUT NOT WATERCOLOR.

### EXPERIMENTATION

Working on a home-made textured surface is an experimental technique, and you will soon develop your own recipes for grounds. Before starting on *Apples and Tea*, Doug Dawson coated his Masonite ground with acrylic gesso, followed by acrylic paint, and finally transparent acrylic medium mixed with pumice powder. For the final coat the artist used a paintbrush and diagonal strokes, which can clearly be seen in the finished painting.

### TEXTURING THE GROUND

The paper you choose for a pastel painting will influence the appearance of the work to a limited extent, but you can also exploit texture in a more dramatic way by laying your own textured ground using acrylic modeling paste, acrylic gesso, or pastels themselves. The textured marks will be visible through the overlaid pastel, resulting in a number of possible effects.

**ACRYLIC MODELING PASTE**
1 Use a large bristle brush to apply the paste in roughly diagonal or multidirectional strokes. Leave to dry.

2 The pastel color applied on top of the dry paste catches on the ridges, while the texture of the brushmarks adds an extra quality of movement to the finished painting.

**PASTELS**
Crushed leftovers of pastels can be rubbed into the paper for a soft, grainy effect.

**ACRYLIC GESSO**
1 Acrylic gesso can be brushed on with a bristle brush in the same way as acrylic modeling paste (see above and opposite). If you don't want to work on a white surface, tint the gesso by mixing it with a neutral shade of acrylic paint.

2 As you apply the pastel colors you will notice that the texture of the ground breaks up the pastel strokes. This method is exciting if you do not fight the texture but go with it.

## TEXTURING THE SURFACE

Acrylic excels in the area of texture. There is almost nothing you cannot do with it. Textured effects can be created in many different ways, but acrylic modeling paste, which is specially made for underlying textures, is ideal for the dramatic textures shown here. It can be applied to the painting surface in any way you choose, but you must use it on a rigid surface; if applied to canvas, it may crack. You can create rough, random textures by putting the paste on with a palette knife. You can comb it on to make straight or wavy lines, or dab it on with a rag or stiff brush. And you can make regular or scattered patterns by imprinting, which is a process of spreading the area with modeling paste and pressing objects into it while it is still wet.

The underlying texture method is usually most successful when the paint is applied in thin glazes; opaque paint over texture can look lifeless. However, there are no real rules in painting, and it is up to you to discover what works best.

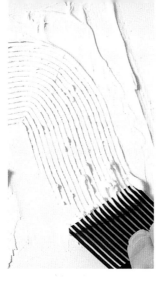

**DRAMATIC TEXTURES**
**1** Working on heavy white board, the artist spreads acrylic modeling paste first with a palette knife and second with a steel comb made for texturing plaster.

**2** Next, he presses a coin into the surface to make an imprint. Modeling paste will remain wet enough for such methods for some time, if used thickly.

**3** Bubble-wrapping also produces an interesting imprint. Each area of texture is kept separate, providing what is essentially a series of individual motifs.

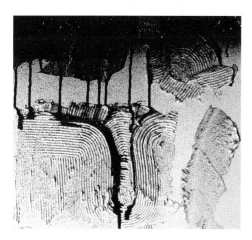

**4** When all the motifs have been placed and textured, the whole picture area is sprayed with red liquid acrylic ink, using a mouth diffuser. Thinned paint of the same red is now laid in a thick band at the top and allowed to dribble down the surface.

**5** After the paint has begun to settle in and around the troughs of the textured areas, the flow is arrested with a hairdryer.

**6** Thicker blue paint is now dragged lightly over the red. Notice that in the more heavily textured areas the color catches only on the ridges.

# MAKING A START

This section focuses on how to build up a painting, whether you are working in watercolor, oils, acrylics, or pastels. There are some important rules, especially in respect of watercolor and oils, but apart from those it is up to you to find your own way with the help of the advice provided.

# ALLA PRIMA

ALLA PRIMA IS AN ITALIAN EXPRESSION WHICH CAN BE TRANSLATED AS "AT THE FIRST TRY." THIS TERM DESCRIBES A PAINTING THAT IS COMPLETED IN A SINGLE SESSION AS OPPOSED TO THE ONCE-TRADITIONAL METHOD OF BUILDING UP PAINT GRADUALLY, USING SUCCESSIVE LAYERS OF COLOR.

The technique can be used with any medium, but is most often associated with oils and acrylics, which can be applied in thick impasto or worked wet-in-wet. Often there is no preliminary drawing or underpainting, the idea being to capture the essence of a scene—the first impression—as boldly as possible.

Alla prima painting first came into practice in the mid-nineteenth century when landscape artists such as Constable in England, and Corot in France, began rejecting the rather staid and idealized depictions of nature painted in the studio, which were then the accepted convention.

SEE ALSO

IMPASTO, pages 48–49
WET-IN-WET, pages 52–53
WET-ON-DRY, pages 54–55

Artists began to work directly from nature, which inspired a new liveliness and freedom of brushwork. This sense of light and spontaneity could never be captured in the studio.

By the 1870s, when Impressionism was at its height, painters like Monet, Pissarro and later Van Gogh were fully exploiting the direct approach to capture the fleeting effects of light which fascinated them.

The ability to apply paint quickly and confidently is the key to the alla prima approach, because you are dealing with shape, color, tone, and texture all at once. It is best to stick to a limited range of colors to avoid complicated color mixing which might obscure the intended image. In addition, it is vital to start out with a clear idea of what you want to convey in your painting and to dispense with nonessential elements which do not contribute to that idea.

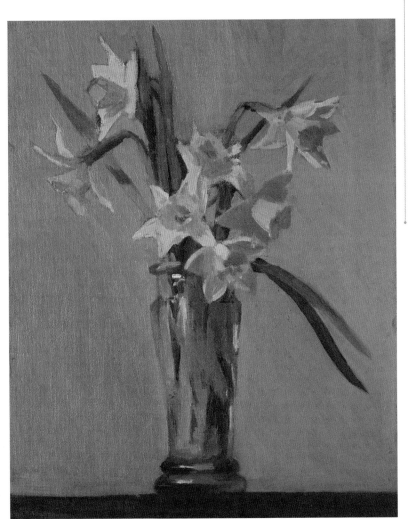

**THIN AND THICK PAINT**
This flower study in oils has been painted rapidly in one session. The background was applied first, using paint thinned with turpentine, which dries quickly, enabling the flower colors to be applied on top without mixing into the deep gray.

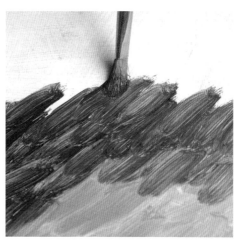

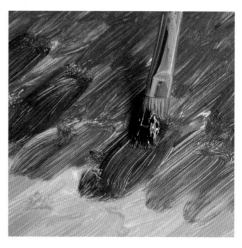

**OIL**

**1** Working on a prepared canvas board, the artist uses a flat bristle brush to apply strokes of lemon yellow and sap green with short, spontaneous brushstrokes. The paint is diluted with turpentine only, so as to avoid the problem of cracking when further layers of thick paint are added.

**2** He continues to build up tones and colors, working wet-in-wet and allowing the colors to mix directly on the surface. Note how the previous layer of color shows through in places.

**3** This is a swift, direct method of painting which can be used to create a bold and exciting picture. The shapes of the strokes themselves can add variety and movement to a scene. Each stroke should be applied decisively, otherwise the colors could become muddied. The advantage of using oil paint is, if a wrong color is put down, it can easily be scraped off, and the artist can begin again.

**ALLA PRIMA: PASTEL**

Since only a limited number of layers can be applied in pastel, it is natural to work alla prima. Pastel is a very direct medium; there is no waiting for coats of paint to dry, and no other equipment is needed. A stick of pastel is ready to use as it is and becomes an extension of your hand, allowing you to respond quickly to your subject. A single pastel stick is capable of producing a host of different effects: using the side of the stick produces broad swathes of color and enables you to cover the surface quickly; it can be blended with fingers, rags, or stumps, and fine lines and details can be added with a sharpened point. In this illustration, the artist is building up an area of color with hatched and blended marks.

**ALLA PRIMA: WATERCOLOR**

Watercolor can be worked in layers wet-on-dry, but if you are painting on the spot it is natural to take the alla prima approach. In this way, you will learn quickly how to control and predict watercolor behavior and how to capitalize on "happy accidents." In this illustration, the artist is working with rapid, fluid brushstrokes, reducing the forms to simple blocks of color and applying the paint directly.

# BUILDING UP: OIL AND ACRYLIC

THE PROCESS OF BUILDING UP AN OIL OR ACRYLIC PAINTING IS LARGELY AN INDIVIDUAL MATTER. SOME ARTISTS LIKE TO COVER THE CANVAS AS QUICKLY AS POSSIBLE, STARTING WITH AN UNDERPAINTING IN THIN, DILUTED PAINT THAT DRIES VERY QUICKLY. THIS ALLOWS THEM TO ESTABLISH THE MAIN BLOCKS OF TONE AND COLOR.

Whether or not you follow this practice, it is always best to begin with the broad masses, concentrating on the main areas of shape and color. If you are painting a portrait, for example, resist the temptation to begin by "drawing" lips and eyes with a small brush. These details should be added only when the main planes of the face have been established. Another golden rule is never to bring one area of the picture to completion before another. Always work over the whole surface at the same time so that you can assess one color and tone against another.

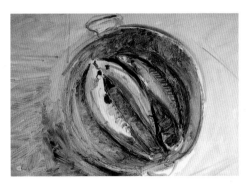

1 The basic shapes are rapidly but carefully established with loose brushstrokes in well-thinned paint: cobalt blue, Payne's gray, raw sienna, and cobalt violet. The white ground glows through this transparent paint.

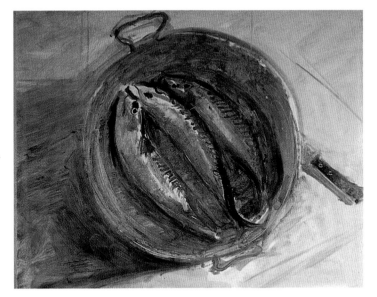

2 Having laid the foundations of the composition, the artist begins to develop the fish by building up layers with more opaque paint. More details are defined at this stage, such as the pot handles and the markings on the backs and eyes of the fish.

**UNDERPAINTING**
Sometimes known as "dead coloring," this is one of the various methods of underpainting for oils. The composition is first sketched in thinned paint and a limited color range. When dry, thicker and more finished passages of paint are applied on top.

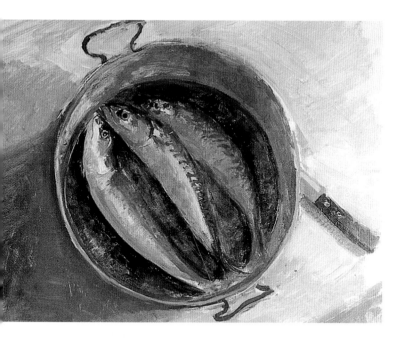

3 Further definition is given to the heads, and applications of thicker paint give more definition to the dark and light areas. Other details, such as the rim and handles of the pot, are clarified.

### FAT OVER LEAN

This is one of the basic principles of oil painting. It refers to the fact that oil paints containing a high proportion of oil should always be applied over those containing less oil; otherwise there is a danger that the painting will eventually begin to crack. Oil paint diluted with an oil medium, such as linseed or poppy oil, is referred to as being "fat," while paint diluted with turpentine or mineral spirits is known as "lean." If lean paint is applied over fat paint, the lean layer dries first, and the fat layer will contract as it dries, causing the dry paint on top to crack.

4 The transparency and wetness of the eyes are skillfully conveyed through additions of thicker, opaque paint, with the colors carefully matched to the subject.

5 Following the principle of fat over lean, each new layer of paint contains an increased oil content. The artist might have chosen to continue with the painting; it is not always easy to know when to stop. By this stage, however, the fresh firmness of the fish was so beautifully captured that further work could have destroyed the spontaneity and liveliness of the picture.

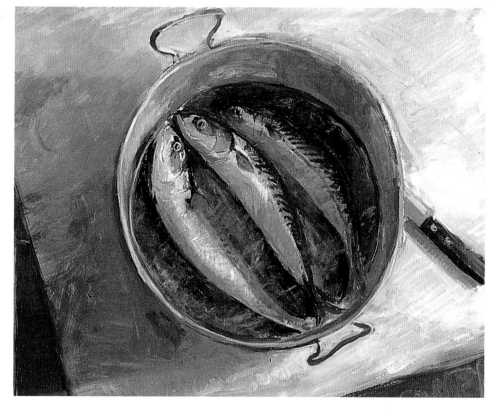

# BUILDING UP: PASTEL

PASTEL, BEING SOFT AND CRUMBLY, IS LESS SUITED TO BEING BUILT UP IN LAYERS THAN EITHER OIL OR ACRYLIC, BUT IT CAN BE DONE AS LONG AS YOU WORK ON A WELL-TEXTURED SURFACE AND SPRAY EACH LAYER WITH FIXATIVE BEFORE ADDING THE NEXT.

Building up layers has the best results with soft pastels used on their side. One of the advantages of the technique is that it enables large areas of the composition to be established quickly. It also encourages the faint-hearted pastellist to develop a bolder, more confident approach to the medium.

You must allow for some darkening of the color, but this can add depth and richness to the work. Edgar Degas often used this method, applying layer after layer of contrasting hues in scribbled hatchings. The result was a rich patina of color "like a cork bath mat," according to the English artist Sickert.

**BUILDING UP A LAYER OF COLOR**

**1** The side of a soft pastel stick is used to apply a thick layer of color.

**2** Spraying fixative between each layer allows you to build up several coats of color. It is customary to allow the fixative to dry before adding more color, but exciting effects can also be produced by working into wet fixative.

**3** A second coat of color is now applied, completely covering the layer below, and is then fixed.

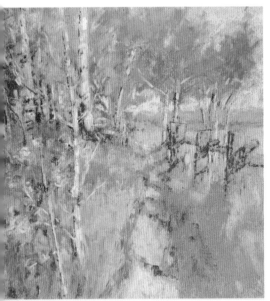

**BUILDING UP STROKES**

In Diana Armfield's *Along The Path In The Rockies*, the detail and character of the slender trees are built up through many small pastel strokes. The soft pastel is handled loosely and economically, blocking areas of grainy color and developing textural detail with a variety of linear marks.

> **SEE ALSO**
>
> BLENDING, pages 32–33
> DRYBRUSH, page 68
> SCUMBLING, page 69

**4** In practice, you can apply color over color almost indefinitely to achieve a rich patina that glows with depth and richness. Also experiment with applying different colors on top of one another.

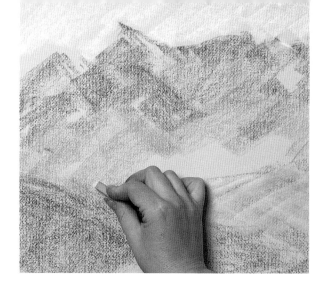

**BUILDING UP A COMPOSITION**
**1** Lightly block in the main shapes and colors with hard pastels. To guide your later work, identify any areas of dark tone, but do not attempt to describe the shapes precisely.

<div style="border:1px solid">

**FEATHERING**

This is a technique used to enliven an area of color that has become dull through excessive blending or rubbing in. It can also be used to soften hard edges or to blur the division between light and shadow. The finished effect of a feathered passage resembles the barbs of a quill, hence the name. To feather one color over another, use a hard pastel or a pastel pencil and make light strokes with an upward and downward movement over the area.

As with scumbling and drybrush, feathering allows the underlying color to show through, producing an optical effect which is more lively than an area of flat color.

</div>

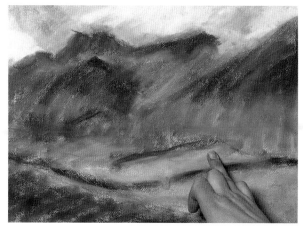

**2** Still keeping the treatment broad and avoiding details, use soft pastels to build up color effects by blending and overlaying. When you are working on the middle area take care not to rest your hand on your previous work.

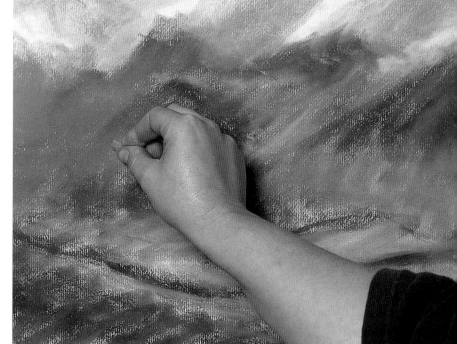

**3** Assess the picture from time to time to decide how much more work it needs. A little detail—a mountain stream, some middleground trees—will bring this landscape into focus.

# COLOR MIXING

MIXING COLORS TO OBTAIN JUST
THE RIGHT HUE AND SHADE YOU ARE
AFTER IS SOMETHING YOU WILL LEARN
WITH PRACTICE.

If working with oils or acrylics it can be helpful to hold up the brush with the mixed color on it against whatever it is you are painting. This will often show you where you may have gone wrong. Watercolor is trickier, because it dries much lighter than it appears when wet, so the best course is to paint a swatch on a spare piece of paper, wait for it to dry, and then compare it with the subject. As a general rule, whatever the medium, you should avoid mixing more than three colors or your mixture may become muddy and dull.

## LAYING OUT OIL OR ACRYLIC COLORS

Whether you use a large palette of colors or a small selection, as shown here, always lay them out in some kind of logical order so that you can find them easily. One blob of dark color looks very much like another one, and it is very frustrating to find you have accidentally added green or brown to a blue sky mix. These colors are laid out from light to dark, with the color "families"—reds, blues, and so on—grouped together. White can be placed at either end, but remember to lay out a larger quantity, as you will use more of this than the other colors.

## MIXING ON THE PALETTE

If you are using one of the stay-wet palettes made for acrylics you will have to mix your paint with a brush, or you could damage the paper membrane. For large quantities of paint mixed on a rigid palette, such as a sheet of glass, you may find it easier to work the colors together with a palette knife. Knife mixing is especially useful if you are using a bulking medium for impasto work, because brushes will quickly fill up with paint and be difficult to clean.

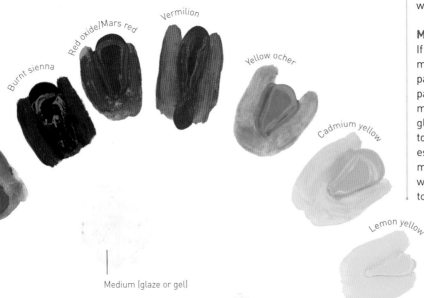

Vermilion

Red oxide/Mars red

Burnt sienna

Yellow ocher

Cerulean blue

Cadmium yellow

Ultramarine blue

Medium (glaze or gel)

Lemon yellow

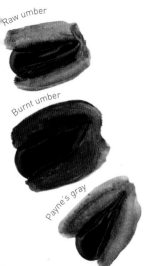

Raw umber

Burnt umber

Payne's gray

Three blobs of white
to keep it clean

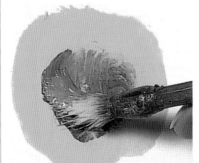

## ORDER OF MIXING

When mixing a pale color, start with the weakest ingredient, usually white. Then add the stronger colors in very small quantities, building them up gradually to the strength you require. If you begin with a very strong hue, you will have to add much more of the pale colors, wasting a lot of paint.

## CLEANING OVERLOADED BRUSHES

This photograph shows what happens when thick paint is mixed with a brush. If a brush becomes overloaded with paint, act fast before it begins to dry. Lay the brush flat on the palette and run the edge of a palette knife or plastic card down the bristles from base to tip. Then immerse the brush in water.

## KNIFE MIXING

Unless you want a streaky effect, which can be useful in certain cases, blend the colors together thoroughly. Don't just mash them together, because this can leave them partially unmixed; use the knife to scoop up the paint and knead the colors into one another.

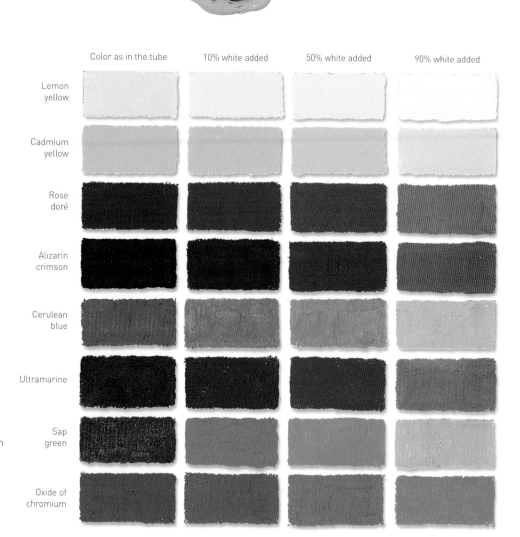

| | Color as in the tube | 10% white added | 50% white added | 90% white added |
|---|---|---|---|---|
| Lemon yellow | | | | |
| Cadmium yellow | | | | |
| Rose doré | | | | |
| Alizarin crimson | | | | |
| Cerulean blue | | | | |
| Ultramarine | | | | |
| Sap green | | | | |
| Oxide of chromium | | | | |

## ADDING WHITE

When white is added to a color, it often has the effect of cooling as well as lightening it. As you can see from the chart, this is particularly noticeable with the reds, which change from warm, vivid colors to quite cool pinks. This is because the warm end of the spectrum of light is partially blocked by the white pigment, leaving a higher proportion of cooler light rays (i.e. more blue).

# SURFACE MIXING

UNLIKE PAINTS, PASTEL COLORS CANNOT BE MIXED IN A PALETTE BEFORE BEING APPLIED TO PAPER. INSTEAD THE COLORS ARE MIXED ON THE PAPER ITSELF. EVEN IF YOU HAVE AN EXTENSIVE RANGE OF PASTEL COLORS, SOME SURFACE MIXING IS ALMOST ALWAYS NECESSARY.

Surface mixing simply involves laying one color on top of another, and different effects can be achieved according to whether you blend the colors or leave them unblended. Blending will achieve a thorough, homogeneous mix, whereas an unblended mix will give a more broken impression of the resulting color. Bear in mind, however, that too much blending can muddy the colors.

Watercolor can also be mixed on the paper, either by working wet-in-wet or overlaying colors wet-on-dry. Since you can seldom achieve great depth of color in a first wash it is customary to build up the deeper tones and colors by laying successive washes. But don't overdo this, because too many layers will muddy the colors and lose the freshness that gives the medium its appeal.

Although it is well-known that watercolors must be worked from light to dark, you can amend colors by overpainting with a lighter color, especially if you use one of the more opaque pigments. In oils and acrylic, one of the most commonly used methods of mixing or amending color on the working surface is by glazing (see pages 58–59).

**BLENDED MIX**
Here the side strokes of yellow over blue have been blended to produce a smooth application of a lively green, which is more visually exciting than a ready-made green.

**UNBLENDED MIX**
Line strokes of yellow over blue have been left unblended. The colors do not mix thoroughly but give the impression of green when viewed from a distance.

**DARK PAPER**
In Rosalie Nadeau's dramatic painting, the pastel has been built up thickly, with successive overlays of color. To set the tonal key for the painting, the artist chose to work on black paper, working up from the darks to the lights.

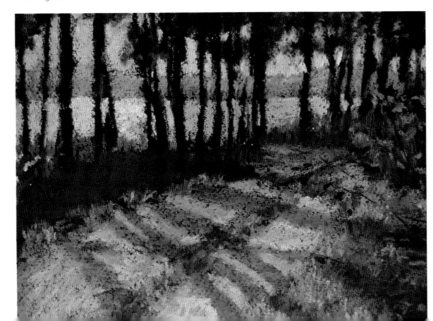

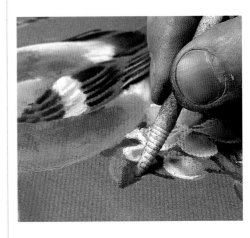

**SUBTLE MIXES**
To achieve soft gradations of color and subtle mixes, lay down two colors, one over the other, and rub them together with a finger or torchon.

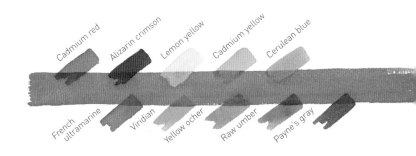

Cadmium red · Alizarin crimson · Lemon yellow · Cadmium yellow · Cerulean blue

French ultramarine · Viridian · Yellow ocher · Raw umber · Payne's gray

## GRADATING COLOR

To depict colors that merge gradually into one another, lay bands of color using side strokes and blend together the edges where the colors meet. This series shows the very subtle effects that can be created by blending one color into another.

## RELATIVE TRANSPARENCY

Some colors are less transparent than others. The more opaque colors in the starter palette are cerulean, lemon yellow, and yellow ocher. Any of these, used in fairly strong solution, will lighten the value of a darker color beneath.

## OVERLAYING TO DARKEN COLOR

In watercolor painting, colors must always be overlaid to some extent, and the crisp edges formed are among the many charms of the medium. Make sure that the first color is completely dry and work quickly so that each new layer of color does not stir up the one below.

Cadmium red
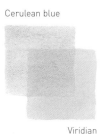

Raw umber

French ultramarine
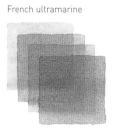

Viridian
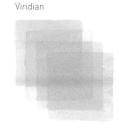

## LAYING ONE COLOR OVER ANOTHER

Although you can alter a color by laying another on top, you can't obliterate the first one; the new color will be a mixture of the two.

Cerulean blue
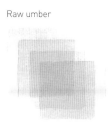
Viridian

French ultramarine
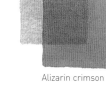
Alizarin crimson

Cadmium yellow
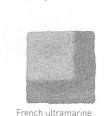
French ultramarine

SEE ALSO
............
WET-IN-WET,
    pages 52–53
WET-ON DRY,
    pages 54–55
GLAZING,
    pages 58–59

## LIGHT OVER DARK

A light color applied over a dark one does not disappear. Although you can change the nature of an underlying color in this way, you can't significantly change its value, the lightness or darkness of the color, unless you paint over it with one of the more opaque colors.

French ultramarine

Cadmium yellow

Raw umber

Lemon yellow

Payne's gray

Yellow ocher

# BLENDING

BLENDING IS A MEANS OF ACHIEVING SOFT COLOR GRADATIONS BY BRUSHING OR RUBBING THE EDGE WHERE TWO TONES OR COLORS MEET.

---

**SEE ALSO**

BROKEN COLOR, pages 66–67

---

**BLENDS AND TEXTURES**
In this lovely flower study, the artist has used acrylic gel to thicken the paint and make light ridges that follow the forms. This medium has also helped her to blend colors into one another.

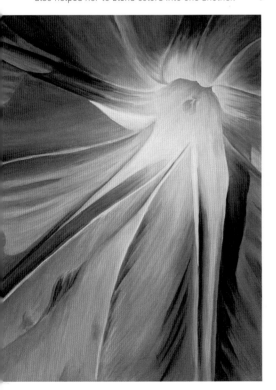

It is easy to achieve soft blends in oils and pastels, and slightly harder with fast-drying media such as acrylic and gouache. But there is a special medium called retarder that helps with acrylic blends, because it keeps the paint workable for longer. In watercolor, the best way of blending is to work on slightly damp paper so that the colors don't form hard edges.

The delicate effects obtained by blending are very attractive, but the temptation is often to overdo it, especially in pastel work, giving a dull and bland result. When painting an object like an apple, it is not necessary to blend the entire area. From the normal viewing distance, the form will look smooth if you blend just that narrow area where light turns into shadow or where one color melts into another.

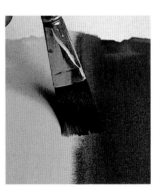

**BLENDING ACRYLIC**
The artist has added retarding medium to both colors, and now uses a flat bristle brush to work one color into the other.

When you are working on a large area, try spraying the surface lightly to help keep the paint moist. Don't use water spray with retarder, as water inhibits its action.

Alternatively, tones or colors can be blended rapidly with vertical strokes of a soft, moist brush.

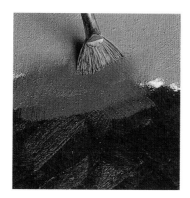

## BLENDING DRY COLOR

When painting with fast-drying media such as acrylic or gouache, remember that blended effects can be achieved even when colors have dried completely. Simply apply loose, scumbled strokes of fresh color (see broken color) across the point where two colors or tones meet.

## BLENDING WITH A FAN BRUSH

Fan brushes are specially designed for blending, for both oils and acrylics. While the paint is still wet, use a gentle sweeping motion with the brush to draw the lighter color into the darker one. Then, with a light touch, keep working along the edge between the two colors until a smooth, imperceptible blend is achieved.

## BLENDING OILS

The buttery, viscous quality of oil paint makes it perfect for achieving softly blended tones. Oil paint for blending should be fluid but not too runny.

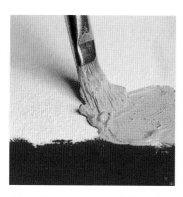

1 Here the artist uses a flat bristle brush to apply two broad bands of color adjacent to each other.

2 Now he uses a softer brush to "knit" the two colors together, using short, smooth strokes. For best results, always work the lighter color into the darker one.

## BLENDING PASTELS

Pastel is incredibly easy to blend because it is so dry and crumbly. All you have to do is rub the colors together with a finger, a rag, or a brush. Fingers are often best, because the slight grease on your skin tends to hold the pigment. A brush may just remove a great deal of it onto the floor. Because it is so easy, you may overdo it: if this happens, spray with fixative and work over it with linear strokes or the feathering method.

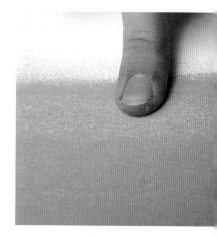

## BLENDING LARGE AREAS

Blending areas is a quick way of laying a foundation of color in a landscape or a background for a portrait. The artist lays in an area of thick color with the side of a soft pastel stick. He then spreads the color out lightly from the center outward, using a piece of cloth.

## ROUGH BLENDING

Many artists prefer to keep rubbing-in to a minimum. Here, hatched marks in orange and yellow pastel have been applied on a dark-toned paper. Using the tip of his finger, the artist softens the lines just a little to give a rough-blended effect which retains the sparkle and freshness of the colors. In pastel work, a combination of smooth areas and rough-textured passages gives the most satisfactory results.

# FLAT AND GRADED WASHES

WASHES ARE THE FOUNDATION OF WATERCOLOR PAINTINGS, WHICH ARE OFTEN BEGUN WITH FLAT, GRADED, OR VARIEGATED WASHES.

SEE ALSO

STRETCHING PAPER, pages 12–13
BACKRUNS, pages 90–91

## WASHES OVER MASKING FLUID

The artist has used graded washes for the sky and hills, first masking out the areas that are to remain as white paper. The smaller, darker areas, like the trees and walls, have been achieved with flat washes of strong color.

When laying a flat wash, it helps to first dampen the paper which allows the brushstrokes to spread and dissolve on the paper without leaving any hard edges. The paper should not be so wet, however, that it buckles (see stretching paper). It is essential to have enough color ready in a deep palette or jar before you begin: mix up more than you think you might need because you cannot stop in the middle of painting to mix a fresh supply. It also helps to use as large a brush as you can. Generally speaking, the fewer and broader the strokes you use, the more successful the wash will be.

When applying the wash, keep the brush well loaded with paint and sweep it quickly and decisively across the paper, without hesitation. If you start going back into a wash you risk unwanted effects such as backruns.

To lay a graded wash, one that becomes lighter or darker from top to bottom, you need to work on dry paper with the board fairly flat. Mix the color as before, but this time dip your brush into clean water between each stroke or "band" of color. This makes it proportionately paler each time. Leave the wash to dry flat.

**FLAT WASH**
1 Starting with a wide, flat brush, load enough diluted color to make one stroke across the top of the paper. Tilting the board slightly toward you allows the paint to flow downward.

**GRADED WASH**
1 Lay down a couple of brushstrokes, left to right, across the top of the paper.

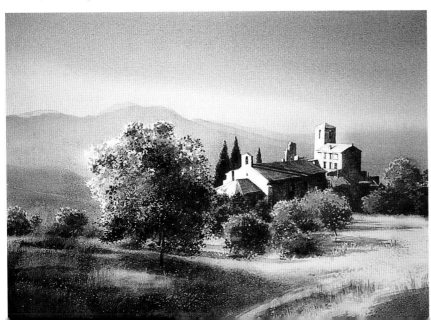

2 Continue down the paper quickly, not allowing the paint to dry between strokes. Work back over uneven lines if necessary to even out any discrepancies in the wash.

3 Continue down to the base of the paper, tilting the board to encourage even flow of the pigment before it settles.

4 Here the paint has dried to a flat, even finish. Some pigments will granulate and produce a grainy effect. Get to know the paints in your palette before applying them to your painting.

2 Continuing down the paper add less pigment and more water until the brushstroke is just water.

3 Lay the board flat for the wash to dry. If you tilt it, the stronger pigment will run down into the lighter areas.

**LAYING A WASH WITH A SPONGE**
A small, natural sponge is also useful for laying a flat wash. Just like before, dampen the paper first to prevent streaks from forming. A sponge allows you to control quite accurately the density of each stroke; for a heavy cover, allow the sponge to absorb plenty of paint. For a paler effect, squeeze the sponge gently until almost dry.

# VARIEGATED WASH

WITH WATER-BASED MEDIA—INK, WATERCOLOR, AND HEAVILY DILUTED ACRYLIC—EXCITING AND UNUSUAL EFFECTS CAN BE OBTAINED BY LAYING DIFFERENT-COLORED WASHES SIDE BY SIDE SO THAT THEY BLEND INTO EACH OTHER WET-IN-WET.

Try using variegated washes when painting misty, atmospheric skies, for example, or simply as the "ground" wash for a painting to be built up with a variety of methods.

Variegated washes are controllable to a certain extent by tipping the board at various angles to encourage the colors to bleed together in a certain way. You can also blot with a sponge if things get out of control.

## SKIES AND LANDSCAPE

Graded or graduated washes, which vary in tone to become lighter toward the bottom, are most often used for skies, which are usually darker at the top and paler over the horizon. They are slightly more tricky than flat washes, as the paint must be progressively diluted for each band of color, but there is an easy way to ensure success. Mix up your wash color; lay the first band at full strength; then dip your brush first into the water and then into the paint for each successive band. This guarantees that the wash mixture becomes lighter by the same amount.

Variegated washes change color, and are often used for skies and other landscape subjects. You will need to mix up two or three colors in advance, and make them all of roughly the same dilution; painting a very watery color into a stronger one may cause backruns.

SEE ALSO

WET-IN-WET, pages 52–53
BACKRUNS, pages 90–91

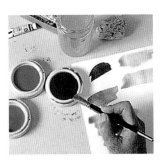

**VARIEGATED WASH**
**1** Many subjects, especially landscapes, call for a wash containing more than one color. Before you start, mix up all the colors and test their strength on a piece of paper.

**2** If you want the colors to blend into one another, dampen the paper first and then lay successive bands of color, quickly rinsing the brush between each one.

**3** With the paint still wet, you can see the separate colors distinctly, but they merge as they dry. If you prefer a less blended effect, work on dry paper.

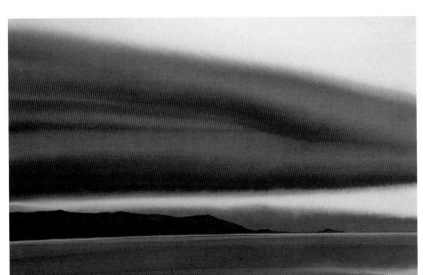

**USING THE WIDTH OF THE PAPER**
Robert Tilling makes extensive use of broad washes worked on damp paper in his evocative seascapes.

**UPSIDE-DOWN WASH**

If a graded wash needs to appear more concentrated in color toward the bottom of the paper, turn the board upside down and start from what will be the bottom, working toward the top. Similarly, if you want it darker at one side, turn the board accordingly.

# DROPPING IN COLOR

DROPPING COLOR INTO A STILL-DAMP WASH IS THE BASIS OF WET-IN-WET TECHNIQUES. THIS IS AN IDEAL WAY OF WORKING FOR SOFT-CLOUD EFFECTS OR DISTANT LANDSCAPE FEATURES WHERE YOU DON'T WANT STRONG DEFINITION, BECAUSE THE COLORS BLEED INTO ONE ANOTHER AND MERGE GENTLY.

A variation of the method is to drop clear water into just-damp paint. To create denser effects you could try dropping in diluted Chinese white or white gouache. Experimental washes, such as these, might form an attractive background for a cloudscape, still life, flower painting, or even a portrait.

**WHITE CLOUDS**
1 Water is dropped into still-damp blue paint.

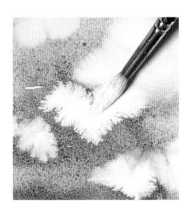

2 Adding Chinese white or white gouache creates denser effects.

**STORM CLOUDS**
1 Red is dropped into a dark indigo.

2 The colors merge to create patterns suggestive of clouds.

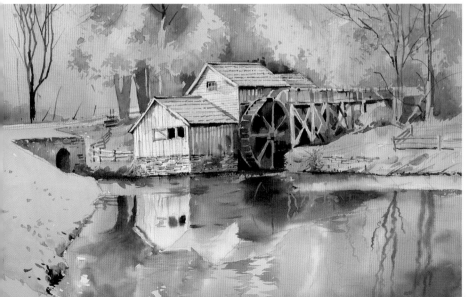

**HARD AND SOFT CONTRASTS**
Lovely soft effects have been created by dropping in colors, both in the sky and in the water. The crisp treatment of the buildings stands in contrast, drawing the eye to them.

# HIGHLIGHTING

IN OILS, ACRYLIC, AND PASTEL PAINTING, THE HIGHLIGHTS ARE NORMALLY LEFT UNTIL LAST. SOME ARTISTS USE REMBRANDT'S METHOD OF APPLYING THE BRIGHTEST LIGHTS WITH A FAIRLY THICK IMPASTO CONTAINING PLENTY OF WHITE. BECAUSE THEY STAND AWAY FROM THE CANVAS, THESE AREAS CATCH MORE LIGHT THAN THE REST OF THE PAINTING AND APPEAR EVEN BRIGHTER.

SEE ALSO

DROPPING IN COLOR, page 37
WET-IN-WET, pages 52–53

In watercolor, highlights are reserved as white paper, so you need to plan the painting in advance by making a light drawing. For fairly small highlights or complex shapes, such as flower heads, you will find masking fluid (liquid frisket) a great help. You simply paint this onto the paper, let it dry, and then wash over it. This gives you more freedom to work boldly, perhaps exploiting wet-in-wet methods or dropping in colors without having to worry about the highlights becoming lost.

Of course, not all highlights are pure white. You may find when the painting is complete and the masking removed that some of the highlights are too startlingly white. If this happens you can simply wash over them with a pale color.

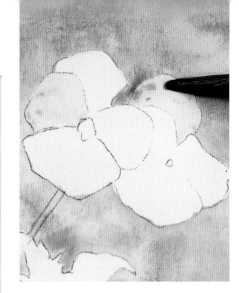

**RESERVING WHITES AND PALE COLORS**
**1** To ensure that highlights will not be lost when washes are added, the artist has begun with a careful drawing before painting wet-in-wet washes around the flower heads.

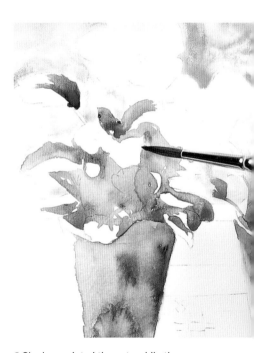

**2** She has painted the pots while the background was drying and now starts on the leaves, again working wet-in-wet and leaving patches of white paper for highlights.

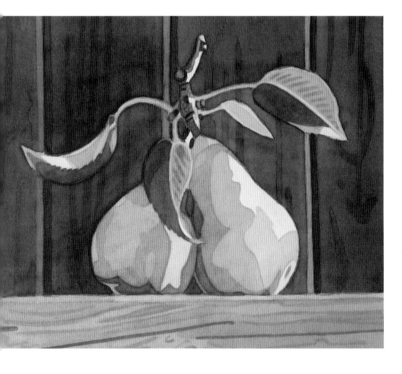

**MODELING FORM**
The highlights and pale-to-middle tones perfectly describe the forms of the fruit. Always look for the shapes made by highlights, because these can be very revealing.

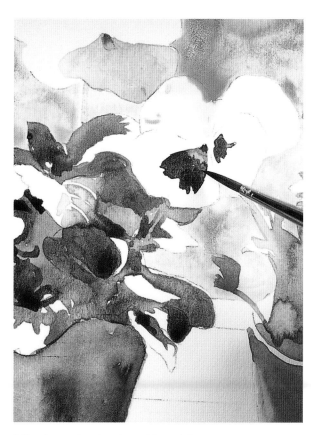

**4** In order to attach the pots to the surface so that they don't appear to float, she paints shadows beneath them, using a mixture of ultramarine and sepia. The same mix is used for the shadow along the inner edge of the tray.

## SCRATCHED HIGHLIGHTS

Tiny linear highlights, such as the light striking a blade of grass or a fence in the foreground of a landscape, can be made by scratching with the point of a sharp knife. This method can be used for watercolors and acrylics, but bear in mind first that the paper and paint must be fully dry and second that this must be the last stage in the painting. Scratching will scuff the paper, and you can't paint over scuffed paper.

**3** The deep-colored centers of the petals are painted with sure brushstrokes, using the point of a round brush.

## SCRAPED HIGHLIGHTS

Artists develop their own techniques. Here a rounded palette knife is used to scrape into the paint to create the pattern of roof tiles—an unusual, but very effective, method.

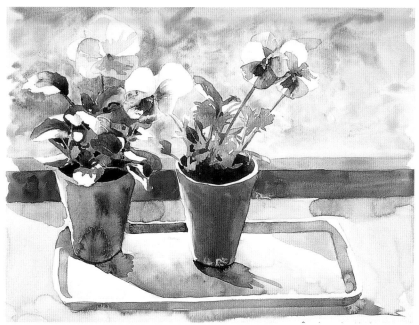

**5** The flower heads have been worked up with yellows and violets, leaving the light-catching petals white. The strong shadows and highlights on the petals, leaves, and pots create a powerful sense of light flooding the whole scene.

# UNDERDRAWING

FOR VERY SIMPLE SUBJECTS YOU MAY NOT NEED MORE UNDERDRAWING THAN A FEW LINES SUCH AS TO MARK THE HORIZON AND MAIN FEATURES IN A LANDSCAPE. BUT FOR MORE COMPLEX SUBJECTS, SUCH AS PORTRAITS OR FIGURE STUDIES, IT IS ALWAYS ADVISABLE TO BEGIN WITH A DRAWING.

Artists working in oils and acrylics often make the drawings with a brush and thinned paint, though some prefer charcoal or pencil. For pastel, either a pastel pencil or charcoal should be used. Pencils are not suitable because they have a slight grease content that repels the pastel.

For watercolor, underdrawings are especially important because it is so difficult to make corrections. Pencils must be used in this case, and if you keep the drawing fairly light, using an HB or B grade, the paint will normally cover it. If you find unwanted lines showing through a first wash, you can erase them as soon as the paint is dry. Some artists, however, like to allow drawn lines to show, and thus use a softer pencil such as a 2B, sometimes reinforcing the original drawing with more pencil work. Watercolor and pencil can make an attractive combination.

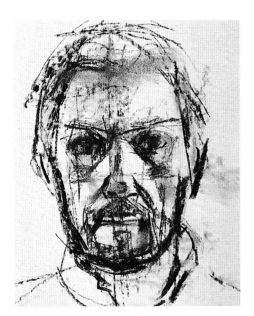

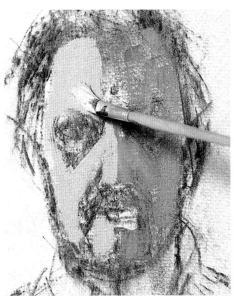

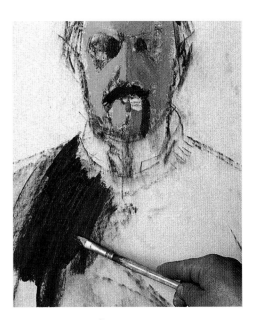

**ESTABLISHING THE STRUCTURE**
1 Drawing is vital in portraiture, as you will not succeed unless you build your painting on a sound foundation. Here the artist has carefully laid the "landmarks" of the sitter's face in charcoal, which is an expressive medium allowing both accurate, fluid lines, and broad areas of tone. It is also easy to rub off, so errors can be rectified before you begin to paint.

2 Once the drawing is completed, rubbed down, and fixed, the artist can direct all their concentration on the application of paint without having to worry about the exact positioning of features.

3 Don't attempt to "fill in" the outlines too slavishly: the drawing should act as no more than a guide. Here the brushwork is kept free and loose, with directional strokes used to block in the dark clothing.

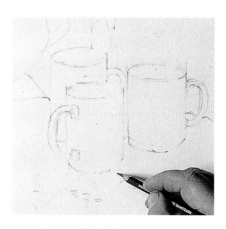

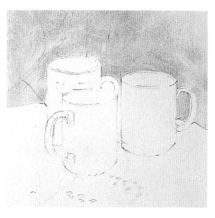

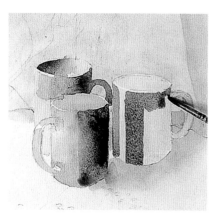

**GUIDELINES FOR WATERCOLOR PAINTING**
**1** The artist is using a sharp but soft pencil (4B) for the drawing. Soft pencils are easier to erase than harder ones such as HB, but the choice is largely a personal one.

**2** Here you can see the importance of the drawing. In a subject like this it is essential to establish the background wash accurately around the shapes.

**3** Again, the outline drawing helps the artist to place the bands of dark and light color that define the form of the mugs.

## WORKING AROUND EDGES

In this painting of buildings, the sky wash is laid with the board upside down to make it easier to follow the drawn lines accurately. Even with a careful drawing, there is a danger of paint slopping over the edges.

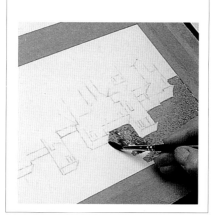

**PAINTING THE FIGURE**
It is essential to make a good underdrawing for anything as complex as a figure or portrait. Here the artist follows her drawn guidelines, which help her to decide where to leave the highlights in the basic skin tone.

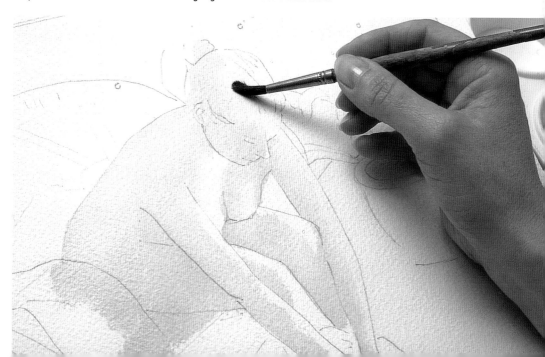

# CORRECTIONS

NOTHING IS MORE FRUSTRATING THAN DISCOVERING HALFWAY THROUGH A PAINTING THAT SOMETHING HAS GONE AWRY; MAYBE THE COLORS DON'T HARMONIZE, OR AN OBJECT IS IN THE WRONG POSITION. THANKFULLY IT IS OFTEN POSSIBLE TO PUT THINGS RIGHT. YOU SHOULD VIEW MISTAKES AS PART OF THE LEARNING CURVE.

Oil paintings are easy to correct while still wet. All you need do is scrape off paint with a palette knife and, if needed, rub down the offending area with a rag dipped into turpentine or mineral spirits. Acrylic can simply be overpainted as long as the paint has not been applied too thickly. Pastel can be corrected by brushing off as much of the top layer as possible, applying fixative, and then reworking. Take care with brushing off; if you are doing this in a selected area only, protect the rest of the painting by rough masking or you will get pastel dust where you don't want it.

Watercolor is more problematic, though corrections can be made. At an early stage you can simply wash your first washes off under cold water (the paper must be stretched for this). Small corrections can be made by lifting out, which is a technique as well as a correction method, and by overpainting with opaque white.

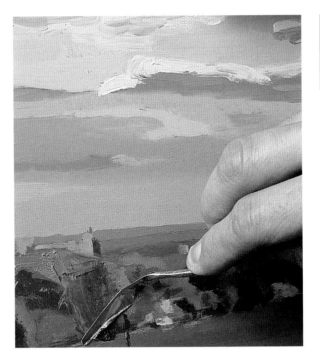

SEE ALSO

LIFTING OUT, pages 56–57

**SCRAPING OFF WHEN WET**

**1** If you are disappointed with the appearance of a particular passage, it can be remedied quite easily while the paint is still fresh. Here the artist is using a palette knife to scrape away excess paint from an area that has been built up too heavily.

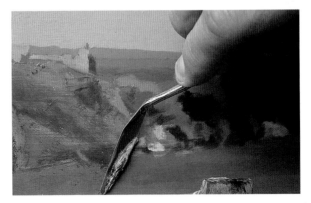

**2** The scraped area is then wiped with a rag soaked in turpentine and is ready to be painted over. If desired, medium can be applied to the area surrounding the correction so that the new paint "takes" more easily and blends naturally with the rest of the painting. This process is known as "oiling out."

**SANDPAPERING OIL AND ACRYLIC**
Thickly applied oil and acrylic can be smoothed down and partially removed by sanding. This may seem a bit drastic but is worth trying if you feel your painting is worth saving.

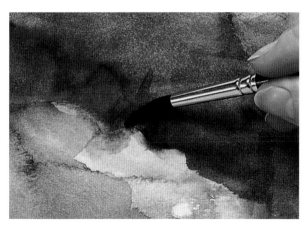

### REMOVING PAINT

Trying to move watercolor once it has dried can be difficult, but it is possible. Once your watercolor has dried, the paint can still be re-wet and moved around or partially removed from the paper. A sponge may work better than a brush for this purpose. Bear in mind, however, that some colors cannot be completely removed because the pigment in the paint will have stained fibers in the paper.

### BRUSHING OUT WATERCOLOR

If you think that the edge of a brushstroke is too hard or soft, and you want to achieve smooth edges, "tickle" them out with the tip of a slightly damp brush.

### TONKING

In oil painting, an area which has become clogged with too thick a paint application can be rescued by the method of tonking. This consists of laying absorbent paper over the area, smoothing it down with the palm of your hand and then gently peeling it away, lifting with it the excess pigment and producing a workable surface. You can then repaint over the area using the "ghosted" image remaining on the canvas as a guideline.

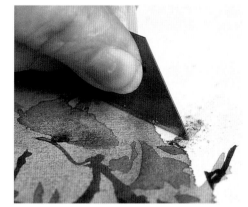

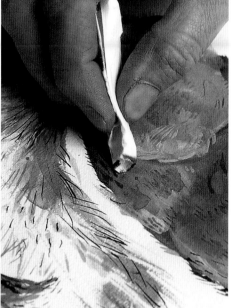
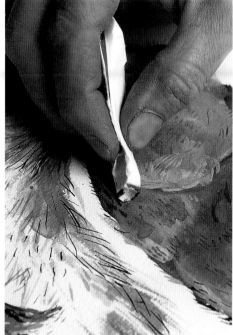

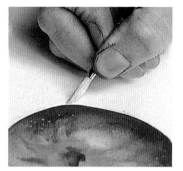

### SCRAPING OFF WHEN DRY

Small blots and blemishes are easily removed by scraping with a knife or razor blade. This must be done with care, however, or the blade might tear holes in the paper.

### BLOTTING OFF

If one color floods into another to create an unwanted effect, the excess can be mopped up with a small sponge or piece of blotting paper.

### OVERPAINTING WITH WHITE

Ragged edges can be tidied up by painting around them with white gouache paint. This is also a good way of reclaiming lost highlights.

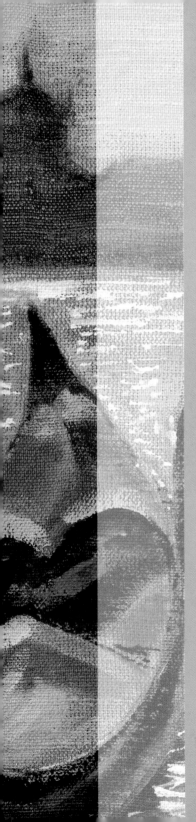

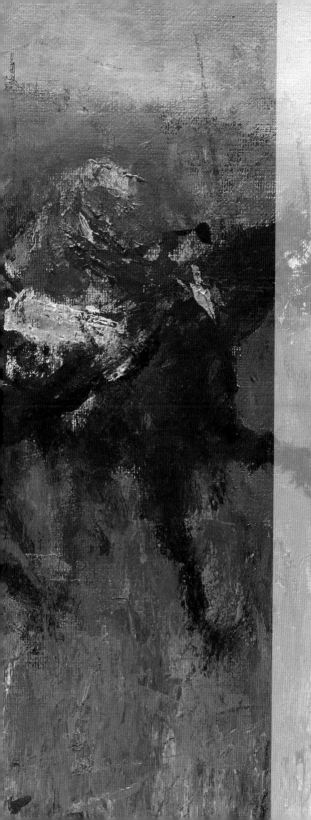

# WAYS OF
# WORKING

Here we look at various different
ways of going about a painting, from
exploiting brushwork to laying thin
glazes over one another in oil and
acrylic. You will also learn important
watercolor techniques, such as
wet-on-wet, and some interesting
methods for creating textures and
unusual effects.

# BRUSHWORK

THE MARKS OF THE BRUSH HAVE PLAYED AN IMPORTANT PART IN OIL PAINTING SINCE FIRST TITIAN, THEN REMBRANDT, BEGAN TO EXPLOIT THEM IN CONTRAST TO THE SMOOTH SURFACES AND SUBTLE BLENDS PREFERRED BY EARLIER ARTISTS.

Brushwork can be very helpful for describing objects. For example, long, upward-sweeping marks can be used for a tree trunk, and short dabs for foliage. Brushstrokes can also simply be a means of adding interest to an area such as a sky.

The extent to which brushwork is used as an integral part of an acrylic painting depends on the artist's approach. Acrylic excels in areas of flat color. Some artists exploit this while others work in much the same way as they would in oil paints.

In watercolor work, paintings can be built up entirely in a series of flat washes, but brushmarks can also be very important in some cases; it depends on your approach. Aim at making the marks of the brush describe the shapes you are painting: foliage, for example, can usually be described in a series of one-stroke marks, as can the ripples in water. In general, the most versatile brush is the round, which, if good quality, makes a good point and can achieve varied effects from fine lines, dots, and squiggles to large shapes. You might also try flat brushes, which can be used on their sides as well as at their full width.

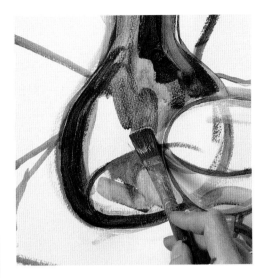

**USING DIFFERENT BRUSHES**
1 In oil painting, bristle brushes are the most commonly used, but acrylics can also be applied with any brush that suits the purpose. Here the artist uses a soft flat brush to apply well-thinned paint.

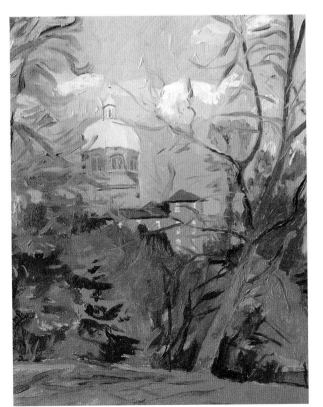

**VARIED BRUSHWORK**
This lively on-the-spot study by Jeremy Galton shows a use of brushwork that is both descriptive and expressive. In general, the strokes follow the shapes and forms of the objects, with different sizes of brush chosen according to whether thick or thin strokes are needed. But the artist has also introduced brushwork into the sky, applying the paint thickly so that little ridges of paint catch the light. Working on location is a good discipline in the context of brushwork, because you have to work fast and will instinctively find ways of letting the brush "make its mark."

**MARK MAKING**
There is always a temptation to reach for a tiny brush when outlining shapes, but the point of a large brush gives many more varied effects.

2 Working over the first thin, transparent washes, she now applies the paint more thickly.

3 Notice how the brushwork follows the shapes and helps to describe the draperies and forms of the objects.

**DOTS AND DABS**
Here fine lines are drawn out into a series of small dots, becoming paler as the brush is progressively "starved" of paint.

**LOOSE MARKS**
To avoid tight, fussy brushmarks in this watercolor painting, the brush is held near the top of the handle to encourage a looser, freer approach. Another trick is to work standing up so that you are forced to make wrist movements rather than just moving your hand.

# IMPASTO

THICK, OPAQUE PAINT (OIL OR ACRYLIC) APPLIED HEAVILY WITH A BRUSH OR KNIFE IS CALLED IMPASTO. THE PAINT IS LAID ON THICKLY, USUALLY WITH SHORT, STACCATO MOVEMENTS OF THE BRUSH, SO THAT THE PAINT STANDS AWAY FROM THE SUPPORT AND CREATES A RUGGED SURFACE.

**DRAWING ATTENTION**
Thick paint has a physical presence that draws the eye. Jeremy Galton has accentuated the waves, figures, and foreground sand with knife-applied impasto.

If desired, an entire painting can be built up with heavy impasto to create a lively and energetic surface. For this reason, impasto often goes hand in hand with the alla prima method of painting, because thick paint and rapid brushstrokes allow the picture to be built up quickly and in a spontaneous manner.

Van Gogh is perhaps the greatest user of expressive impasto. He often squeezed the paint straight from the tube onto the canvas, "sculpting" it into swirling lines and strokes, which conveyed the intensity of his feeling for his subject.

Impasto can also be used in combination with glazing to produce passages of great richness and depth. Titian and Rembrandt painted their shadows with thin, dark glazes to make them recede, while modeling the highlights on skin, fabric, and jewelry with thick impasto to make them pop forward. These small, raised areas catch the light and appear especially

brilliant. When glazing over impasto you must use a drying agent in the impasto, such as an alkyd-based medium. An impasto passage that is perfectly dry can then be painted over with a transparent glaze which sinks into the crevices of the paint and accentuates the rough texture. This technique is useful for rendering a subject such as wood, bark, or rough stone.

When building up heavily textured impasto, brushwork is all-important. If the pigment is pushed and prodded too much, the freshness and sparkle of the colors will diminish; think carefully about the position and shape of each stroke beforehand, then apply it with confidence, and leave it alone.

**SEE ALSO**

ALLA PRIMA, pages 22–23
GLAZING, pages 58–59

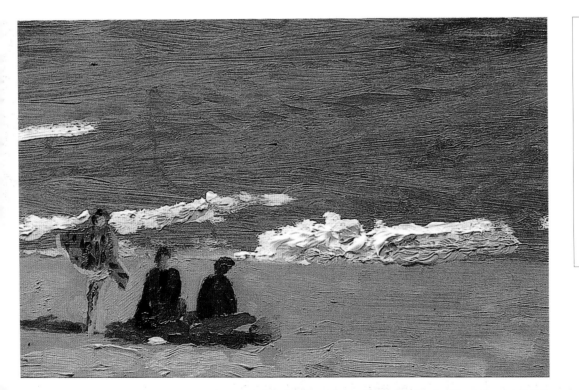

**DRYING THE LAYERS**

If thick layers of oil paint are applied on top of each other, the different speeds of drying between layers can cause cracking. It is essential that you allow each layer to dry out before applying the next. With acrylic you won't have the cracking problem, but make sure each layer is dry before adding the next or you will stir up paint below.

**OIL IMPASTO**

1 On a neutral ground, the composition is sketched freehand and the distant landscape and the grass painted in. The color of the horses is then laid down using a painting knife and brush in combination. The underdrawing is obscured, and the painter makes minor alterations to the legs of the horses.

2 Brighter colors are applied to represent the clothing of the riders. At this stage the painter tries out various color combinations and removes certain knife strokes of paint that do not seem to work. The lack of detail here will be in the spirit of the fast-moving subject.

**USING PAINT FROM THE TUBE**
Color can be squeezed onto the painting surface straight from the tube, but you will be limited to premixed colors. An alternate method is to add your own color mixes to a piping bag, or a plastic bag with one corner removed, and squeeze them onto the surface.

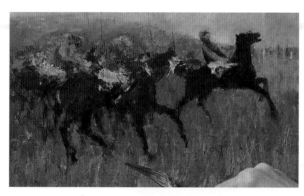

3 The grass is applied freely with the knife in two or three colors semimixed on the surface. The knife point is used to add a sgraffito texture in the foreground. Small dots of red break the monotony of the green.

**USING DIFFERENT TOOLS**
You can use any number of tools to apply thick paint. Wedges of thick cardboard are very useful since they can be cut to any size. It will gradually lose its stiffness during use because water and acrylic mediums soften fibers, but you can easily cut off the soft portion or use a fresh piece.

4 The finished picture has a moderately impastoed surface that adds to the sense of movement and excitement in the scene, and brings the horses and the racing ground forward from the sky and hills. Details are sacrificed in favor of the whole piece.

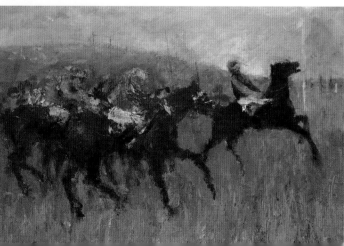

# KNIFE PAINTING

A KNIFE MAY SEEM A LESS SENSITIVE PAINTING TOOL THAN A BRUSH, BUT IN FACT MANY DIFFERENT PAINTING KNIVES ARE AVAILABLE IN A HUGE RANGE OF SHAPES AND SIZES THAT GIVE A VARIETY OF EFFECTS.

These are quite expensive, however, so experiment with one knife (not a palette knife) to see if you like this way of working. Painting knives are specially designed for the job, made of pliable steel with cranked handles that hold your hand away from the work.

Paint applied with a brush can be thin, thick, or somewhere in between, but for knife painting it must always be thick. This is a form of impasto, but the effect is quite different from that of thick paint applied with a brush. The knife presses the paint onto the surface, giving a flat plane bordered by a ridge where the stroke ends. In a painting built up entirely of knife strokes, these planes and edges will catch the light in different ways, creating a "busy" and interesting picture surface. The marks can be varied by the direction of the stroke and the amount of paint. You do not have to restrict yourself to the flat of the knife; you can also flick paint on with the side to create fine, precise lines. As with any impasto method, you will probably need to mix the paint with a bulking medium, or it will not be thick enough to hold the marks of the knife.

**MIXING COLORS**
Here the artist is partially blending two colors wet-in-wet. Cadmium yellow is first squeezed onto a previously applied layer of ultramarine. Then the knife is used, as if spreading butter, to distribute the paint in different directions. If care is taken not to overblend the colors, attractive subtleties of tint can be achieved.

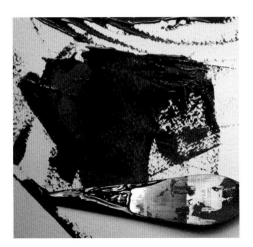

**SPREADING THE PAINT**
Apply the paint thickly to the support and spread it with a trowel-shaped painting knife to achieve a variety of interesting textures. One way of moving the paint is to rest the heel of the knife on the support and move it in an arc, spreading the paint with it.

**THE PAINTING SURFACE**
This painting was executed entirely with knives. Each separate patch of color joins with its neighbors to form a near-continuous layer of paint. The final texture of smeared and ridged paint has a lively, sparkling quality.

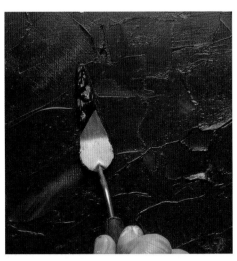

**SMOOTH STROKES**
A color painted with a knife often looks more brilliant than one painted with a brush, since the knife can leave an absolutely smooth stroke of color which reflects the maximum amount of possible light. To retain the purity of each color, always clean the blade of the knife between each application.

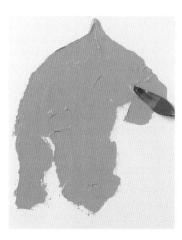

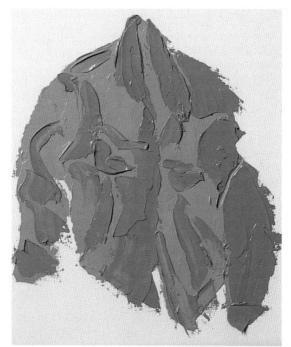

**2** The first layer was allowed to become touch dry and a second layer is added with a pointed knife. This time the paint has been applied more lightly, creating thick ridges with distinct edges.

**LAYERING WITH ACRYLICS**
**1** The artist is working on canvas board, and blocks in the main shape with a mid-toned color immediately. The paint is spread out flatly and is pushed onto the surface, so that it does not take too long to dry.

**3** By twisting the knife slightly as he works, the artist allows the point to scratch into the paint, thus combining knife painting with a version of the sgraffito technique.

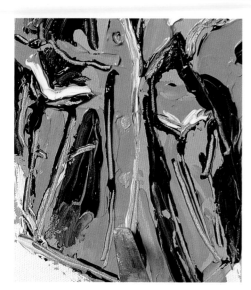

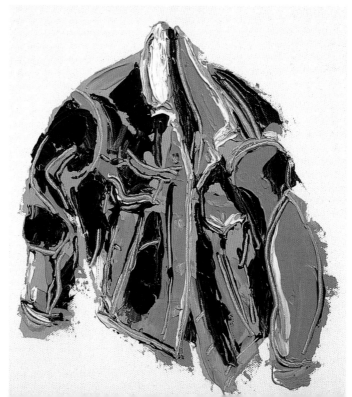

**SEE ALSO**

BUILDING UP: OIL AND ACRYLIC, pages 24–25
IMPASTO, pages 48–49
SGRAFFITO, pages 88–89

**4** An ordinary, straight-bladed palette knife is now used to remove small areas of the still-wet brown paint, suggesting the buttons on the jacket. Thickly applied paint dries slowly and can be manipulated on the surface for a considerable time.

**5** Further knife strokes of both black and white paint were added in the final stages to complete the definition of the jacket.

# WET-IN-WET

IN WET-IN-WET PAINTING, COLORS ARE APPLIED OVER OR INTO EACH OTHER WHILE THEY ARE WET, LEAVING THEM PARTIALLY MIXED ON THE CANVAS OR PAPER. IT IS ONE OF THE MOST SATISFYING METHODS TO WORK WITH, PRODUCING BOTH LIVELY COLOR MIXTURES AND SOFTLY BLENDED EFFECTS.

SEE ALSO

STRETCHING PAPER, pages 12–13
ALLA PRIMA, pages 22–23
BLENDING, pages 32–33
SCUMBLING, page 69

The method is often used for oils or acrylics. For example, the Impressionists exploited the method in their alla prima paintings. But it is most often associated with watercolor, and is one of the classic techniques. For all-over wet-in-wet effects, such as the first washes in a landscape, the paper must first be well dampened and must not be allowed to dry completely at any time. However, you can paint wet-in-wet for smaller areas either by dampening the paper selectively or by dropping a new wet color into a first one that has not been allowed to dry fully. Judging the precise wetness of the paper or underlying color is vital to the method, and is a skill that you will learn with practice. Paradoxically, when all the colors are very wet, they will not actually mix, although they will bleed into one another, but on slightly damp paper they will mix to a greater degree.

Acrylic may be quick-drying, but this property does not rule out the possibility of using the wet-in-wet technique. For example, tube color heavily diluted with water behaves similarly to watercolor, creating soft, blurred strokes. If you require a greater degree of control, dilute the paint with matte medium and perhaps some retarder (see blending).

**FOCUSING THE EYE**
Although painted mainly wet-in-wet, the highlights on the boat are crisp and clear, providing a strong focus. The edges of the reflections are soft, while those of the hills above are hard and sharp. Too many soft edges fail to attract attention.

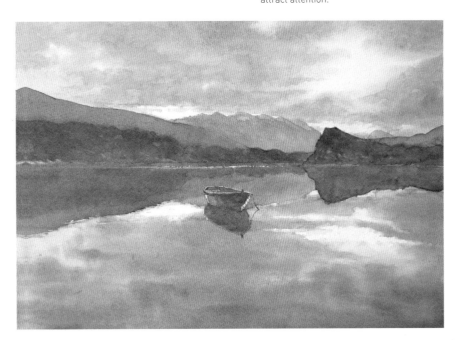

**WET-IN-WET WATERCOLOR**
1 Either use a heavy-grade paper or stretch it before you start (see stretching paper). Dampen the paper and blot off any excess so that the paper is evenly damp, not wet. The board should be laid flat or at a very slight incline. Load your brush with pigment and apply it in random strokes on the damp surface. Don't dilute the paint too much beforehand; this creates a weak, runny result. Because the paper is already wet, you can use quite rich paint. It will soften on the paper but will retain its richness.

**2** While the first strokes are still damp, further colors can be added so that the strokes spread and blur softly together. It is possible to manipulate the flow of paint by tilting the board to make the color "roll" on the paper. Keep a tissue handy for wiping away color where you don't want it to go.

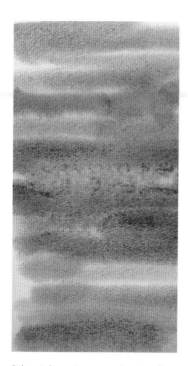

**3** A wet-in-wet passage has a soft, impressionistic feel. The technique is unpredictable but exhilarating, and it is worthwhile experimenting on scrap paper to see what effects you can create with it.

## WET-IN-WET ALLA PRIMA PAINTING

Wet-in-wet is a feature of much alla prima painting in oils, where each stroke is painted next to or over another wet stroke to produce softly blended tones.

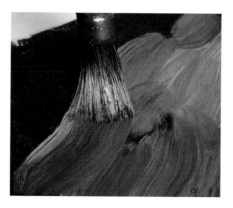

**WET-IN-WET OIL**
**1** Lay a patch of color. While it is still wet, brush into it with a second color, using loose, random strokes.

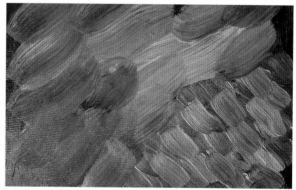

**2** Continue building up tones and colors as desired, taking care not to overwork the brushstrokes: a wet-in-wet passage should have a fresh, lively appearance. Here you can see how scumbling strokes leave an interesting texture. The complete passage contains hints of the two separate colors as well as a subtle range of tones in between.

### SELECTIVE WET-IN-WET

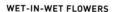

If you want to use the technique in only a certain part of the painting, for example the background, one object, or just one flower petal, simply dampen the paper in this one area. The paint will stop flowing as soon as it meets dry paper, creating a crisp hard edge.

**WET-IN-WET FLOWERS**
This delightful flower piece has been painted more or less entirely wet-in-wet, but selectively so. The white highlights were carefully reserved by leaving the paper dry.

# WET-ON-DRY

THE OPPOSITE APPROACH TO WET-IN-WET, PAINTING WET-ON-DRY MEANS APPLYING FRESH PAINT OVER A PREVIOUSLY DRIED COLOR. THIS METHOD IS USED IN GLAZING, AND FOR RENDERING PRECISE OR STRONGLY MODELED FORMS.

SEE ALSO

DRYBRUSH, page 68
SCUMBLING, page 69

Wet-on-dry is the normal method for acrylics because they dry so fast, and exciting results can be achieved by scumbling or drybrushing over an earlier passage of color. You can do this with oils also, but you will have to wait longer, especially if the paint has been applied thickly.

In watercolor work, wet-on-dry produces the hard edges that are very much a characteristic of the medium. By laying smaller, loose washes over previous dry ones you can build up a network of fluid, broken lines that give a sparkle to the work. But you don't always want hard edges in every part of the painting. A combination of wet-in-wet and wet-on-dry is always effective, especially in flower painting. Wet-in-wet washes capture the delicacy of leaves and petals in the initial stages, and then further washes, applied over the dried underlayer, add form and definition.

Depending on the wetness of the initial wash and the type of paper used, watercolor can take up to 15 minutes to dry thoroughly, so the technique does require a little patience; if the overlayer is applied too soon, the colors turn muddy and the crispness and definition are lost.

**CREATING DEPTH**
The wet-in-wet work in the background gives an out-of-focus effect that places it firmly in the distance, while the crisp edges on the cows and grass bring the whole area forward to the front of the picture.

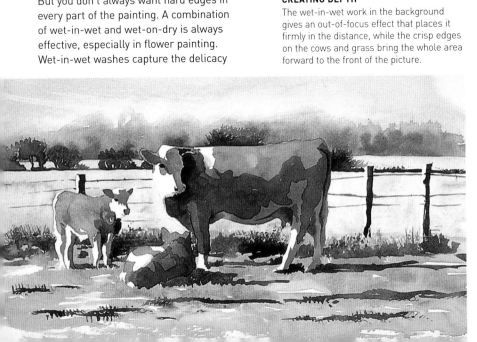

**WET-ON-DRY DETAIL**
The painting was begun loosely, working wet-in-wet, with highlights reserved as dry paper. Now the artist adds fine detail wet-on-dry with the point of a brush.

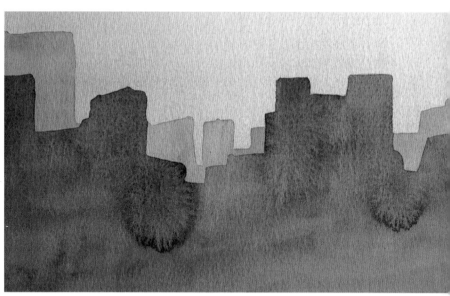

## LAYERING WATERCOLOR

1 The artist applies a flat wash of Hooker's green. When this is completely dry he overlaps it with another wash of the same color to achieve a layered effect. The overlapped wash creates a darker tone. To produce a still darker tone, add a third layer.

2 This simple image shows how building up overlapping washes, from light to dark, creates a convincing impression of aerial perspective; the lighter tones look farther away. It is most important to allow each color layer to dry before applying the next one. Otherwise, the characteristic clarity and transparency of the medium is lost. Remember that the fewer the overlaid washes, the cleaner and brighter the result. Watercolor tends to become "muddy" with too many superimposed washes.

### DRYING

You don't have to wait around for watercolor washes to dry before laying the next ones; simply use a hairdryer; few watercolor painters are without one of these. The same method can be used for acrylics, which are also water-based paints, but hairdryers are no good for oils.

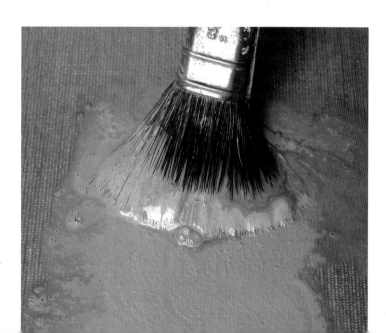

### COMBINING METHODS

With acrylics you can combine two methods. For example, if you wish to paint wet-in-wet over a dry underlayer of paint, simply brush water or medium over the dry paint. The next layer of color can then be softly blended into the wetness.

# LIFTING OUT

THIS SIMPLY MEANS REMOVING SMALL AREAS OF COLOR USING A SOFT BRUSH, A SPONGE, OR A TISSUE. THE TECHNIQUE IS OFTEN USED AS A CORRECTION METHOD, BUT IN THE CASE OF WATERCOLOR IT IS OFTEN USED AS A TECHNIQUE IN ITS OWN RIGHT TO SOFTEN EDGES, DIFFUSE AND MODIFY COLOR, AND CREATE HIGHLIGHTS WHICH CANNOT BE RESERVED.

For instance, the effect of wind-streaked clouds in a blue sky is quickly and easily created by laying a blue wash and wiping a dry sponge, paintbrush, or paper tissue across it while it is still wet. The white tops of cumulus clouds can be suggested by dabbing the wet paint with a sponge or blotting paper.

Paint can also be lifted out when dry by using a dampened sponge or similar tool, but the success of the method depends on the color to be lifted. Some colors act rather like dyes, staining the paper, while others, such as the "earth colors," lift out very easily. Large areas of dry paint can be lifted with a dampened sponge, but for smaller areas the most useful tool is a cotton swab. Use gentle pressure to prevent the stick poking through and scratching the surface of the paper.

**TISSUE PAPER**
When working with lots of wet washes, tissue is useful for wiping areas that have become too wet and for controlling the flow of paint. Use a blot-and-lift motion with the tissue; rubbing may damage the surface of the paper.

**BLOTTING PAPER**
Blotting paper is thicker and more absorbent than tissue and, once dry, it can be re-used. If you wish to lift out a small, precise area, hold the corner of the blotting paper against the surface until the excess paint is absorbed.

**BRUSHING OFF PASTEL**
To lift off excess color in pastel, use a delicate scrubbing motion with a soft brush, blowing away the surplus dust as you work. To lift out color in small areas, use a kneaded eraser pulled to a point.

SEE ALSO
HIGHLIGHTING, PAGES 38–39
CORRECTIONS, pages 42–43
WET-IN-WET, pages 52–53

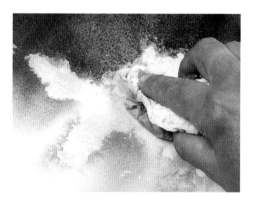

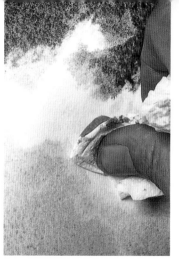

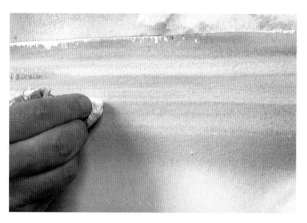

**LIFTING OUT CLOUDS**
**1** First a loose, uneven wash is laid down for the sky. While the paint is still wet, cloud shapes are lifted out by pressing with kitchen paper.

**2** By varying the pressure applied, different amounts of color can be removed. The paper can also be rolled to a point to lift out fine details, as shown here.

**3** A pale wash is applied for the sea. A piece of paper towel is dragged across the damp wash to create varying bands of tone and color. The paint is left to dry.

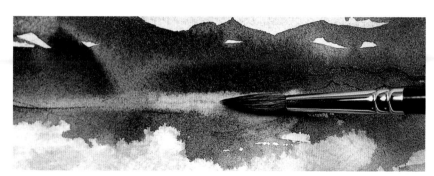

**4** A clean, dry brush is used to lift out color in the middle distance to suggest a flat area between the hills.

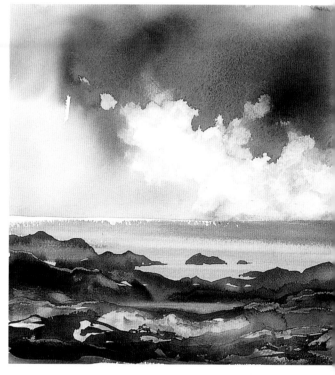

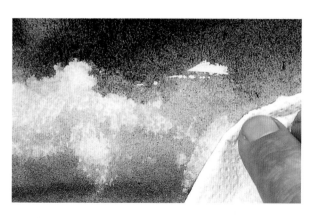

**5** The distant headlands are painted in a gray-blue wash and the hills in the foreground in a deep green. A paper towel is again used to blot some of the color in the foreground, suggesting forms in the landscape.

**6** Although the palette has been restricted to somber blues and greens, the finished piece has considerable drama, and the sky is completely convincing.

# GLAZING

GLAZING IS A TECHNIQUE MOST OFTEN ASSOCIATED WITH OIL PAINTING, BUT CAN ALSO BE USED WITH ACRYLICS, EGG TEMPERA, WATERCOLOR, AND INKS.

Glazing is a system in which thin, transparent washes of color are laid on successive layers of dried colors, such as many sheets of colored tissue paper. Each glaze qualifies earlier ones, and the result is rich, transparent, and glowing.
The reason for this is that a glaze, being transparent, allows light to pass through it and be reflected back off the underlying color. The colors thus combine optically and take on a resonance impossible to achieve by mixing them physically on the palette.

Glazing requires an understanding of how different colors interact with each other; it is worthwhile to experiment on pieces of scrap canvas, board, or paper, depending on the medium you are using.

## OIL

Paint for glazing should be thinned with a glazing medium which contains special film-forming ingredients that impart a soft luster to the paint surface. For best results, use a ready-made medium that contains beeswax; linseed oil is not ideal for glazes because it tends to move around after it has been applied.
Do not dilute the paint with turpentine alone. This makes the color go flat and dull and sometimes results in a cracked surface. For best results, apply the glaze with a large, flat, soft-haired brush. Position the canvas or board at an angle of about 15 degrees rather than vertically.

**GLAZING • OIL**

**1** Mix the color on your palette, then add an equal quantity of medium. The paint should have a thin but oily consistency. Beware of overthinning!

**2** Apply the glaze in a thin layer over a light ground. The color appears bright because of light reflecting back off the canvas. Lay the canvas flat to prevent drips and runs. Allow each layer to dry fully before adding more glaze.

**3** This example shows how the color underneath glows through the glaze, giving the paint a three-dimensional quality.

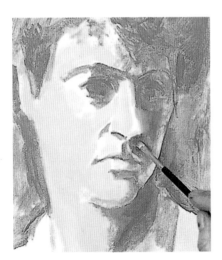
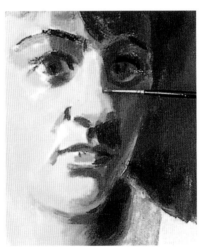

**ESTABLISHING THE TONES**

**1** This acrylic portrait was begun with a green underpainting, which was the traditional method used by the Old Masters for skin tones.

**2** Glazes were built up gradually layer by layer until the correct depth of color was achieved. Notice the rich glow of the skin tones.

## GLAZING TO MODIFY TONE

If you are unhappy with a certain color or tone, adjust it by glazing over it. A glaze will soften contrast and help to unify disparate tones, although it will not obscure the form beneath it. Shadow areas, in particular, appear more luminous when deepened with a dark glaze.

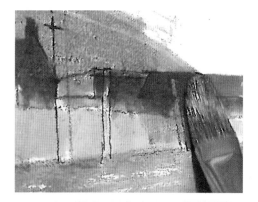

**APPLYING A DARK GLAZE**
1 Apply the glaze in a thin layer over the dried underpainting so that it forms a transparent film.

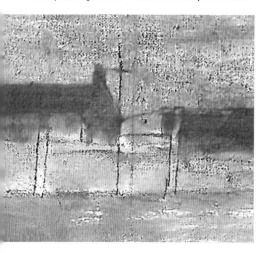

2 The colors underneath glow through the glaze, but the hues are modified.

## GLAZING OVER IMPASTO

Glazing can be used to enhance impasto. The thinned color settles in the crevices, accentuating the craggy texture of the paint.

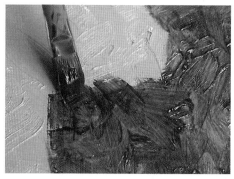

**ENHANCING IMPASTO WITH GLAZE**
1 Lay thick paint with a knife or brush, creating a coarse, craggy texture. Leave until the surface has dried out.

2 Mix a thin glaze, and brush it lightly over the impasto.

3 Let the impasto settle into the textural surface and let it dry before applying the next layer of paint.

**SEE ALSO**

IMPASTO, pages 48–49
WET-ON-DRY, pages 54–55

# SCRAPING ON

THIS METHOD CAN BE USED FOR EITHER OILS OR ACRYLICS. PAINT CAN BE SQUEEZED ONTO THE SURFACE STRAIGHT FROM THE TUBE, APPLIED WITH THE FINGERS, AND PUT ON WITH A PAINTING KNIFE OR SPONGE. IT CAN ALSO BE SCRAPED ONTO THE SURFACE.

This latter method—which can be carried out with an improvised scraper such as a plastic ruler, half an old credit card, or with one of the metal-bladed tools used for removing wallpaper—is allied to knife painting, but produces flatter layers of paint which cover the surface more thinly. It is thus ideal for layering techniques in which transparent paint is scraped over opaque layers or vice versa. You can also scrape lightly tinted acrylic medium over existing color, producing a glazing effect that enriches the color and gives it depth.

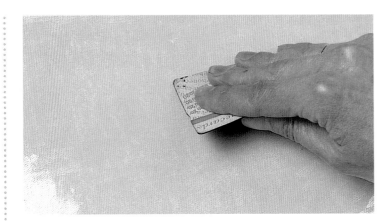

1 A plastic card is used to drag paint thinly across the surface. A metal paint scraper can also be used, but the flexibility of plastic makes it more sensitive. The working surface is a canvas board laid flat on a table and secured with tape.

## USEFUL IMPLEMENTS

Almost anything can come in handy for oil and acrylic painting, so keep a stash: old combs for texturing, credit cards, pieces of board which can be cut to size to make improvised painting knives, spoons which can be pressed into wet paint to make textures, and, most important of all, old toothbrushes, which have a myriad of uses. Never throw anything away before you consider its possible painterly use.

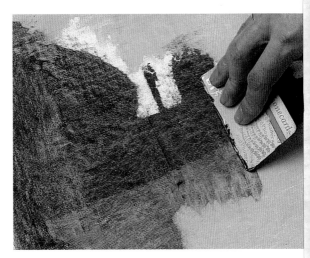

2 A darker color is laid over the blue. Although the paint is at tube consistency, coverage is thin enough to reveal the color beneath and give an effect almost like that of glazing.

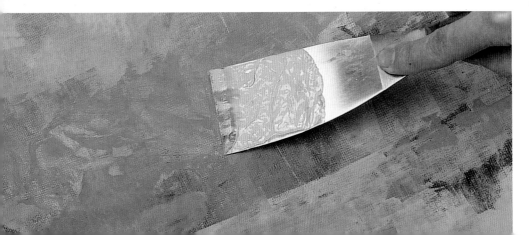

3 The greater rigidity of a paint scraper produces thicker, more irregular coverage. This method is applied in this example to build up surface texture in places.

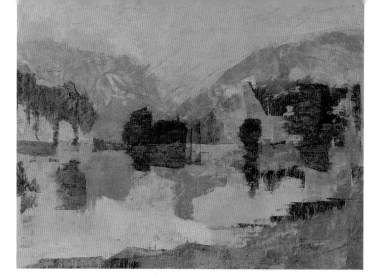

SEE ALSO

KNIFE PAINTING, pages 50–51

4 Here you can see the effect of the paint scraper in the areas of mountain above the trees at the top left and the transparent overlays of color achieved with the plastic card.

5 The card is pulled downward to create a veil of color which accurately suggests the reflections. The pigment used in this case is relatively transparent.

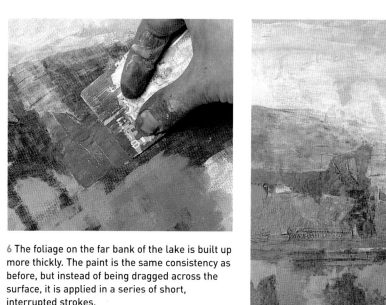

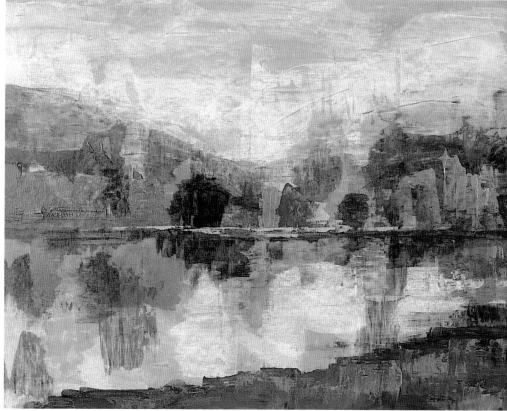

6 The foliage on the far bank of the lake is built up more thickly. The paint is the same consistency as before, but instead of being dragged across the surface, it is applied in a series of short, interrupted strokes.

7 The finished painting shows a variety of effects that would be impossible to achieve with any conventional painting tool. Thin veils of color contrast with the discreet semi-impasto and lively edge qualities.

# SPONGE PAINTING

THE SPONGE IS A HIGHLY VERSATILE PAINTING TOOL, CAPABLE OF PRODUCING A BROAD RANGE OF EFFECTS IN ANY PAINTING MEDIUM. MOST ARTISTS KEEP TWO SPONGES IN THEIR PAINTING KIT: A SYNTHETIC ONE FOR LAYING A FLAT, EVEN LAYER OF COLOR IN LARGE AREAS, AND A NATURAL SPONGE FOR CREATING PATTERNS AND TEXTURES.

Natural sponges are more expensive than synthetic ones, but they have the advantage of being smoother and more pliable to work with. Their irregular texture produces more interesting patterns in the paint. For example, a mottled pattern is produced by pressing a moistened sponge into fairly thick paint and then dabbing it onto the paper. You can dab one color over another or produce a graded tone by dabbing more heavily in one area than another. Also, by twisting or stroking with a paint-soaked sponge, you can achieve subtle gradations of tone when painting soft, rounded forms such as clouds, fruit, or misty hills in the distance.

## USING SPONGES

Painting with a sponge gives textural effects that are often impossible to render with a brush. The mottled patterns produced by dabbing color on with a sponge are perfect for simulating the textures of weathered rock, crumbling stone, pebbles, sand on a beach, sea spray, and tree foliage. In addition, you can create lively broken-color effects by sponging different colors over each other.

> **SEE ALSO**
>
> BROKEN COLOR, pages 66–67

**SPONGE PAINTING FRUIT**
The mottled finish that sponging creates is ideal for conveying the pitted surface of fruit, such as oranges. Here sponging has been combined with light brushmarks.

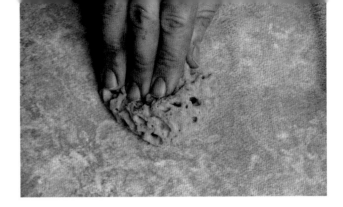

**NATURAL SPONGES**
**1** Paint for sponging should be diluted with just a little water or medium; if it is too fluid the marks will be blurred. In acrylic painting, diluting the pigment with matte medium gives sharper results than water will. Always use a damp sponge. Soak it in water, squeeze it out until just damp, then dip it into the pool of color on your palette. Apply the color with a soft dabbing motion, without pressing too hard.

You can also press a damp, clean sponge into a wet wash to lift out color and leave a subtle texture.

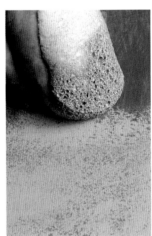 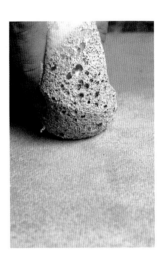

**SYNTHETIC SPONGES**
**1** Sponging often works better when a light color is applied over a darker underpainting. Here the artist is sponging over a gray-toned ground, a mixture of titanium white, raw umber, and cadmium yellow, with acrylic. A thick, synthetic sponge produces an even, close-textured pattern which is often used for building up tones and textures.

**2** When the first coat is dry, a lighter color with more white added to it is sponged over part of the first layer of paint.

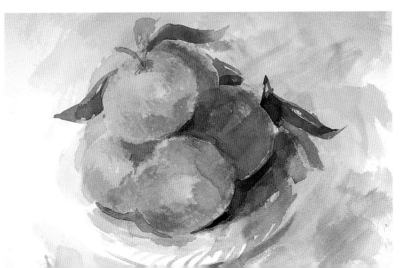

# FINGER PAINTING

THIS METHOD IS BEST SUITED TO OIL PAINTING, BECAUSE ACRYLIC DRIES TOO FAST TO ALLOW YOU TO MOVE PAINT AROUND. IT IS PERHAPS THE MOST NATURAL, AND CERTAINLY THE MOST DIRECT, METHOD OF APPLYING PAINT. THE FINGERS ARE SENSITIVE TOOLS AND ARE OFTEN SUPERIOR TO EITHER BRUSH OR PALETTE KNIFE FOR SUBTLE EFFECTS AND FINE CONTROL OF PAINT THICKNESS.

The fingers and hand are particularly useful for the rapid application of undiluted paint over large areas; as the paint can be rubbed well into the canvas fibers to give a greater degree of adherence. Paint can also be smeared off by hand until it is at its desired thickness. When modeling rounded forms, as in portraiture or figure painting, this technique can be invaluable, because it allows you to obtain very smooth gradations of color and tone in which the underlying layer shows through as much or as little as you want it to.

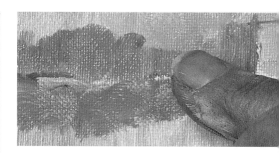

1 A combination of fingers and brushes is used for this painting. Having blocked in the basic features in paint mixed with alkyd medium, the artist blends them with her finger and then adds further thin layers. She is careful to keep the colors very close in tone so as not to lose the misty atmosphere.

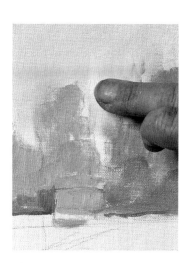

2 Layer upon layer of pale colors are rubbed into one another in the sky to produce a luminous effect. The trees, in contrast, are blended to a lesser degree to retain their outlines. Then, the contours of the distant trees are smudged into the sky so that they appear to recede.

3 The water, like the sky, is built up with many thin layers of paint. The thickness of the paint can be very precisely controlled by the finger method, and, in this case, it becomes both thicker and darker toward the bottom of the picture.

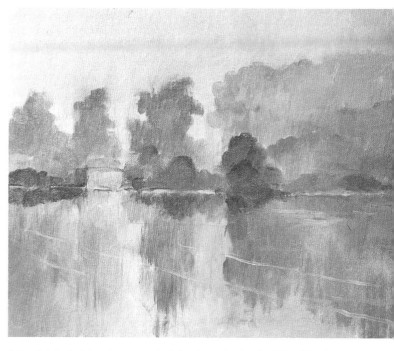

4 The finished picture has a wonderfully atmospheric effect. Handling the paint with the fingers has helped to ensure the ethereal quality of the scene is maintained throughout. The picture has been painted in a limited, high-key color range; only pale color mixtures have been used.

# COLORED GROUNDS

PAPERS FOR PASTEL WORK ARE
ALWAYS PRE-COLORED, BUT BOARDS
AND CANVASES PRODUCED FOR OIL
AND ACRYLIC WORK ARE WHITE.
ARTISTS OFTEN COLOR THESE BEFORE
STARTING A PAINTING, AND THERE
ARE TWO GOOD REASONS FOR THIS.

The first is purely practical; white can be difficult to work on. In nature you seldom see any pure light, because white, more than any other color, is altered and modified by the effects of light. Thus, by providing an artificial comparison, a white surface makes it difficult to assess the first colors you lay down.

You will quickly find this out if your subject includes a number of pale tones. The blue of a wintry sky, although substantially paler than shadows or tree branches, is still much darker than pure white, so even a correctly mixed pale blue will look too dark initially. If you work on a middle tone, such as gray or light brown, it is easier to work up to the lights and down to the darks.

The second reason for coloring the ground is that it will influence the overall color scheme of your picture and can set up exciting contrasts. Artists often choose a color for the ground that

is the opposite of the dominant color in the painting. For example, a dark yellow will set off the violets in a flower painting, or a red underpainting may contrast well in a green summer landscape. If you use a thin or a medium consistency paint, the ground will show through, creating vibrant passages of color. If you prefer to work thickly, you can leave small patches of the ground color showing between and around brushmarks, which achieves a lively broken-color effect.

SEE ALSO

BROKEN COLOR, pages 66–67

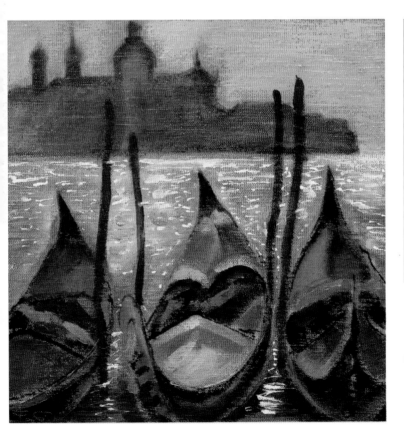

## PASTEL PAPERS

In pastel work, large areas of the paper are often left uncovered, especially in portraiture, where the background can simply be the color of the paper. Always choose a paper with your intended color scheme in mind and decide whether you want a contrasting paper or one that echoes the dominant color of the subject. If you can't obtain the exact color you want, try laying a watercolor wash on stretched watercolor paper.

**ESTABLISHING THE DOMINANT COLOR**
For this rich and glowing oil painting, the artist has begun with a warm, mid-toned reddish brown, because red is to be the dominant color. He has used a limited color scheme and has relied on the strong contrasts of tone to provide additional impact.

## THE EFFECT OF PAPER COLOR

Both the hue and tone of the paper influence the effect of applied pastel colors. If you practice making tint charts like these, you will be able to predict and make use of these effects. Notice, for instance, how the yellow patch appears much more vibrant on the dark gray paper than on the buff, and the brown pastel comes up surprisingly light-toned on a dark gray or red ground. The red paper gives greater intensity to the greens, because the colors have complementary contrast.

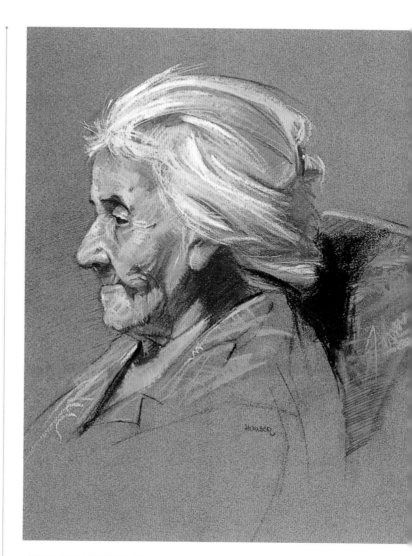

### LEAVING THE PAPER COLOR

This technique of using the paper itself as the background is known as vignetting, and is often used by pastel portraitists. Artist John Houser has chosen the tone and color of the paper with care, so that it contrasts with the light skin tones yet echoes the shadows in the hair.

# BROKEN COLOR

THE TERM "BROKEN COLOR," WHICH REFERS TO ANY AREA OF COLOR THAT IS NOT COMPLETELY FLAT, COVERS A WIDE RANGE OF COLOR TECHNIQUES. DRY BRUSH AND SCUMBLING, FOR EXAMPLE, BOTH PRODUCE BROKEN-COLOR EFFECTS, AS DOES DRAGGING A THIN WASH OF COLOR OVER A ROUGH WATERCOLOR PAPER. IN THE LATTER CASE THE PAINT WILL ADHERE ONLY TO THE RAISED GRAIN OF THE PAPER, PRODUCING A SLIGHT SPECKLING.

However, broken-color effects are most often seen in opaque techniques. If you look at a landscape painting in thick acrylics or oils, you would probably see that any large area of sky, sea, or grass consists of many different but related colors. Examine a close-up of sky which simply looks blue from a distance, and you may be able to identify a wide range of blues, and possibly some mauves, greens, and touches of brown as well. These colors all mix "in the eye" to "read" as blue.

Broken-color effects are often created by working on a colored ground which is only partially covered by the paint or by laying down a layer of flat color and working over it with other colors. Acrylic is particularly well suited to the latter method, because the first layer of paint will quickly dry.

SEE ALSO
..........
COLORED GROUNDS, pages 64–65

1 The composition is roughly mapped out with a few linear brushstrokes before the artist begins to apply small, separate areas of color. She is working on heavy medium-surfaced watercolor paper.

2 For the sun-struck white areas of the building, thick paint is used over the earlier thin washes.

3 Although she is building up the painting with a patchwork of colors the artist takes care to establish color relationships, repeating the blues and yellows from one part of the picture to another (right).

**5** Notice how the paint surface varies (right). Particularly on the buildings, transparent washes in the shadow areas contrast with thicker paint, where the grain of the paper has broken up the brushstrokes to give a textural effect.

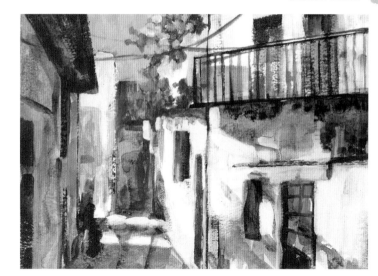

**4** With an architectural subject, it is important to maintain correct perspective and straight verticals. A piece of spare paper is used as a ruler with the brush drawn lightly along the edge.

**6** The painting is nearly complete, but the foreground is not yet sufficiently strong. A large, soft brush is used to lay washes or glazes of thinned paint, which create pools of deeper color.

**7** In each area of the picture both the colors and the brushwork are nicely varied. The contrast between thick and thin paint adds to the lively, sparkling effect.

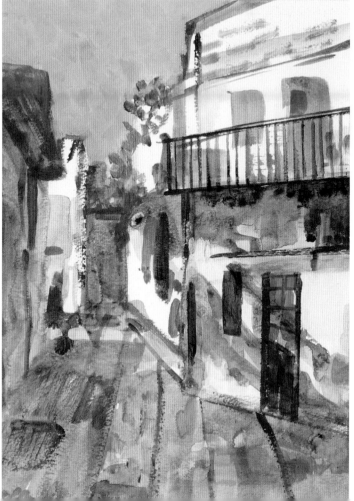

# DRYBRUSH

IN THE DRYBRUSH TECHNIQUE, A SMALL AMOUNT OF THICK COLOR IS PICKED UP ON A BRUSH WHICH IS SKIMMED LIGHTLY OVER A DRY PAINTING SURFACE. THE PAINT CATCHES ON THE RAISED "TOOTH" OF THE PAPER OR CANVAS AND LEAVES TINY SPECKLES OF THE GROUND, OR THE UNDERLYING COLOR, SHOWING THROUGH.

The ragged, broken quality of a drybrush stroke is very expressive, and there are many subjects that lend themselves to this treatment. The technique can be used to portray the coarse texture of the weathered surfaces of rock, stone, and wood for example. Loose drybrush strokes convey a sense of movement when painting delicate subjects such as grass, hair, or the foam of a breaking wave.

Drybrush allows you to suggest detail and texture with minimal brushwork; in waterscapes, for example, a deft stroke of dry color that leaves the white ground showing through can convey the sparkle of sunlight on water with the utmost economy. This quality is particularly useful in watercolor painting which relies on freshness and simplicity of execution, though drybrush works equally well in all media.

Never labor drybrush strokes: use quick, confident movements. The technique works best on a rough-textured ground which helps to break up the paint.

> **SEE ALSO**
> SURFACE MIXING, pages 30–31
> SCUMBLING, page 69

**DRYBRUSHING WATERCOLOR**
**1** Moisten the brush with very little water and load it with fairly thick paint. Flick the brush lightly across a piece of blotting paper to remove any excess moisture.

**2** Use a chisel-shaped brush or fan out the bristles of a round brush between your thumb and forefinger. Hold the brush at an angle of 45 degrees and drag it lightly and quickly across the surface of the paper. This technique works best on a rough or medium-rough paper.

**3** Drybrushing with more than one color or tone can create highly expressive effects, particularly when used in conjunction with washes. The underlying hue breaks through the drybrush to produce a fascinating optical mixture.

**DRYBRUSH PATTERNS AND TEXTURES**
By dragging, scrubbing, or smearing with the brush, you can produce a whole range of patterns and textures from delicate lines to heavy, broad passages. Experiment with rough and smooth papers and see how the character of the stroke differs with round and flat brushes.

**COMBINED TECHNIQUES**
Drybrush has been used for the marram grass. The paint was then scratched into with the point of a knife to create highlights. A little white gouache was dragged lightly over the paper grain to give sparkle to the sea.

# SCUMBLING

SCUMBLING IS THE ROUGH APPLICATION OF A DRY, LIGHT, AND SEMI-OPAQUE COLOR OVER A DARKER LAYER OF DRY, OPAQUE PAINT. THE SCUMBLED LAYER IS APPLIED THINLY, CREATING A DELICATE "VEIL" OF COLOR WHICH ONLY PARTIALLY OBSCURES THE UNDERLYING COLOR.

SEE ALSO

BUILDING UP: PASTEL, pages 26–27
BLENDING, pages 32–33
BROKEN COLOR, pages 66–67

Scumbles are usually applied by using a circular, scrubbing motion with a brush or crayon, but the effect can also be achieved with streaks, dabs, smudges, or stipples. The important thing is that the color be applied unevenly to produce a lively, unpredictable texture in which the marks of the brush or crayon are evident.

If painting, use a bristle brush in preference to a soft one. An old, worn brush is most useful, because the scrubbing action could damage the hairs of your best brush. You can also scumble with a rag, a sponge, or even with your fingers.

If you have an area of color that looks flat and dull, scumbling another color over it will make it appear richer and more vibrant. For example, a dull gray will sparkle if you scumble over it with yellow or red. This is because the two colors mix optically and become more resonant. Similarly, colors that are too warm, too cool, or too bright can be modified with a scumble of a suitable color.

**SCUMBLING WITH OIL AND ACRYLIC**
Paint for scumbling should be fairly dry, so wipe the brush on blotting paper to remove any excess moisture or oil. Using a bristle brush, scrub the paint on with free, vigorous strokes. The paint can be worked with a circular motion, with straight back-and-forth strokes, or in various directions. The idea is not to blend the color but to leave the brushmarks showing. Here various yellows and greens were scumbled together.

**COLOR INTERACTIONS**
Here a semi-transparent layer has been laid over another dry color. The underlayer is covered only partially so that it shows up through the scumble. Usually, a light scumble over a dark color gives the best results; add a touch of titanium white to the pigment to lighten it and make it semi-opaque. Build up scumbles thinly, in gradual stages. If the paint is applied too heavily, the hazy effect will be lost.

**TRANSPARENT SCUMBLE**
In acrylic painting, try mixing a lot of matte medium and water with the tube color; this combination produces delicate, transparent scumbles. For even greater depth and luminosity, you can glaze one transparent scumble over another.

**BLENDING WITH SCUMBLES**
Scumbling can also be used as a means of blending colors. The scumble allows some of the undercolor to show through and the two layers blend in the eye of the viewer. You can also scumble one wet color into another where they meet, as shown here.

**WATERCOLOR**
Used over washes, scumbling is useful for representing rough textures, such as a weathered stone.

# UNDERPAINTING

UNDERPAINTING IS LESS USED NOWADAYS THAN IT USED TO BE. IT WAS ONCE THE STANDARD METHOD OF LAYING THE FOUNDATION FOR A PAINTING, BY BLOCKING IN THE MAIN SHAPES AND TONES WITH THIN PAINT PRIOR TO THE APPLICATION OF MORE DETAILED AND/OR THICKER COLOR. THE IDEA IS TO ESTABLISH THE OVERALL COMPOSITION AND TONAL RELATIONSHIPS AT THE OUTSET, PROVIDING A FIRM BASE FROM WHICH TO DEVELOP THE PAINTING.

Mapping out the composition in this way gives you an accurate idea of what the final painting will look like. You will be able to see, at a glance, whether or not the picture hangs together, and, if not, any necessary changes can be made. Because the paint is used so thinly in underpainting, mistakes in oil paints are easily corrected by wiping off the paint.

   You have several choices regarding the colors used for underpainting: you may choose to block in the light and dark areas in a rough approximation of their finished colors; you may use neutral grays, blues, or earth colors which will help to unify the later layers of color; you may choose a color that contrasts with the final coloring of the subject, such as a warm red under green trees. You can also work over a tonal underpainting in shades of gray. This can be a very good method for acrylics, because you can either match the first applied colors to the tones or simply glaze over them to build up the colors.

   When underpainting in oil, always use lean paint diluted with turpentine to a fairly thin consistency. Allow the painting to dry thoroughly before painting over it. A convenient alternative is to use acrylic paint as the underpainting for an oil painting. This dries within minutes, allowing you to begin the overpainting in the same session.

SEE ALSO

BUILDING UP: OIL AND ACRYLIC, pages 24–25
CORRECTIONS, pages 42–43
COLORED GROUNDS, pages 64–65

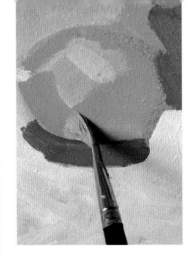

## TONAL UNDERPAINTING

1 Many artists choose to underpaint in tones rather than colors; this is called monochrome underpainting. The artist is using thinned acrylics applied with short, scrubby strokes with a large flat brush. It is a matter of personal choice as to how you tackle the underpainting. You can work from light to dark, from dark to light, or you can start with the middle tones and then establish the lights and darks.

2 Here we see the basic shapes and areas of tone beginning to take form. Try not to create too many extremes of tone. For example, keep the shadows lighter than they will finally appear and the highlights more subdued. The lighter the underpainting, the more vibrant the finished picture will be.

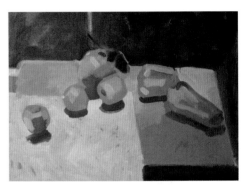

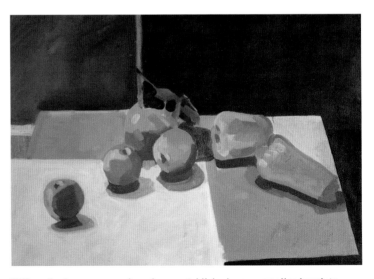

3 When the large masses have been established, use a smaller brush to refine the shapes if desired. Guard against too much detail, however. The underpainting is only a guide and should not be so perfect as to inhibit your freedom of handling in the later stages of the painting.

## COLOR UNDERPAINTING

1 The artist is working in oils. The board was first stained with yellow ocher, and cobalt blue, diluted with a large quantity of turpentine, was used for the preliminary underpainting. In this case, it was not intended to play an important part in the finished painting. The main aim is to establish the dark and light passages within the intricate pattern of leaves, stalks, and reflections.

2 The dark background on the left has been blocked in with thin, lean paint, and the artist now works on the leaves.

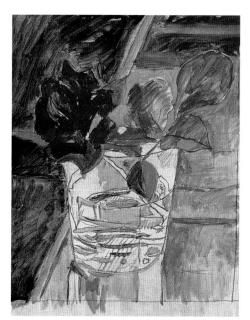

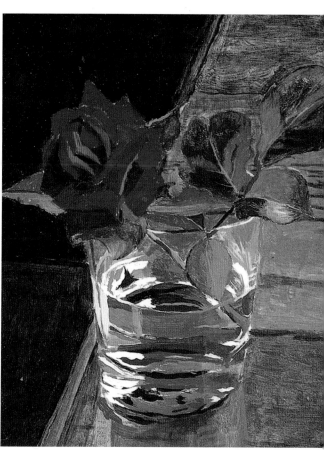

3 The painting has now reached a halfway stage, with the thinned paint now dry and ready to receive some of the final colors.

4 The underpainting has been very loosely handled, although care has been taken not to lose sight of the carefully measured-out drawing, particularly that of the glass—a difficult subject. Some of the final colors are now being applied.

5 In the finished picture, very little of the underpainting is visible, since great care has been taken to "tidy up" the painting. The main benefit of the underpainting was to incorporate fluid brushstrokes that help to keep the picture alive. Small, intricate subjects like this can very easily become overworked and tired-looking.

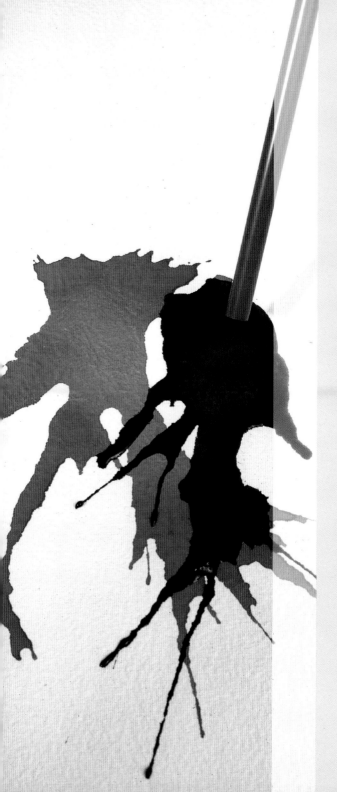

# SPECIAL TECHNIQUES

In this section, we explore the "fun" techniques. Which is not to say that they are just for fun; many have been used for decades and will be used again. But they are enjoyable to try, even without a specific context. Once you have mastered each one, you will find ways of applying them that work for you.

# SPATTERING

THIS METHOD GIVES A RANDOM EFFECT AND IS IDEAL FOR SUBTLY SUGGESTING TEXTURES, SUCH AS PATTERNS IN STONEWORK OR BEACH PEBBLES. SPATTERING CAN BE USED SUCCESSFULLY IN ALL THE PAINTING MEDIA, BUT IS MOST OFTEN USED IN WATERCOLOR WORK.

**DEPICTING FOLIAGE**

Spattering gives a loose and random look to the foliage of the trees in this scene. The artist prepared several olive green washes. After placing tissue over the lower half of the painting to protect the foreground, she spattered on the paint, applying lighter tones to the top left and darker shadows underneath and to the right.

There are two basic methods of spattering. One is to dip an old toothbrush into fairly thick paint and, holding it 3–6" (7–15 cm) above the paper, quickly draw a knife blade or your thumbnail across it to release a shower of fine droplets onto the paper below. The second method is to load a stiff bristle brush with thick paint and tap it sharply against the palm of your free hand, an outstretched finger, or the handle of another brush. This produces a slightly denser spatter, with larger droplets.

Artists often use a touch of spatter to enliven an empty foreground, because its randomness can suggest all manner of things while not claiming too much attention. Also, a spattered passage has an inherent sense of movement, which can be used to your advantage when painting sea spray, or a snowstorm, for example.

Take care, though. Spattered paint can travel a surprising distance, so make sure that nearby walls, floor, and furniture are covered. Similarly, when applying spatter to a small area of a painting, mask off the areas not to be spattered with sheets of paper fixed with masking tape.

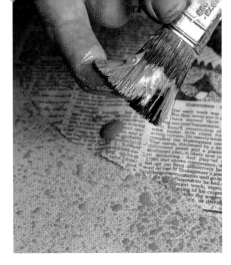

**USING ACRYLIC**

**1** The paint must be thinned with water to a cream-like consistency, and the board should be laid flat or the paint will run down. Use newsprint to mask off those parts of the painting that are not to be spattered. Load your brush well, then draw your finger through the bristles to release a shower of small drops onto the surface.

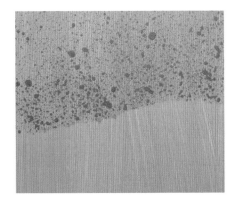

**2** When the paint is thoroughly dry, remove the mask. Here you can see the edge where the flat wash and the spattered area meet.

**SEE ALSO**

SPONGE PAINTING, page 62
BROKEN COLOR, pages 66–67
SALT SPATTER, pages 76–77

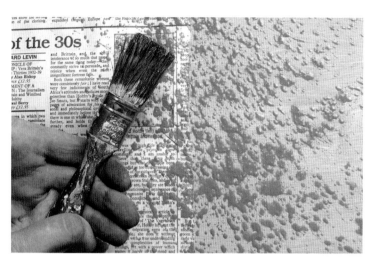

**3** Spattering from different directions will give a variety of effects. In this example the artist holds the brush closer to the surface and slightly to one side. He then hits the handle of the brush sharply against the palm of his free hand. This method produces oblique marks instead of dots, because the paint hits the surface at an angle.

## BLOTTING

If too much spattered paint has been applied, or if it looks over-obtrusive, the effect can be softened by blotting with newsprint or kitchen paper. This will also produce variations in size, because the paper will spread out the droplets.

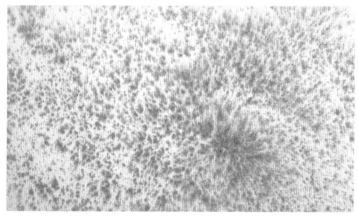

## WATERCOLOR ON DRY PAPER

The delicate, fluid nature of watercolor lends itself well to the spattering technique. Use a stiff hog's hair brush and work as above to release a shower of fine dots onto the paper. The paint should be a stiff mix, like heavy cream. Always test the density of the spatter on a scrap of paper before applying it to a painting. Generally, the brush should be held about 6" (15 cm) above the paper, but you will discover by trial and error which is the best distance for the effect you want.

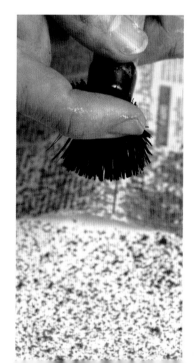

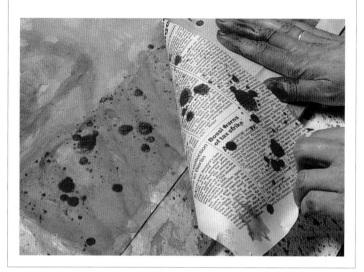

## WATERCOLOR ON DAMP PAPER

Spattering on damp paper creates a soft, impressionistic effect, because the dots of paint blur together. This spontaneous way of painting often produces accidental effects which can be further worked to produce pleasing images. Try spattering with two or more colors and allowing them to blur into each other.

# SALT SPATTER

THE USE OF SALT SPRINKLED ONTO A WET WASH OF WATERCOLOR, INK, OR THINNED ACRYLIC PRODUCES EXCITING TEXTURES AND EFFECTS.

The granules of salt soak up the paint where they fall, and, when the paint is dry, the salt is brushed off. A pattern of pale, crystalline shapes remains. These delicate shapes are very efficient for producing the illusion of falling snow in a winter landscape or for adding a hint of texture to stone walls and rock forms.

The technique sounds simple, but it takes practice to get the timing of the salt application right. The ideal time to apply salt is when the wash is wet, not soaking, but also not too dry. Large, soft shapes are produced by applying salt to a wet wash, whereas smaller, more granular shapes are produced in a wash that is just damp.

If you want to produce a fine, delicate pattern, ordinary table salt can be used. But in general, coarse rock salt works better. Do not sprinkle on too much, because this spoils the effect. Once the salt is applied, leave the surface in a horizontal position for 10 to 15 minutes or until the wash is completely dry, then simply brush off the salt.

Be aware that salt will not react on pigment that has previously dried and been re-wetted. Nor will it work on poor-quality paper or with inferior paints.

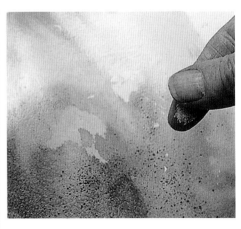

**VARIEGATED SALT WASH**
**1** The artist has laid a variegated wash, working wet-in-wet, and scattered salt into the still-wet paint.

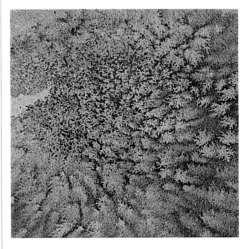

**2** Many different effects can be achieved, depending on how much salt is put on. In this case, a good deal has been used, and it has been spattered closely.

**IMITATING TEXTURES**
In this painting, several layers of salt spatter have been used to give an accurate description of the crumbly texture of the rocks.

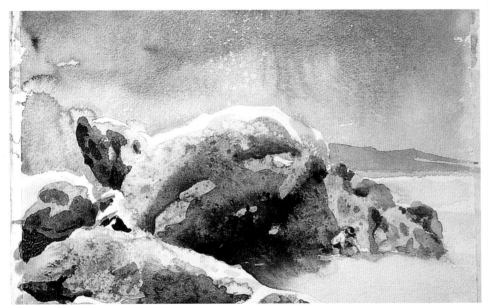

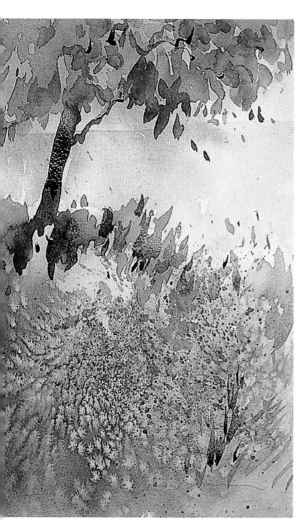

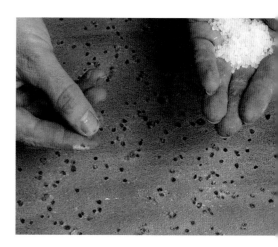

**USING ROCK SALT**

**1** Apply a flat wash of color to the paper. Just before the wash loses its shine (you can see this by holding the paper, horizontally, up to the light), sprinkle a few grains of rock salt into it. Leave the surface flat and allow it to dry naturally.

**2** When the paint is dry, brush off the salt. Pale, crystalline shapes are left where the salt granules have soaked up the pigment around them.

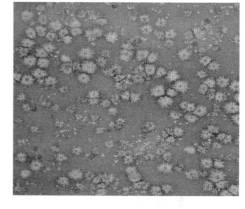

**3** Sometimes the textures created by the salt technique will suggest other images which can be developed further. These flower-like forms were created by dropping salt crystals into a slightly wetter wash.

**3** The spatter has been cleverly integrated into the landscape to create an exciting sense of movement and suggest texture without being literally descriptive.

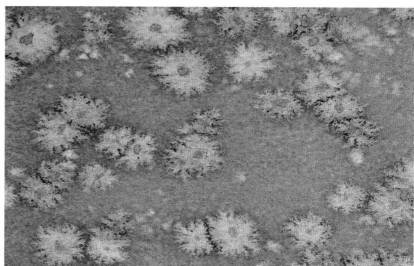

**SEE ALSO**

SPONGE PAINTING, page 62
SPATTERING, pages 74–75
BLOWN BLOTS, pages 82–83

# WAX RESIST

WAX RESIST IS A VALUABLE ADDITION TO THE WATERCOLORIST'S REPERTOIRE. THE TECHNIQUE IS BASED ON THE ANTIPATHY OF OIL AND WATER AND INVOLVES DELIBERATELY REPELLING PAINT FROM CERTAIN AREAS OF THE PAPER WHILE ALLOWING IT TO SETTLE ON OTHERS.

The idea is simple, but can yield magical results. If you draw over paper with wax and then overlay this with watercolor, the paint will slide off the waxed areas, giving an attractive mottled effect. You can use either an ordinary household candle or inexpensive wax crayons, and the wax underdrawing can be as simple or as complex as you like. You can suggest a hint of pattern on wallpaper or fabric by means of a few lines, dots, or blobs made with a candle, or you can make an intricate drawing using crayons.

**WATERCOLOR**

**1** Having first lightly penciled in the outlines of the figures, the artist roughly scribbles over the sunlit background and trees using first a white wax candle and then green and yellow oil pastels.

**2** Dark shades of watercolor are then flooded over the whole area. The waxy parts reject the watercolor, but where there are tiny gaps in the waxy surface, the color adheres, creating broken shapes and a speckled effect that is characteristic of the technique.

**3** When the initial washes are dry, additional tones are added to define the forms without overworking them.

**4** The finished piece shows just how effective the wax resist technique can be. The sunlit background and the shadowy forms in the foreground are suggested with just enough tone and detail in the lightest, most impressionistic way.

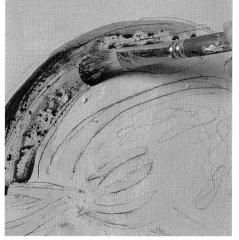

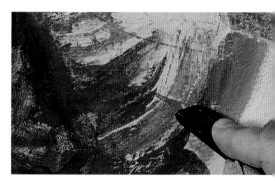

**ACRYLIC**

1 Watercolor paper is tinted with colored gesso (see priming), which provides a slight texture as well as reduces the glare of white paper. A pencil drawing is then made as a guide and wax applied lightly to the top of the cabbage.

2 The thin, watered paint slides off the wax. Thick paint is less suitable for this method, because the tough plastic skin formed by opaque acrylic can cover the wax completely.

3 To create more precise, linear effects, the point of a knife is used to scratch away the small drops of paint that have settled on top of the wax. The artist has turned the board around to gain access to this area of the picture.

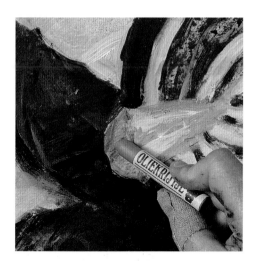

4 Following further applications of wax and paint, touches of green oil pastel are added. Oil pastels can also be used under the paint, but they are less effective as resists than candles, crayons, or oil bars.

SEE ALSO
.............
PRIMING AND STAINING, pages 16–17
UNDERDRAWING, pages 40–41
BROKEN COLOR, pages 66–67

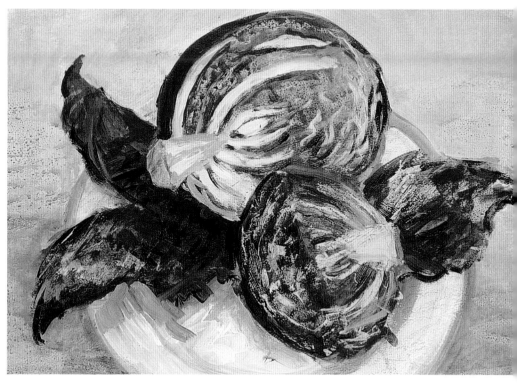

5 The finished picture shows a lively combination of pattern and texture. The oil bar, which has been used on the cabbage and the plate, gives a painterly quality to the image.

# GUM ARABIC

GUM ARABIC IS THE MEDIUM, TOGETHER WITH GELATINE, THAT BINDS THE PIGMENTS IN WATERCOLOR, AND IT CAN ALSO BE BOUGHT FROM ART STORES SPECIFICALLY FOR ADDING TO THE PAINT.

**SEE ALSO**

HIGHLIGHTING, pages 38–39
BRUSHWORK, pages 46–47
LIFTING OUT, pages 56–57

Never incorporate it undiluted, because this may make the paint crack. Instead mix it into the water in a proportion of not more than half and half. The addition of the gum makes the paint thick and glossy and enriches the color. It also prevents colors from running together and is especially useful for a painting that is built up in small, separate brushstrokes.

It is also very useful for lifting out. If you paint a wash mixed with a little gum arabic over a dry base color and allow this to dry, you can lift out the second color very easily with a damp brush, because the water dissolves the gum. Interesting effects can be created in this way. For example, you might paint a strong yellow wash for a tree, overlay it with green, and lift out highlights. The second layer of color will come off much more cleanly than paint mixed with water alone, revealing the brilliance of the underlying color.

Gum arabic can also be used as a varnish for an area of a painting that has gone dead. But it should never be used alone, because this could cause cracking. Experience will teach you how much to dilute it when using it as a painting medium, but a general rule is that there should be a lot more water than gum; it is sometimes referred to as gum water for this very reason.

**GUM ARABIC AND MASKING**
**1** The paper is first covered with a pale wash of blue-green. When dry, liquid frisket (masking fluid) is used to mask out the shapes of the goldfish.

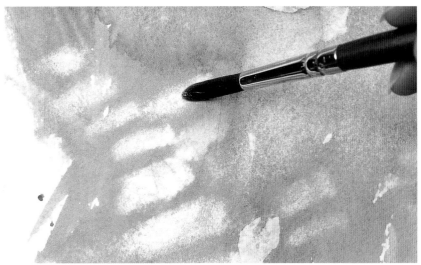

**2** A wash of green and blue mixed with gum arabic is painted over the whole surface. While this is still damp, a clean, wet brush is pressed into the wash to lift out highlights in the water. Notice how cleanly this removes the color.

**USING GUM ARABIC**

**1** This medium should never be used undiluted. Here a few drops are added to the water before being mixed with the paint.

**2** As you brush the mixture onto dry paper, you will notice a syrupy look to the paint.

**3** A further color is added before the first has fully dried.

**4** The paint does not travel as far as it would without the added gum.

**3** The masking fluid is removed, and darker washes and highlights are built up in the same way as before. Additional highlights are lifted out with a knife blade while the paint and gum mixture is still slightly damp.

**4** To complete the picture, the goldfish are painted in tones of orange, contrasting vividly with the blue-greens of the water.

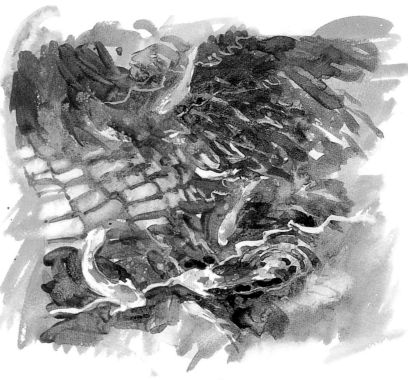

# BLOWN BLOTS

THIS IS AN EXCITING AND SPONTANEOUS WAY OF APPLYING PAINT OR COLORED INKS. BLOWING VIGOROUSLY ONTO WET BLOTS OF FAIRLY LIQUID PAINT, OR SIMPLY TILTING THE SUPPORT IN VARIOUS DIRECTIONS, SENDS STREAMS OF PAINT TRAVELING IN ALL DIRECTIONS. THE ACCIDENTAL SHAPES PRODUCED OFTEN SUGGEST AN IMAGE—FLOWER FORMS, ANIMALS, A MYSTERIOUS LANDSCAPE—WHICH THE ARTIST THEN DEVELOPS WITH FURTHER APPLICATIONS OF PAINT.

This kind of "action painting" has much to offer for the artist who occasionally seeks a change from purely representational painting. Allowing the painting to evolve of its own accord stimulates the imagination, and the benefits gained will have a positive effect when the artist returns to his or her normal methods of working. The eighteenth-century Russian-born painter Alexander Cozens wrote a book on developing images from ink blots. The idea of applying color in a free, uncontrolled manner was given further credibility by Jackson Pollock and other Abstract Expressionist painters of the 1960s, who often laid their canvases flat on the floor and applied the paint in seemingly haphazard dribbles and splashes.

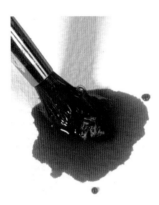

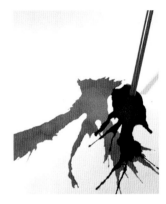

**1** The artist splashes a large brushful of yellow ink onto dry watercolor paper to produce a deep pool of color.

**2** He then blows hard at the ink blot at close range, causing the ink to spread in spidery trails. Blow in several directions until the ink takes on an interesting shape.

**3** When the first color is dry, a blot of purple ink is applied. Here the artist blows through a straw to create even finer trails of ink. This method allows you more control over the shape and direction of the trails.

**4** A blot of red ink is added, using an eye dropper. Experiment with several different colors, making them overlap partially, or try adding new colors while the underlying ones are still wet.

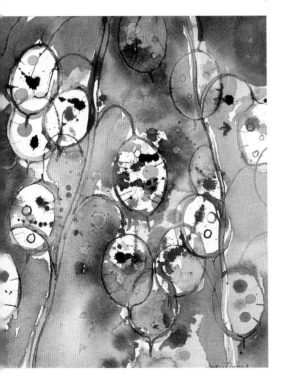

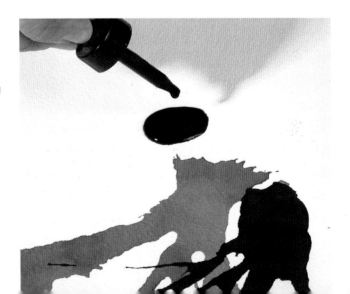

**LETTING THE PICTURE DEVELOP**
This image began with random flicks of dark paint, which suggested "honesty seeds," and was gradually developed with wet-in-wet washes and wet-on-dry detail.

# IMPRESSING AND IMPRINTING

IN BOTH TRANSPARENT AND OPAQUE PAINTING, INTERESTING RESULTS CAN BE ACHIEVED BY PRESSING REAL OBJECTS INTO WET PAINT. IN OIL AND ACRYLIC PAINTING, THE TECHNIQUE INVOLVES SIMPLY PRESSING THE OBJECT FIRMLY INTO A LAYER OF THICK, FAIRLY TACKY PAINT, THEN REMOVING IT QUICKLY. OBJECTS WITH A RAISED OR OPENWEAVE SURFACE TEXTURE WORK BEST. TRY USING A POTATO MASHER, A FORK, A PIECE OF BARK, OR SIMPLY ROUGH FABRIC. THE POSSIBILITIES ARE ENDLESS!

An allied method, called imprinting, is to coat the object itself with paint and press it onto a dry area, or straight onto the canvas or paper. This works particularly well with ink and watercolor, because the pattern left behind when the object is removed often has a soft, delicate quality. Natural objects—leaves, feathers, and grasses, for example—work well with this method, as do scraps of fabric and lace.

**WATERCOLOR AND FABRIC**
A variegated wash has been laid loosely onto the paper, and a heavy-textured canvas pressed into it while still wet. The fabric is removed, leaving an interesting random texture that could suggest old, crumbling brick or stone.

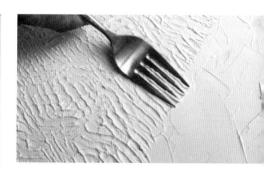

**ACRYLICS**
A kitchen fork is pressed into wet paint mixed with modeling paste, leaving a lively pattern of grooves and ridges.

**SEE ALSO**

TEXTURING, pages 18–19
VARIEGATED WASH, pages 36–37
WAX RESIST, pages 78–79

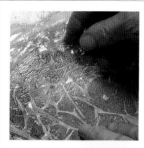

**USING PLASTIC WRAP**

1 A wide variety of effects can be achieved with plastic wrap, depending on how you crumple or fold it and how long you leave it in place. Here, the artist makes small pleats in the wrap with his fingers before placing it on the paint.

2 When the wrap is removed, you see a pattern of small, dark pools and lighter lines that could suggest a number of textures in the real world.

**IMPRINTS**
1 Almost any object, as long as it has one relatively flat side, can be used for the imprinting technique. Here the artist has used a large, soft brush to coat a leaf with a layer of acrylic, and he now lays the leaf onto the paper and presses it down firmly.

2 The leaf is removed, revealing the printed image. A smooth or medium-smooth paper gives the cleanest print, but a rougher paper creates an interesting broken effect because the paint doesn't "take" so evenly.

# LINE AND WASH

LINE AND WASH (OR WASH AND LINE) IS A CLASSIC TECHNIQUE OF BOTH PEN-AND-INK WORK AND WATERCOLOR.

The combination of finely drawn lines and delicate washes has great visual appeal and is particularly well suited to flower studies. The method allows a combination of fluid, freely applied paint and fine detail, also lending itself well to paintings of animals and birds.

Some artists begin with the line work, adding color, and then adding more line work. But in the classic method, colors and tones are laid in as light washes, allowed to dry, and then fine lines are drawn in with a pen or a brush. Varying the pressure on the pen or brush will produce subtle variations in the quality of the line. The line and wash drawings of Rembrandt and Hogarth are worth studying in this respect.

A variation is to use water-soluble ink for a preliminary drawing, then wash over it with wet paint which will partially dissolve and soften the lines. The painting can then be built up with more line and color. Experiment to find out whichever method you prefer.

SEE ALSO
VARIEGATED WASH, pages 36–37

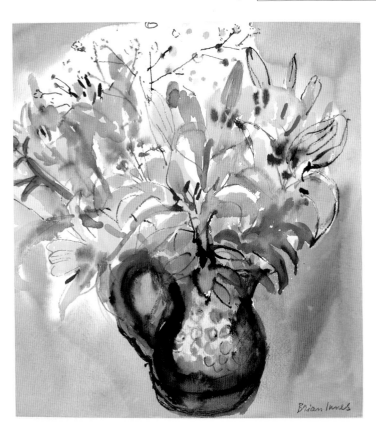

**SUGGESTING DETAIL**
In this painting, line has been used freely and kept to a minimum, suggesting rather than describing individual shapes and forms. Although the line plays a subsidiary role, it gives structure to the mainly wet-in-wet treatment.

**THE CLASSIC METHOD**
**1** Lay a wash with broad strokes using a soft brush and thin, fluid paint. Make sure the wash is not too wet before applying the lines.

**2** Use pen and ink to draw in lines over the washes. The combination of crisp lines and translucent washes is highly attractive.

**3** A crisp line is obtained where the wash is quite dry. Where the surface is still wet, the lines are soft and feathered. It is also possible to draw the lines first and apply the wash on top; use waterproof ink if you wish to retain the crispness of the lines when the wet wash is applied.

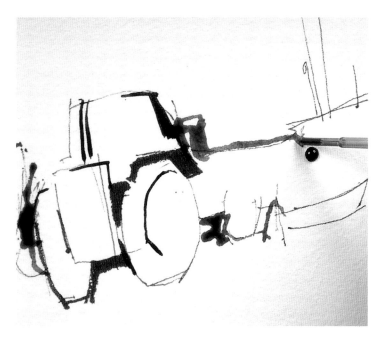

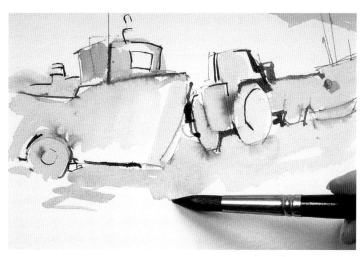

**2** Loose patches of gray are laid over the boats and foreground, leaving plenty of white space to retain the freshness of the picture. Where the wash has been taken over the water-soluble pen lines, the ink dissolves and bleeds into the damp paper, creating pockets of intense color.

### VARYING THE LINE COLOR

**1** To maintain the liveliness of the painting, the artist has chosen a variety of waterproof and water-soluble fiber-tipped pens in different colors for the line work, rather than choosing the more common approach of drawing in a single color. Here, she draws in some of the outlines in green and others in red and/or dark blue.

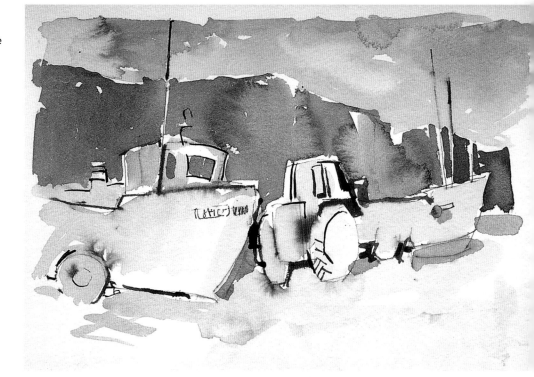

**3** To complete the picture, slate-gray and pale crimson washes are applied to the cliffs in the background. When the paint in the foreground is dry, a few small details, such as the name on the boat on the left, are added with fiber-tipped pen. Notice how the color of the pens spreads when washes are applied.

# WET BRUSHING PASTEL

IF YOU BRUSH WATER OVER SOFT PASTELS YOU WILL ACHIEVE A GRAINY WASH OR A LOOSE MIXTURE OF LINE AND WASH. THE GRANULAR TEXTURE OF THE PASTELS IS RETAINED BUT THEIR COLOR TINTS THE WATER.

The extent to which the pastel color can be spread depends on the type of brush used. A bristle brush, used with fairly heavy pressure, leaves little of the original line visible, but a soft watercolor brush will take color only from the top of the paper's grain, retaining the character of the pastel strokes. The strokes you use also affect the wash. Washing over side strokes gives a dense, fairly even effect, while the linear pattern of scribbled or hatched strokes will be retained through a diffused, pale tint of washed color. Oil pastels can also be wet brushed simply by replacing water with mineral spirits.

### SEE ALSO

BUILDING UP: PASTEL, pages 26–27
BRUSHWORK, pages 46–47
LINE AND WASH, pages 84–85

**LINE WASH**
Linear and gestural strokes stand out clearly against the paler tone of the wet-brushed color. The water picks up the color of the pigment but does not actually dissolve the pastel mark.

**WET BRUSHING OIL PASTEL**
1 Lay down your strokes in oil pastel, in this case an overall shading.

2 Dip a bristle brush in mineral spirits and use this to spread the color. The pastel can be pushed around like paint, here in a loose, scumbling motion.

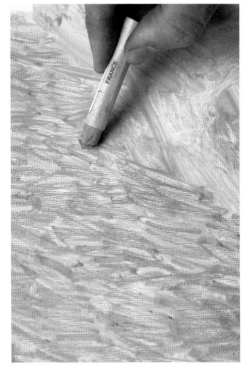

3 The spirit makes the pastel greasier, so when you work back into the still-wet paper with dry pastel, the color will spread easily.

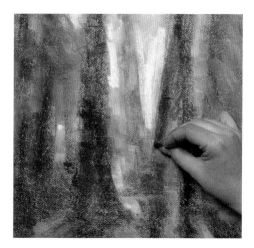

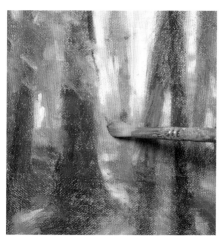

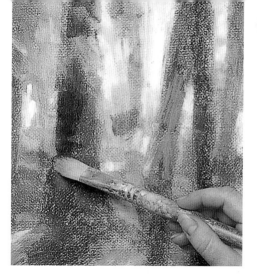

**WET BRUSHING SOFT PASTEL**
**1** Side strokes are used to establish composition and color scheme.

**2** A bristle brush is dipped in clean water and used to spread the color, taking care that the brushstrokes follow the pastel marks.

**3** The form of the tree trunk is built up by drawing with a black pastel on one side and then spreading the pastel with a brush as before, having first washed the brush to remove any traces of the light color.

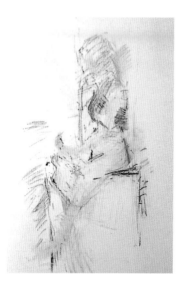

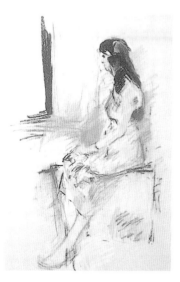

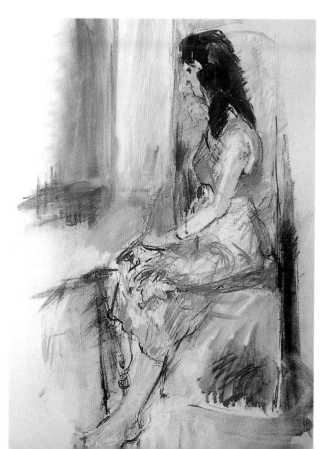

**SOFT PASTEL WITH A SOFT BRUSH**
**1** In the first stage, a quick impression is built up in soft pastel.

**2** Dark tones are added to give definition to the figure.

**3** The colors are moistened with a damp brush, and the image is further developed with further color first worked into the damp surface and then added wet-on-dry.

# SGRAFFITO

THIS TECHNIQUE, WHOSE NAME COMES FROM AN ITALIAN WORD MEANING "TO SCRATCH," INVOLVES SCORING INTO THE PAINT WITH ANY RIGID IMPLEMENT, SUCH AS A PAINTBRUSH HANDLE OR A KNITTING NEEDLE, TO REVEAL EITHER THE GROUND COLOR OR A LAYER OF DRY COLOR BENEATH.

It can be used with either oil or acrylic. Lines of any thickness can be drawn into the paint and the separate layers of color can be chosen to contrast with or complement each other. Dark brown paint, for example, could be scored to reveal a pale blue, or a dark green to reveal a brighter, lighter one beneath.

The quality of line depends on the thickness of the paint and to what extent it has dried. Even thoroughly dry paint can be scratched into, as long as a really sharp point is used. However, in this case, the scored lines will be white, because all the layers of paint will be removed. For this method it is best to work on a rigid surface, such as canvas board. Stretched canvas might be damaged.

SEE ALSO
SCRAPING ON, pages 60–61
COLORED GROUNDS, pages 64–65

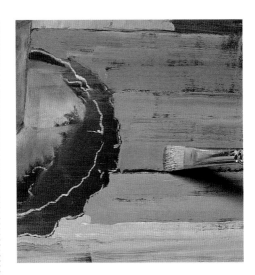

**OILS**
**1** The background color of the wooden tabletop is applied in fairly thick paint. The pattern of the wood grain will be defined by scratching at a later stage to reveal the dark brown ground color.

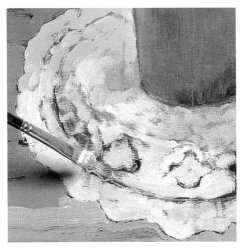

**2** The doily is now painted with thick off-white paint, leaving small areas of the ground color showing.

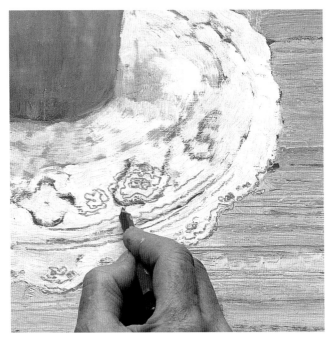

**3** The complex pattern of the doily is drawn into the still-wet paint with a pencil. Like the paintbrush handle used earlier, this scrapes the paint aside, but also leaves its own mark. The brown ground only shows in the regions where it was left unpainted.

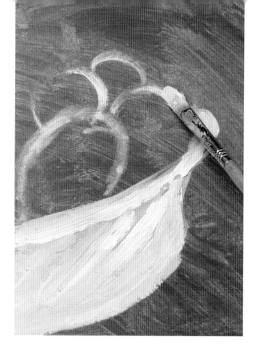

**ACRYLIC**

**1** The artist has used retarding medium so the paint remains wet enough to be removed with the point of a knife. If it becomes too dry, harder pressure has to be applied, and this can remove the first layer of paint as well as the second.

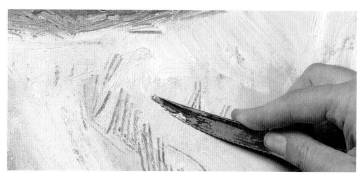

**2** To echo the reds elsewhere in the painting and create foreground interest, the tablecloth is also scratched into with the knife.

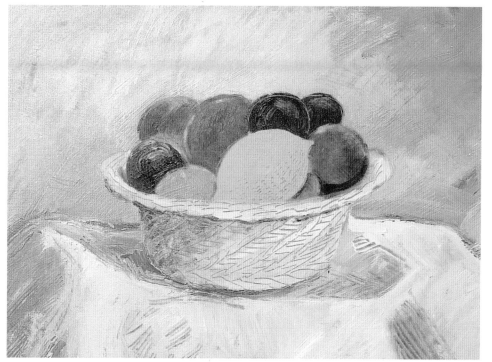

**3** The effect of the painting relies to a large extent on the color scheme, which has been well chosen to provide blue/red contrasts in each area. The red sgraffito into blue balances the bright colors of the fruit. The color contrast also gives extra impact to the scratched lines.

**INDENTING**

An allied method, which can only be used with watercolor, is to draw into damp paper or a still-damp wash with a pointed, but not sharp, implement. The paint flows into the valleys, creating a line that is darker than the surrounding colors. This method is often used for leaf veins or the linear patterns of tree bark.

# BACKRUNS

FOUND IN WATERCOLOR PAINTING, BACKRUNS ARE THE HARD-EDGED SHAPES THAT SOMETIMES ACCIDENTALLY OCCUR WHEN YOU TRY TO WORK INTO A STILL-DAMP WASH.

Backruns may be the despair of newcomers to watercolor. But these effects, sometimes called blooms, can be used to great advantage in a controlled situation, producing textures and effects that would be impossible to obtain through normal painting methods. The technique consists of dropping water or wet pigment into a wash that has lost its shine but is not yet dry, or even into a dry wash. The paint dropped in must have a higher water content than the original wash; dropping in darker color does not cause backruns. Dropping in watery pigment loosens the already applied paint and causes it to flow outward into the surrounding wash, accumulating in an irregular, hard-edged shape.

The manner in which the water or pigment is applied determines the finished result. For example, several drops of water, allowed to spread and diffuse, create a mottled texture suggestive of weathered stone or rock. In a winter landscape, delicate strokes of clear water applied with a soft brush might convey the impression of frost-covered trees in the distance.

**CLEAR WATER**

1 Attractive mottled patterns can be formed by dripping clear water into a just-damp wash, from the end of a brush held 3–4" (7.5–10 cm) above the paper.

2 The finished effect depends on how damp the wash is. Water droplets applied to wet paper will produce a soft, diffused pattern; when the paper is almost dry, a crisper, more defined pattern will emerge. This mottled texture can be used to suggest rocks and stones in a landscape, because the patterns can be further developed with washes to suggest shadows and highlights.

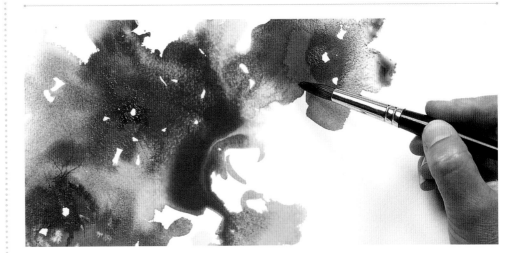

**EXPLOITING BACKRUNS**

1 In this painting, the artist aims to exploit the natural backruns formed by watercolor to suggest the loose, organic shapes of flowers. She begins in the center of the painting, applying patches of very wet wash and allowing the paint to spread and settle naturally. When the paint is partially dry, she floats in other colors on top. Notice the "eyes" of unpainted white paper left in the center of each flower.

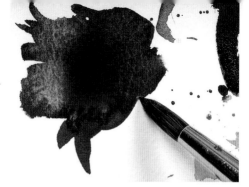

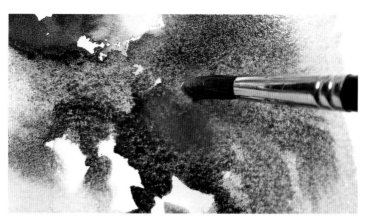

3 By paying careful attention to the relative dryness of different areas, various effects can be achieved. Here blue has bled into damp yellow to form a patch of green. While the green is still damp, the artist feeds in red on top.

2 While the paint is drying, the artist works on other parts of the picture. Here, she adds another flower form, applying a rich blue over a patch of damp red.

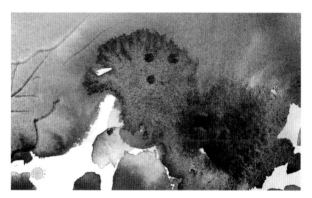

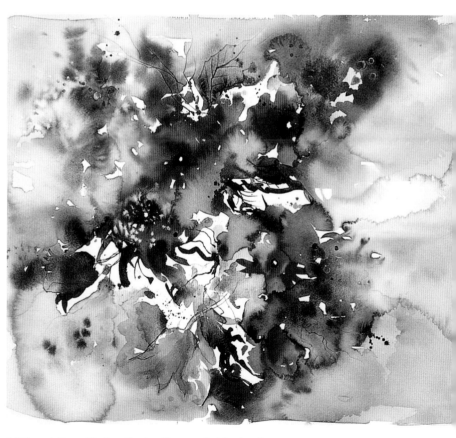

4 Different drying times of the various washes can lead to such happy accidents as this green "cauliflower" leaching into the underlying yellow wash. Such pleasing organic shapes, which form the basis of the painting, can then be given definition with deliberately added detail, such as the finely veined leaf seen here.

5 Yellow washes loosely applied and allowed to settle in their own way form distinctive though abstract shapes at the bottom of the painting.

6 Although the subject matter is still recognizable, the picture retains a pleasing looseness and spontaneity. The trick here is to know when to stop so as not to ruin the effect by overworking the painting.

# MASKING

IT IS EXTREMELY DIFFICULT TO PAINT A COMPLETELY CLEAN EDGE OR A PERFECTLY STRAIGHT LINE. IT CAN HELP TO HOLD YOUR BRUSH AGAINST A RULER, BUT THE PAINT TENDS TO SLIP UNDERNEATH, SO IT IS BETTER TO USE MASKING TAPE.

Masking techniques are often used by abstract painters who want crisp, hard-edged divisions between shapes, but they also have their uses in representational painting. You might be painting an interior with a window frame and could use masking tape to create a sharp division between this and the view outside. Masking tape can be stuck down over thinly applied oil, acrylic, and watercolor paint, as long as it is dry, so it can be applied at various stages in a painting.

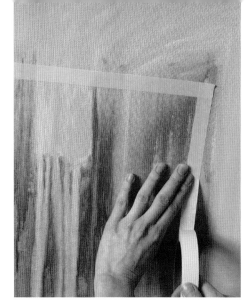

**HARD-EDGED APPROACH**
**1** Thin red and yellow paint is streaked onto canvas board and allowed to dry before masking tape is applied.

SEE ALSO
HIGHLIGHTING, pages 38–39
SPATTERING, pages 74–75

**2** The contrast between opaque, flatly applied paint and thinner, rougher applications is one of the features of this painting. The brilliant red is applied with a soft brush, evening out the brushstrokes.

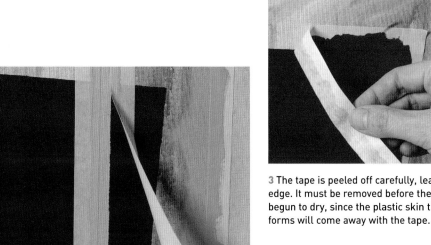

**3** The tape is peeled off carefully, leaving a crisp edge. It must be removed before the paint has begun to dry, since the plastic skin that quickly forms will come away with the tape.

**4** The red paint has been dried with a hairdryer, more tape applied, and the area between the strips of tape painted in blue before the tape is again removed. It would be virtually impossible to achieve this thin, straight, and slightly tapered line by any method other than masking.

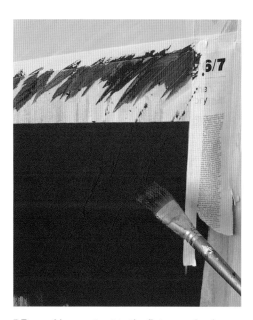

**5** To provide a contrast to the flat area of red, thin purple paint is flicked onto the surface and allowed to run down in dribbles. The artist is working with the board upright on an easel to encourage this effect.

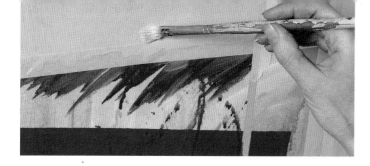

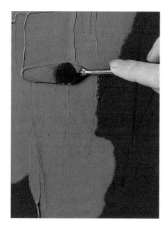

6 Because the purple paint was thin, it had seeped under the masking tape. The hard edge is reinstated by painting over it first in white and now in yellow.

7 The final stage is a thick application of green over parts of the red, applied with a knife (see pages 50–51).

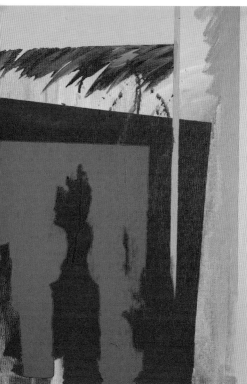

8 To achieve a contrast of shapes, edge qualities, and texture, the final green layer is masked at the top only, then drawn out to form a series of irregular shapes.

## SOFTER EDGES

The disadvantage with most masking techniques is that the resulting shapes tend to have hard, crisp edges. If you wish to mask off a shape while retaining a slightly softer edge, try using absorbent cotton as a mask. This method works especially well in conjunction with the spattering technique.

1 Take a small piece of absorbent cotton and tease it out until it is fairly thin. Lay the cotton on the paper, pulling and teasing it into the desired shape.

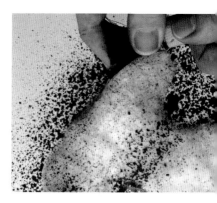

2 Holding a stiff brush a few inches above the surface, spatter color onto the area surrounding the mask by running your finger through the bristles of the brush.

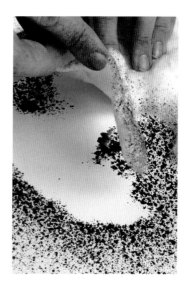

3 Wait until the paint is thoroughly dry before removing the absorbent cotton.

4 The soft edges of the cotton mask have allowed the spattered paint to seep under it in places. The finished shape has a softer, more natural outline than those achieved with other masking techniques. This method could be used in painting natural subjects, such as trees and clouds.

# MASKING FLUID

MASKING FLUID FORMS A WATERPROOF SEAL THAT PROTECTS THE PAPER UNDERNEATH, ENABLING WASHES TO BE PAINTED OVER WITHOUT HAVING TO CAREFULLY LEAVE TINY AREAS WHITE.

Apply the masking fluid before the washes are put on, allow it to dry, and then paint over it. This allows you to work freely, exploiting loose washes and wet-in-wet techniques without the worry of paint splashing over the edges of a white area. The fluid can be removed at any stage in the painting and can produce pale-colored highlights as well as pure white.

The two great advantages of masking fluid are that it allows you to make very small highlights, such as flower stamens, and that it is a way of painting in "negative." You can exploit the shapes of the brushmarks just as you do when painting with color.

**2** You can now apply paint speedily and fluidly. Once the shadows have been painted and allowed to dry, rub or peel off the masking, revealing the white paper underneath.

**MASKING TO RESERVE THE PAPER**
**1** To apply masking fluid to all the white areas of a flower, such as this backlit magnolia, use an old synthetic fiber brush. To help you clean it after use, first dip it in liquid soap and then wipe it.

**3** You now have white areas you can work into. If the paper appears too white when the fluid is removed, lightly color the area. In this case, the pure whites are ideal for the subject.

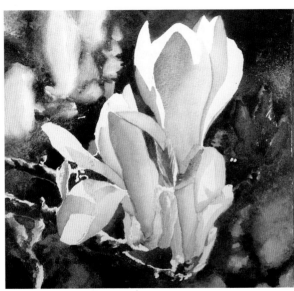

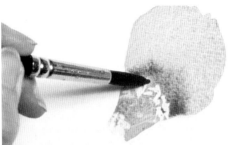

**MASKING FOR DETAILS**
**1** To reserve details, such as these poppy stamens, paint with masking fluid using an old synthetic fiber brush. Wash the brush out immediately with warm, soapy water.

**2** When the masking fluid is dry, you can paint freely over it, because it acts as a block to the paint.

**3** When the paint has dried, remove the masking by gently rubbing with a finger or soft eraser to reveal clean, white paper. If the highlights are a pale color rather than pure white, they can be tinted in the final stages.

# WASH-OFF

INK AND GOUACHE WASH-OFF IS AN
EXCITING TECHNIQUE THAT PRODUCES
A TEXTURAL EFFECT NOT UNLIKE THAT
OF A WOODCUT OR LINO PRINT. THE
PROCESS, THOUGH QUITE A LENGTHY
ONE, IS HIGHLY SATISFYING AND THE
RESULTS CAN BE SPECTACULAR. THE
SECRET OF SUCCESS LIES IN A PATIENT,
METHODICAL APPROACH: EACH STAGE
MUST BE ALLOWED TO DRY COMPLETELY
BEFORE THE NEXT STAGE CAN BEGIN.

The basic wash-off method is as follows:
a design is painted onto paper with white
gouache and allowed to dry. The whole paper
is then covered with a layer of waterproof black
ink. When this is dry the painting is held under
running water. The gouache, being water
soluble, dissolves and is washed off. This
causes those areas of dried ink that were
covering the gouache to wash off at the same
time. Meanwhile, the areas of black ink that
covered parts of the design not painted with
gouache remain intact. The result is a negative
image of your original design. You will only
need one tube of gouache, white only.

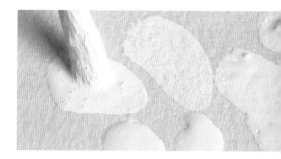

**1** Cover the entire paper with a flat wash of
watercolor so that you can see where you are
placing the gouache. When the watercolor wash
is completely dry, the design is painted in white
gouache. If the image is a complex one, it will
help to make an underdrawing before applying
the watercolor wash.

**FLOWER PIECE**
This example shows how effective the method
can be for an intricate subject. The artist has
slightly tinted a few of the leaves, but otherwise
it has been left as a black and white image to
make the most of the woodcut-like effect.

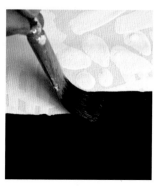

**2** Allow the gouache to dry
thoroughly, then cover the
entire painting with black
waterproof ink. Check that you
have enough ink to cover the
whole paper and shake it well
before starting. Always use a
large, flat, and soft brush to
apply the ink and work in
broad horizontal strokes from
top to bottom. Make sure your
brush is well loaded, because
you can only go over each area
once. Otherwise the white
gouache starts to come off and
mixes with the ink. Let the ink
dry naturally until it is hard.

**3** Now the wash-off part
begins. Hold the board in a
tilted position and pour large
quantities of cold water over
the paper, or hold the board
under a running tap. Eventually
the white gouache starts to
dissolve and the ink that covers
it also breaks up and is washed
away. It may take several
washings before all the ink
over the gouache comes off
the board.

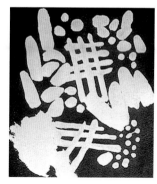

**4** Use a soft brush to remove
any excess gouache. The
waterproof black ink that was
not painted over gouache stays
firmly in place, despite
repeated washings.

SEE ALSO

STRETCHING PAPER, pages 12–13
UNDERDRAWING, pages 40–41

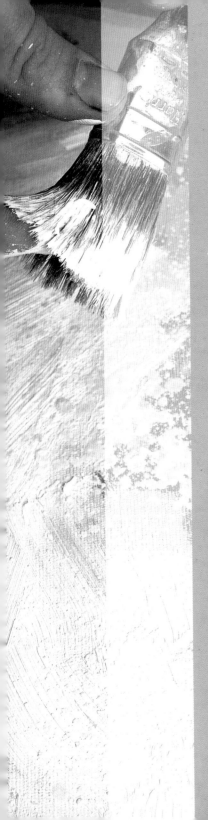

# THEMES

In this section, a number of painting themes have been selected, from landscape to portrait painting. This section shows, with step-by-step illustrations, how many of the different techniques described earlier can be used in context of a theme. Eight main themes have been chosen; although the subjects within each theme widely vary, all are based on something you can observe for yourself. It is this personal observation that is most important. The techniques are there only to enable you to realize your own vision.

# ANIMALS

Animals have a reputation for being difficult to paint, mainly because they tend to move most of the time. But capturing the grace and agility of an animal, especially a moving animal, is one of the most rewarding experiences an artist can have.

Painting animals does not require a textbook knowledge of their anatomy. Intelligent observation, sensitivity, a basic awareness of form and structure, and a willingness to practice and practice again will suffice. By all means study pictures in books and magazines. However, it is generally not a good idea to make a painting by copying from a photograph, because photographs tend to flatten form and freeze movement. Photographs are useful, however, as a backup to sketches. Another point to bear in mind is that too much attention to detail can make an animal appear stuffed rather than alive. It is often a good idea to give a high degree of finish to the main features and a sketchy quality to the others. This will give added force to your painting and also leave something to the viewer's imagination.

## LEARN BY SKETCHING

Even though they are moving, you will find that most animals tend to repeat certain gestures. A good tactic is to work on several sketches at once, shifting from one to the other as the animal alters and regains certain positions. This may be frustrating at first, but gradually your reflexes will quicken. You will soon learn how to capture the essential character of the animal you are portraying.

## SETTING ANIMALS IN CONTEXT

The most common mistake seen in animal paintings is that the creature appears to be "stuck on" to the picture surface or floating in mid-air. One way to overcome this problem is to establish the tone and color of the background first, working around an approximate outline of the animal. It is always easier to integrate the subject into the background than vice versa. Another way to avoid the "cut-out" look is by using a variety of hard and soft edges. Where the form of the animal is in shadow, the outline will be "lost" or blurred, and where the animal meets the light, the outline will be sharp. This combination of hard and soft edges makes the animal appear to blend naturally with its surroundings.

## TEXTURE

Another challenge presented by animal painting is the accurate rendering of texture. Here you can let the techniques you have learned help you, using methods such as drybrush, line and wash, and even sponge painting. The step-by-step demonstrations that follow should give you some ideas, but also try to come up with your own solutions.

### SKETCHING

Quick sketches are the best way to get to know animals. Here the artist has used a combination of watercolor and pencil.

SEE ALSO

SPONGE PAINTING, page 62
DRYBRUSH, page 68
LINE AND WASH, page 84–85

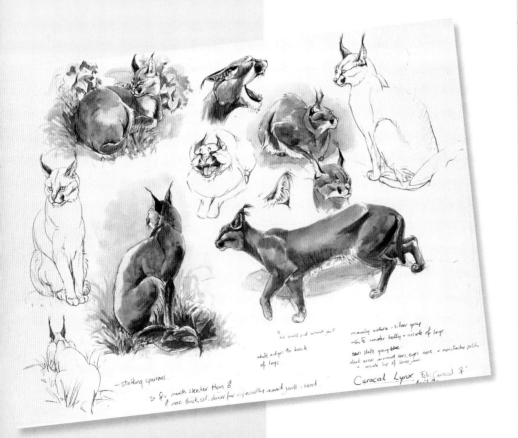

# FEATHERS

IN MOST BIRDS, THE WING AND TAIL FEATHERS ARE QUITE SMOOTH AND PRECISE IN SHAPE, WHILE THOSE ON THE NECK AND THROAT HAVE A DOWNY QUALITY.

Begin by painting the bird with a pale underwash. Then use a small, soft brush to delineate the markings of the main feathers, working wet-on-dry to achieve a precise pattern. The soft, downy feathers should be added last, using light, scumbled strokes.

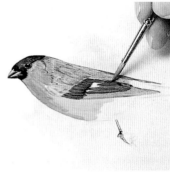

**LIGHT AND DELICATE**
Try to capture the lightness and delicacy of feathers in your work.

SEE ALSO

WET-ON-DRY, page 54–55
SCUMBLING, page 69

**FEATHERS • GOUACHE**
1 Once the washes of base color have dried, you can start adding details to the plumage, gradually building up the color and texture. The artist here has used a very dry brush with the occasional touch of liquid paint to emphasize the changes in tone and to bring vitality to the image.

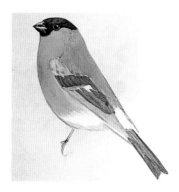

2 The vivid colors of the breast feathers are added in crimson and cadmium red. The texture of the feathers on the back is built up in tones of gray using a fine sable brush.

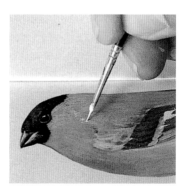

3 Stroke by stroke, the artist creates the fine texture of the back feathers. Highlights have been added using white paint, and here he is adding darker tones using a No. 0 sable brush.

4 Using a very small sable brush the artist paints fine, parallel strokes in dry, undiluted paint to add the final touches to the plumage. This hatching technique is particularly good for conveying the texture of feathers.

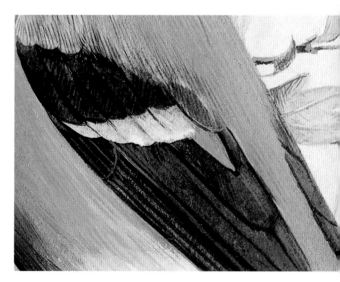

5 In this detail, you can see the wide range of tones used, and the careful hatching and cross-hatching of the strokes.

## FEATHERS • WATERCOLOR

In this dramatic study of an owl in flight, the artist uses very loose brushmarks, which not only capture the texture of the feathers but also accentuate the impression of flight.

For obvious reasons, it can be difficult to study birds from life, but working from a photograph is not always satisfactory. In this particular case, a high-quality photograph provided a ready-made composition. However, the artist also made studies of a dead owl which he had found, so he could record the coloring and arrangement of the feathers more accurately.

1 Detail from the wing feathers. The artist begins with a fairly accurate outline drawing of the bird and then blocks in the lightest tones of the wing feathers with a No. 4 sable brush and a very pale wash of yellow ocher.

2 When the first wash is dry the artist begins to indicate the patterning on the feathers with a middle tone of burnt sienna and raw umber.

3 With a dark mixture of burnt sienna and ivory black, the darkest pattern on the feathers is blocked in.

4 The drama of the painting lies in the clear, light shape of the owl against the inky black sky. Here the artist is blocking in the dark background with a very dark wash of Payne's gray. He first cuts carefully around the precise shapes of the feathers using a No. 2 sable brush. Once safely away from the edges of the feathers, he uses a ½" (1.25 cm) flat Dalon brush to complete the background.

5 The artist now adds just a hint of texture to some of the feathers by applying hatched lines with a sharp HB pencil.

6 Although the texture of the feathers is important, the artist has taken care not to become too bogged down in detail. Instead, he has worked quite loosely in places, and has given a lovely impression of the overall shape and color of the owl, heightened by the dark background.

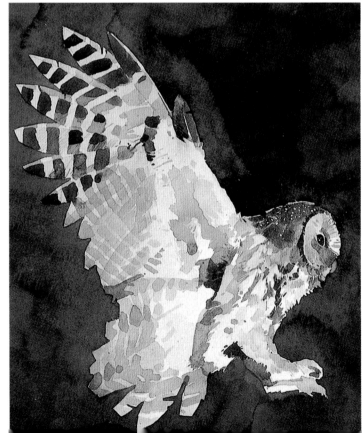

# FUR

FUR, JUST LIKE HUMAN HAIR, COMES IN A WIDE VARIETY OF TEXTURES. HOW YOU RENDER THESE DEPENDS ON THE TYPE OF ANIMAL YOU ARE PORTRAYING, THE MEDIUM YOU ARE WORKING WITH, AND WHETHER THE ANIMAL IS TO BE SEEN CLOSE-UP OR IN THE DISTANCE.

Below are some examples of suitable techniques. It is wise to always start by defining the outline of the animal, then suggest the pattern of light and shade on its body, and lastly, pay attention to the markings and individual features.

## GLOSSY FUR

For animals with a sleek, glossy coat, use a wet-in-wet technique. Observe the patterns of light and shadow carefully, then paint them with fast, fluid brushstrokes. Use as few strokes as possible to accentuate the glossiness of the coat.

## SHAGGY COAT

For animals with a fluffy, shaggy, or wiry coat, use scumbling or drybrush with a bristle brush and fairly thick, dry paint. Another method, often used in watercolor and gouache, is to block in the colors and tones of the coat with broad washes; when this is dry, use the tip of the finely pointed brush to tick in tiny lines that follow the pattern of hair growth. This technique is effective for rendering short-haired animals such as dogs and foxes.

## VELVETY HIDE

Some animals, such as horses, cows, deer, and smooth-haired dog breeds, have a short, sleek, and velvety coat. The muscular structure beneath the coat is much more pronounced than in longhaired animals, so attention must be paid to the subtle modeling of tones. You could start by defining the form with a series of watery washes, and then suggesting the lie of the coat with very short strokes using a finely pointed brush.

**FUR • OIL**
**1** Layers of pigment have been applied thinly to build up the depth of color. The details of the hairs are added on top, using a fine brush to smudge in the color.

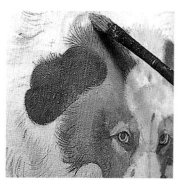

**2** White hairs are added with a No. 0 sable brush, painting each individual hair slowly and methodically. The pencil marks of the underdrawing indicate the folds of the dog's flesh and the way the fur stands out. In the final picture, right, the pencil marks are strengthened and flake white is added to pick out the fur against the background.

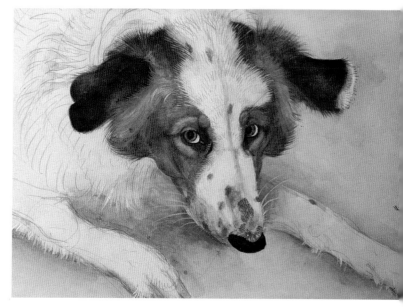

**3** The head is most important, so the artist has concentrated on this before painting the body.

## FUR • PASTEL

1 The background was laid in a watercolor wash because it is easier to apply over a large area than pastel is. A gray pastel is added and black is laid on top, to build up the depth of color of the cat's coat. The artist used the pastel stick on its side, because the result is more grainy than when the tip is used. The soft but dense color achieved is just right for the texture of fur.

2 To increase the density of color the artist blends the black and gray pastels, working them into the grain of the paper.

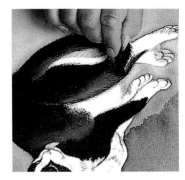

3 The fine black hairs are added individually using a black pastel stick which has been broken in half to create a sharp drawing edge.

## FUR • WATERCOLOR I

1 A soft outline was drawn in pencil using short strokes to convey the fur, and a light wash was then added. Once some of the details of the animal's hair had been drawn, the artist concentrated on the head. Here the artist applies the paint onto wet paper because he wants the edges to remain soft.

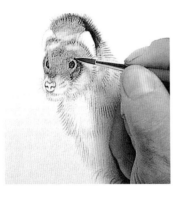

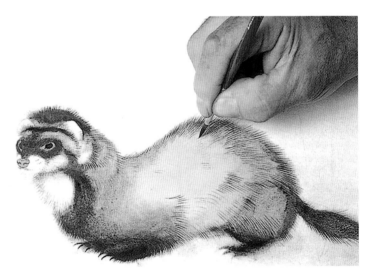

**CONTRASTS**
The texture of the fur contrasts tellingly with the hard sheen of the eyes and delicate pink tongue.

2 Having dried the picture using a hairdryer, the artist begins working on the body color. A pale mixture of cadmium yellow, cadmium red, and white is applied in a thin wash with shadows added in washes of black where necessary. Remember that you can always soften the edges of a wash using a brush loaded with water.

## FUR • WATERCOLOR II

In this close-up of a tiger's head, a combination of overlaid washes and linear work has been used to render the texture of the fur.

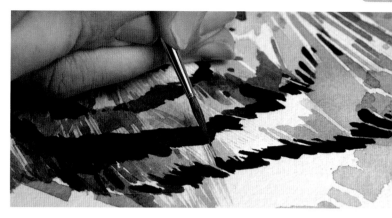

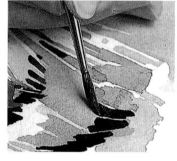

**1** Working on a sheet of stretched 200lb Bockingford paper, the artist begins by blocking in the middle tones of the fur with a No. 4 sable brush and varied mixtures of Payne's gray, ivory black, and burnt sienna. The lighter hairs are indicated by working these tones around negative white shapes.

**2** When the middle tones are completely dry, the tiger's black stripes are added using a dryish mixture of ivory black and burnt sienna. Again, negative white shapes are left to indicate where lighter hairs cross over the stripes.

**3** When the paper is dry, the tiger's golden-yellow fur is painted in. The artist begins by blocking in a pale tone of burnt sienna, once again leaving white spaces for the light hairs. This is allowed to dry. Switching to a well-pointed No. 2 brush, the artist uses burnt sienna, darkened with a touch of ivory black, to tick in individual hairs with long, crisp strokes over the dried underwash.

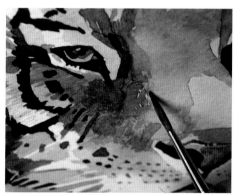

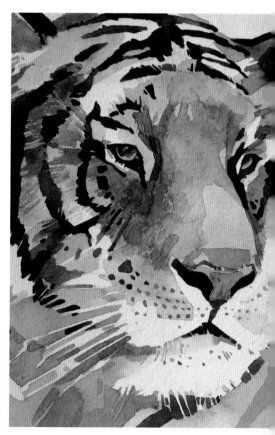

**4** Tiny dots or "whisker holes" are painted on the muzzle using the ivory black/burnt sienna mix. Here you can see how the negative white shapes now read as whiskers.

**5** The hairs on a tiger's nose are very fine, so very little modeling of individual hairs is required. The bridge of the nose is modeled with loose washes in various tones of Payne's gray, glazed wet over dry. Then the tip of the nose is painted with a pale wash of brown madder alizarin.

**6** The relatively loose treatment suggests the fur without literally describing it.

# EYES

THE EYES ARE OFTEN THE MOST
EXPRESSIVE FEATURE OF AN ANIMAL
OR BIRD, SO THEY ARE WORTHY OF SOME
ATTENTION. IN CREATURES THAT ARE
NATURAL PREDATORS, FOR EXAMPLE,
THE EYES HAVE A HARD, WATCHFUL, AND
IMPERIOUS QUALITY WHICH SHOULD BE
EMPHASIZED WITH HARD, CRISPLY
DEFINED OUTLINES.

Compare this quality to the soft, vulnerable
appearance of the eyes of young animals
and of non-predatory species such as
horses, cows, and deer. Pale colors and a
smudgy technique will portray the dewy,
liquid look of these eyes.

The eyes of animals and birds have a
pronounced spherical shape and their
surface is glassy and highly reflective.
Applying your colors in thin glazes is the
best way to capture the subtle nuances of
light and shade that give the eyes their
depth and three-dimensionality. Also pay
attention to the shapes of the highlights and
shadows which follow the convex contour of
the eyeball.

## EYES • WATERCOLOR

The transparency of watercolor
makes it an excellent medium
for rendering the subtle nuances
of tone and color that give
eyes their unique depth and
three-dimensionality.

1 Working on a sheet of stretched 200lb Bockingford watercolor
paper, the artist sketches a simple outline shape for the eye
with an HB pencil.

2 The artist begins by painting the
area surrounding the eye with pale
washes of Payne's gray and cobalt
blue mixed with yellow ocher. Using
a No. 2 round sable brush, he then
defines the outer rim of the eye with
ivory black.

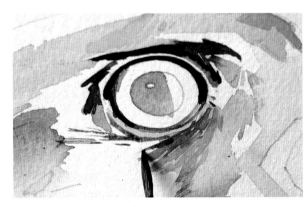

3 The feathers surrounding the eye are built up further with
washes of cobalt blue and yellow ocher. Then the pupil of the
eye is painted with cobalt blue, leaving a tiny dot of white paper
for the brightest highlight.

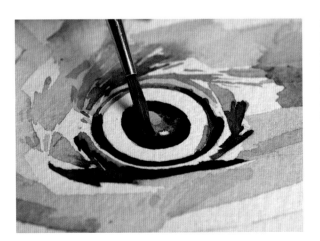

4 The darks of the pupil are
gradually built up with repeated
glazes of cobalt blue and Payne's
gray. Because each glaze shines up
through the next one, the color has
a depth that captures the glassiness
of the bird's eye. The darkest part of
the pupil is painted with ivory black.

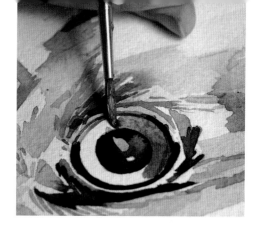

5 When the pupil is completely dry the artist paints the iris with a mixture of brown madder alizarin and cadmium orange. This is allowed to dry thoroughly before adding the next wash.

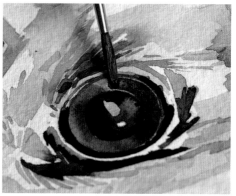

6 The rounded form of the eye is developed by adding a shadow wash over the iris with a mixture of burnt sienna and cadmium orange. In this close-up, notice how the artist has used a combination of hard and soft edges to define the form of the eye and prevent it from looking too static. The gradual build-up of washes helps to define the convex contour of the eyeball.

7 The clean, sharp, and bright highlight of the eagle's eye conveys the fact that this bird is very much a predator.

**DOG'S EYES**
Using a very fine, No. 0 sable brush, the eyes were painted in layers of the same color, after each previous one had dried, to build up the density of color. The paint was laid on thinly to achieve a soft finish, leaving the paper white for the whites of the eyes.

**CHIMPANZEE'S EYES**
The eyes of this young chimpanzee, a non-predator, are much softer than the tiger's, below. There is much more light in the eye, and the outer rim is less sharply defined.

**TIGER'S EYES**
The expression in this tiger's eyes is bold and unfaltering, accentuated by the small size of the pupils and the hard, glinting highlight.

# FISH

THE SILVERY, IRIDESCENT SKIN OF FISH MAKES THEM AN EXCELLENT SUBJECT FOR PAINTING. THEY ARE PARTICULARLY WELL SUITED TO THE DELICATE, AQUEOUS MEDIUM OF WATERCOLOR.

To portray the shiny, wet appearance of the skin, work with broad, loose washes of pale color on damp paper. Allow the colors to merge wet-in-wet. While the paper is still damp, indicate the dark markings of the fish with dryish color, allowing the edges to bleed softly into the underlying wash. Do not attempt to indicate every scale on the fish's skin because the resulting appearance is too tight and stilted and destroys the essentially fluid form of the creature. Simply use a small, well-pointed brush to hint at the overlapping scales along the back. When the markings are dry, apply a final, thin wash of color over the fish's body. This creates a translucent effect, with the dark markings glowing through the final glaze of color.

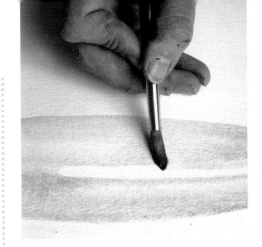

1 Working on a sheet of stretched paper, the artist begins by establishing the shape of the fish. He first dampens the area with water; then, using a round No. 10 sable brush, he applies pale washes of Payne's gray, turquoise, and cadmium red. It is best not to outline the shape in pencil, because this can inhibit the spontaneity of the succeeding washes of color. An outline should always be fluid enough to be altered during the painting process.

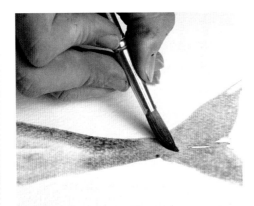

2 The dark shape of the tail is painted with Payne's gray. The artist has mixed gum arabic with the pigment on the palette. This gives a slight sheen to the color which captures the shiny, lustrous appearance of the fish's skin.

3 Switching to a No. 4 brush, the artist defines the head and spine of the fish with a darker wash of Payne's gray. Notice the broken quality of the line, which lends a sense of movement; a perfectly straight outline would look too static.

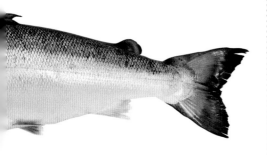

**SCALES**
The iridescence and intricacy of a fish's scales can be quite a challenge to capture.

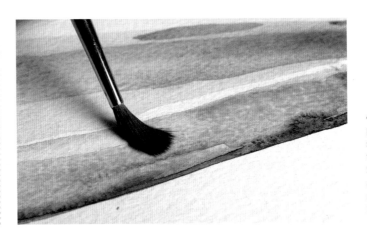

4 After allowing the previous colors to dry slightly, the artist starts to add further colors. Sap green, turquoise, and brown madder alizarin are applied and allowed to bleed together wet-in-wet.

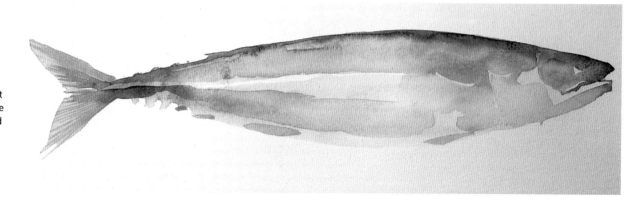

5 At this stage, you can see how the underlying form of the fish has been established using wet washes. In places, the colors were lightened by gently lifting out with a clean, moist brush which helps to create the soft luster of the fish's skin.

6 When the underlying washes are almost dry, the artist indicates the mottled pattern on the back using a No. 4 sable brush and a dark, dryish mixture of Payne's gray and sap green. The bottom edge of the pattern is then flooded with water using a clean brush to make it bleed into the body of the fish.

7 The mouth and eye are defined with a dark mixture of Payne's gray and burnt umber and a pale mixture of Payne's gray and sap green is used to paint the gills. You can see also where small, spontaneous strokes have been applied here and there over the dried underlayer, giving depth and luminosity to the colors.

8 In developing this picture, the artist has exploited the fluidity and transparency of watercolor to the full. The completed image captures the essence of the subject perfectly. It is the harmonious balance of loose, wet washes and darker, sharper details that gives freshness and vitality to the painting.

9 When the painting is dry, the artist adds a final touch: the highlights on the eye are painted with processed white.

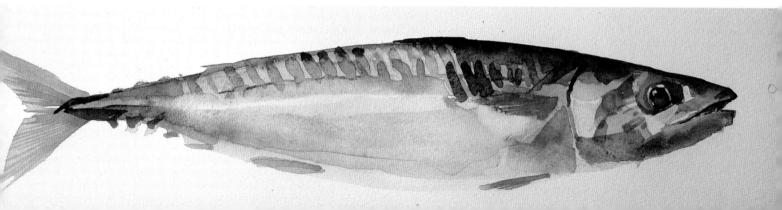

# BUILDINGS

Buildings and other man-made structures, such as bridges, fences, and walls, attract the attention of painters because of their fascinating shapes, textures, and patterns. In the countryside, these features provide a good foil to the surrounding trees and fields; in a city or town the variety of architecture can suggest interesting contrasts, allowing the artist to play with shapes, moods, and tensions. In addition, the size and position of these structures within a composition lend a sense of scale to the scene and add an element of human interest.

### PERSPECTIVE
If you look up at a building from a low angle, the verticals will appear to converge slightly toward the top. This is even more apparent in photographs, and artists who work from photographic reference often deliberately reproduce this effect rather than straightening out the verticals. In this painting, Catherine Bernard has used the shallow diagonals to add drama and extra interest.

**SEE ALSO**

SPONGE PAINTING, page 62
SPATTERING, pages 74–75
WAX RESIST, pages 78–79

It goes without saying that buildings should always be accurately rendered in terms of proportion and perspective and be given a sense of volume and solidity. But the way they are treated depends on the artist's intention. A good painter will always approach man-made structures in exactly the same way as they would any landscape subject, using expressive brushwork and thoughtful use of color.

### ANGLE OF VIEWING
To render the solid, three-dimensional appearance of buildings, it helps if you can find an angle that takes a corner view and creates strong diagonals. Buildings viewed straight-on tend to look two-dimensional and rather like a flat piece of stage scenery, but this is not always a bad thing. Straight-on views can provide a subject when pattern is all-important, such as a house-front with window boxes, ornamental balconies, and other elements. Whatever view you decide on, bear in mind that strong contrasts of light and shadow accentuate the form and volume and will pick out the details. Long shadows cast in the late afternoon, for example, are particularly useful in this respect.

### TEXTURE AND PATTERN
The textures of buildings, such as uneven whitewashed walls, crumbling brickwork, and peeling paint, can be fascinating in themselves. Some buildings and parts of buildings, such as walls and roofs, provide a strong patterned element. For textures, let special techniques such as wax resist, spattering, and sponge painting help you. For patterns, try looking down on a building from above, because roof tiles, chimney pots, and gutters can make exciting and unusual subjects.

# BRICKWORK

WHEN YOU LOOK CLOSELY AT THE WALLS OF A BUILDING, YOU CAN SEE EVERY BRICK AND TILE. BUT WHEN YOU TAKE IN THE OVERALL LOOK OF A BUILDING, YOU DON'T SEE INDIVIDUAL BRICKS, ALTHOUGH YOU KNOW THEY ARE THERE. THIS IS THE EFFECT YOU SHOULD CONVEY IN YOUR PAINTING: BY DESCRIBING A FEW BRICKS HERE AND THERE, YOU WILL SUGGEST THEM ALL WITHOUT BURDENING YOUR VIEWER WITH TOO MUCH TIRESOME DETAIL.

Always begin by indicating the overall tone of the wall or roof, and the pattern of light and shade. Then add a suggestion of texture.

Beware of painting bricks and tiles too bright a color, but you should notice how the color can vary from brick to brick. Use warm, muted reds, greens, blues, and earth colors to describe them.

**BRICK WALL**

**1** The artist begins painting the wall by laying in a pale wash of raw sienna to provide a background tone. When this is dry, a No. 6 chisel brush is used to paint the bricks, leaving uneven white spaces between the bricks to indicate light-colored mortar.

**2** Notice the irregular shapes and the variety of colors and tones used to describe the brick. It is a good idea to have your colors mixed up ready on the palette rather than mixing them haphazardly as you go along. This facilitates speed of handling, and you can be sure your colors will be clean and fresh. Wash the brush thoroughly between each application of color. The colors used here were raw umber, raw sienna, burnt sienna, and Payne's gray. They were used in varying strengths.

**3** When the first colors are dry, the artist adds shadow washes, wet-on-dry, with a weak solution of Payne's gray. This gives form and texture to the bricks.

**4** The shadows are developed further with washes and glazes to achieve a crisp, rugged look. Finally, a weak solution of Payne's gray and raw umber is mixed on the palette and then lightly spattered over the picture surface to accentuate the pitted, weathered character of the bricks.

# STONE

WALLS AND BUILDINGS MADE OF STONE ARE ALWAYS AN ATTRACTIVE FEATURE, BECAUSE OF THE HUES AND THE INTERESTING COLORS THEY TAKE ON AS A RESULT OF THE EFFECTS OF WEATHERING AND THE GROWTH OF MOSS AND LICHEN ON THEIR SURFACE.

Start with a pale wash of color to define the overall tone of the wall and then imply the texture of the stone's surface with drybrush strokes and/or sgraffito techniques, as shown below. Watercolorists frequently use spattering to indicate the pitted nature of stone; the addition of a few granules of salt while the paint is still wet adds an interesting weathered appearance.

When painting the dry stone walls often found on farms, it is usually best to begin by painting the wall as one mass rather than defining the individual stones. When the light and shadow planes have been established, you can then suggest individual stones, but without giving emphasis to every one. Use neutral tones, never black, to paint the cracks between the stones and the shadows cast by some stones protruding over the ones below.

### DRY STONE WALLS

The dry stone walls often seen in the countryside have a special character resulting from prolonged exposure to the elements. The stones lie unevenly, some protruding over the ones below and some indented, and their surface is pitted and cracked with age.

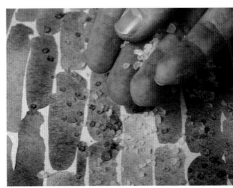

### DRY STONE WALL • WATERCOLOR

**1** The first stage in painting the wall is to apply an all-over wash of raw umber on a sheet of rough-textured paper. When this is dry, a chisel brush is used to indicate the rough shapes of the stones. The colors used here were raw umber, Payne's gray, and yellow ocher, mixed in various quantities to create a variety of sludgy tones and colors.

**2** Just before the paint dries, the artist sprinkles a few granules of rock salt over the painting and leaves it to dry in a horizontal position.

### STONE WALLS

This detail from a landscape painting shows a wall made of new smooth stone. Notice how only some of the stones are picked out in detail; a wall in the foreground should never be too sharply rendered, because this sets up a "barrier" instead of inviting the viewer into the picture. The artist began with an overall tone of watered-down raw sienna then picked out the stones with glazes of raw sienna, Payne's gray, and burnt umber to give life and warmth to the stone.

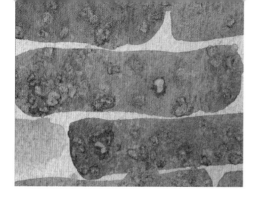

3 When the painting is dry the salt is brushed off. The salt granules have soaked up the paint where they landed, leaving tiny pale shapes which effectively simulate the pitted texture of the stones.

**DRY STONE WALL • OIL**

1 Thick oil is applied to a surface that has already been painted on. This means that it sticks to the raised parts of the surface and allows the undercolor to show through the hollows, creating a sparkling result.

4 A strong mixture of Payne's gray and sap green is used to render the dark cracks between the stones. Introduce variety by making the cracks lighter in some places.

5 The painting is allowed to dry, then pale washes of raw sienna and Payne's gray mixed with sap green are used to add glazes that darken the wall in places.

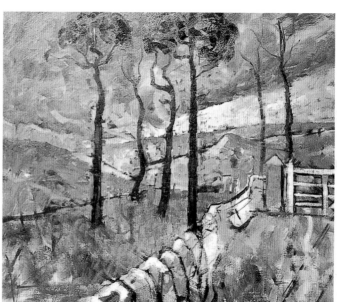

2 In the final painting, the artist has succeeded in capturing the bleakness of the landscape accurately. The picture has a unity, which the artist achieved by keeping a fixed image in mind and by developing every part of the picture simultaneously.

6 The same colors used in step 5 are lightly spattered over the picture surface. Here you can see how washes, glazes, spatter, and salt texture have been combined to give a suitably weathered look to the wall. The stones jutting out into the sunlight are sharply defined and those farther back are blurred into the shadows.

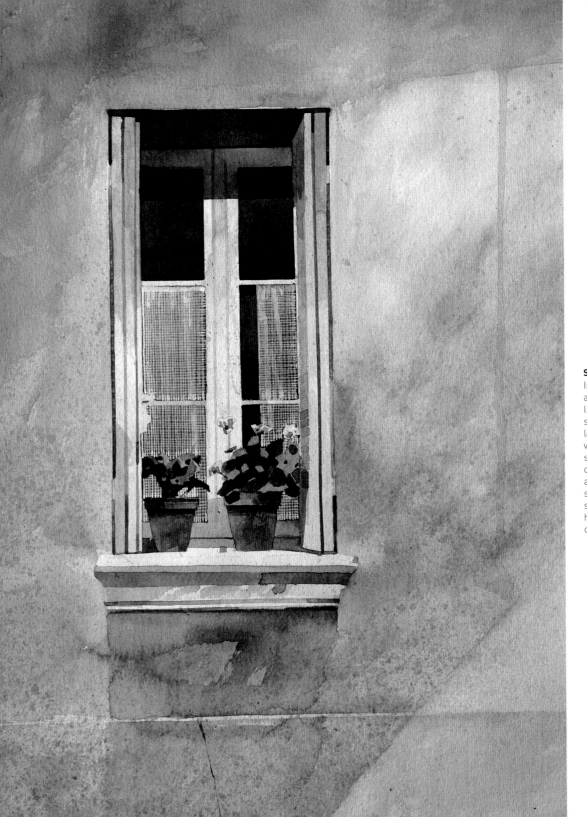

## STONE WALLS

In this close-up we see how shadows and a hint of texture are used to add life and a feeling of light to a potentially static subject like a stone building. The long, slanting shadow offsets the verticality of the window and lends a sense of atmosphere. The pitted texture of the stone is rendered with washes and glazes, overlaid with a hint of spatter in a similar tone. To prevent shadows on buildings from looking too harsh, keep some edges crisp and others soft and diffused.

## STONE HOUSES

The warm yellows and grays of stone houses often found in villages in Europe make these buildings an attractive subject to paint, particularly if they are set against a stunning landscape.

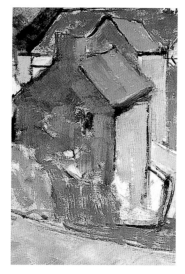

**3** The short stabbing brushstrokes have given the walls texture. They allow the ochers on the sunny wall and the greens on the shaded wall to show through the overlying grays, conveying the subtle tonal variations of the stone.

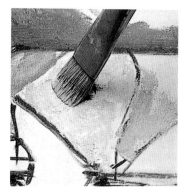

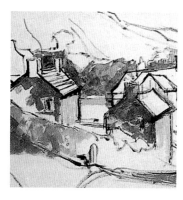

**1** The artist first establishes the outines of his composition in charcoal, which he then traces over with fine lines of black paint diluted with turpentine.

**2** He then starts to block in areas of color in such a way that allows him to judge the effect of each color on those adjacent to it.

**4** Ultramarine, green, and black have been used for the thick stone slabs on the roof, to which the artist adds detail with diluted black paint.

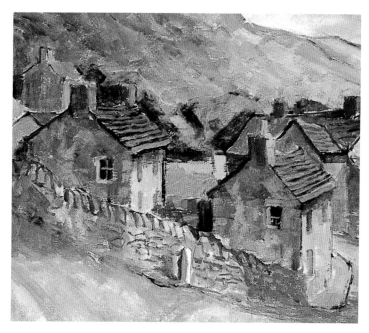

**5** The way the paint has been used gives a rugged effect in keeping with the subject.

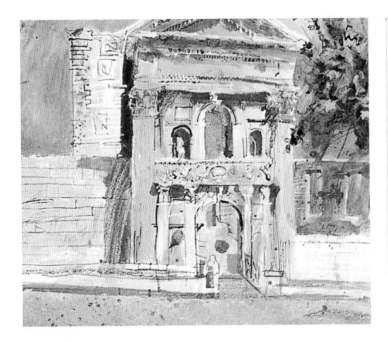

## WEATHERED WOOD

Wooden doors, fences, and gates that have been exposed to the effects of the weather make attractive painting subjects. Heat and cold cause the wood and paint to crack, split, and blister, or to become warped and twisted; the sun bleaches the color, and rusty nails in the wood leave huge red-brown stains.

Once again, do not be tempted to overdo the surface texture. After defining the overall tone and shadows, you could just suggest pattern and texture with drybrush strokes and/or sgraffito techniques.

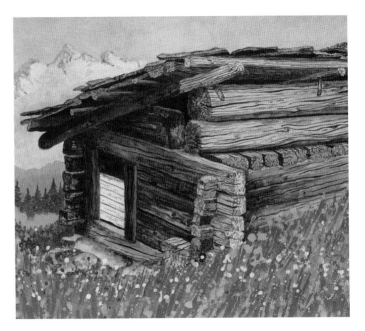

**FORM THROUGH LINE**
The fine lines, made with the point of a brush, don't only suggest the texture; they also help describe the forms of the rounded and flat planks of wood.

**STONEWORK • LINE AND WASH**
Line and wash with pen and ink perfectly capture the intricate carvings on old buildings; you don't have to render each detail painstakingly. In this example, a dip pen and sepia ink were used to convey the shadows and forms of carvings in a stone facade.

**WEATHERED STONE**
A painted stone wall might at first glance seem to be lacking in tonal variety, but closer examination will reveal a vast range of colors and textures which result from the effects of the climate. The pitted surface can be rendered with cool shadows to contrast with the warmth of the paler tones, and texture can be rendered with a combination of hard and soft edges.

**SEE ALSO**
DRYBRUSH, page 68
SGRAFFITO, pages 88–89

# WHITE BUILDINGS

WHITE HOUSES AND BUILDINGS LOOK ESPECIALLY STRIKING IN BRIGHT SUNLIGHT OR WHEN THE SETTING SUN CASTS LONG SHADOWS ACROSS THEIR WALLS. CAPTURING THE QUALITY OF LIGHT ON SUCH BUILDINGS IS SIMPLY A QUESTION OF LOOKING FOR THE SUBTLE NUANCES OF COLOR IN THE LIGHTS AND THE SHADOWS.

Shadows on white objects are not always neutral gray, as is often thought. On a sunny day, for example, they tend toward a cool blue, because white reflects the blue of the sky. In addition, the colors of both the shadows and the bright areas may be affected by color reflected from the surroundings. In particular, look for warm reflected light which is thrown up from the ground onto overhanging eaves and windowsills. The juxtaposition of warm and cool reflections sets up a translucent "glow" which effectively captures the feeling of sunlight.

## WHITE BUILDINGS

Weathered white buildings are an appealing subject to paint, whether they are East Coast weatherboard houses or Mediterranean whitewashed cottages. They are, however, quite difficult to depict; to make them look interesting, you must be aware of and able to portray the subtleties of color in the white surface. These tonal variations are not easy to see, particularly in harsh sunlight, and are difficult to depict with a limited palette. By

**SHADOWS**
The ability to render the effects of reflected light is a major factor in creating atmosphere and luminosity in your paintings. Although the tiny balcony in this watercolor is attractive in itself, what makes the picture come alive is the interplay of cool shadows and the warm reflected light on the building. Even from this tiny detail, we can sense the atmosphere of intense heat and light so characteristic of early afternoon in a hot country. In a high-key, sunny situation like this it is important to keep your color mixtures clean and simple. Here, the artist has suggested the brilliant light on the wall by leaving it as pure white paper, which reflects the maximum amount of light.

accentuating the contrasts between the cool and hot areas you can convey the sense of bright light while breaking up the limited color. By heightening texture and pattern you can also add variety and interest to the image.

**TONE AND COLOR**
The contrasts of tone and the simple color scheme combined with the geometric structure make a strong impact.

# WINDOWS

PAINTING GLASS IN WINDOWS IS LIKE PAINTING REFLECTIONS IN WATER: GLASS IS COLORLESS, BUT REFLECTS ITS SURROUNDINGS. BECAUSE WINDOWS TEND TO BE VERTICAL, RATHER THAN HORIZONTAL, THEY REFLECT AN EVEN GREATER VARIETY OF THINGS AND OFTEN LOOK DARK IF THEY ARE NOT REFLECTING ANY OF THE SKY. YOU CAN ALSO SEE THROUGH GLASS, WHICH MAKES THE REFLECTIONS EVEN MORE COMPLEX. WHEN PAINTING GLASS WINDOWS, ALWAYS USE SIMPLE, FLAT AREAS OF COOL LIGHTS AND DARKS.

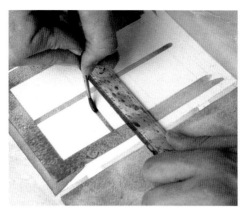

## WINDOWS • WATERCOLOR

1 Working on a sheet of stretched 200lb Bockingford paper, the artist begins by lightly sketching the main shapes of the windows and shutters. The surrounding wall is then painted with a pale wash of raw sienna, lightly drybrushed and spattered with Payne's gray to give it some texture.

2 The window frame is painted with ultramarine blue. To insure that the lines of the frame are perfectly straight, the artist uses the brushruling technique: holding the ruler at an angle to the paper, he carefully draws the brush along with the ferrule of the brush held firmly against the edge of the ruler.

3 The cast shadow of the window frame is painted with Payne's gray. The wooden shutters are textured with glazes and scumbled strokes of cobalt blue and ultramarine. Notice how the colors granulate on the paper's surface. This texture provides the basis for the old and weatherbeaten appearance of the shutters.

4 Now the artist paints the view through the window. A pale wash of cobalt blue is washed in for the sky, followed by washes of sap green and Payne's gray for the landscape. The landscape shapes are kept very simple, indicating their distance from the window. When this is dry, a shadow wash of Payne's gray is blocked in around the window and behind the shutters. Finally, detail is added to the shutters with Payne's gray and a small, well-pointed brush.

# LANDSCAPES

Pure landscape painting was not taken seriously as a painting subject until the eighteenth century. Since then it has acquired a wider appeal than any other form of painting.

As a source of visual stimulation, the landscape is inexhaustible. Ironically, this is what presents the landscape painter with the first problem: faced with the enormous complexity of shapes, colors, and textures present in nature, it is difficult to decide what to paint. Very often, the solution lies in asking yourself what aspect of nature moves you more than any other. Is it the sky? The rugged texture of coastal or mountain scenery? Or are you fascinated by the play of light on the landscape? Once you've found a subject that elicits an emotional response in you, it will be easier to communicate that response to the viewer.

Ideally, landscapes should be painted on location rather than in the studio or from photographs. The benefits of on-the-spot painting are obvious: standing in the middle of a field or on a riverbank, you are acutely aware of the colors, forms, and textures around you. There is a sense of immediacy, and you are sensitive to the fleeting, often dramatic effects of the light. All this sensory stimulus is important in helping you to produce a painting that is fresh and alive.

## PLANNING THE COMPOSITION

Having chosen the scene you wish to paint, the next step is to sit down and analyze it in terms of pictorial design. A scene that looks breathtaking in reality does not necessarily make a good painting. Trees, rocks, or buildings might be scattered over too wide an area or be too uniform in shape. The sky may be full of small clouds which would compete for attention with the complex shapes on the ground. Never feel duty-bound to represent a scene exactly as it is. Your aim is to present a balanced and harmonious picture. You will often have to bend reality a little, grouping trees together to form a strong focal point or eliminating clouds if they threaten to overcrowd your composition.

## BRINGING THE VIEWER IN

You will also need to "invite the viewer into the picture." A common compositional device is to take the viewer's eye into the picture by means of directional lines, such as a path leading in from the foreground, getting narrower as it recedes, or the lines of a plowed field leading from foreground to middle distance. In general, avoid harsh horizontals, such as a wall in the foreground, because these will act as a block to the eye. Another general rule is not to place the focal point, or center of interest, right in the middle of the picture. You want to lead the eye from one area to another.

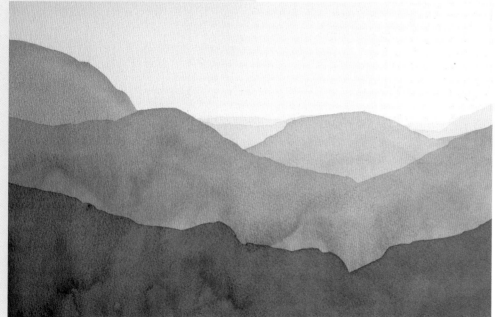

**AERIAL PERSPECTIVE • WATERCOLOR**
One of the basic rules of landscape painting is that cool, pale tones appear to recede into the distance, whereas darker or warmer tones appear to come forward. Always remember this principle when painting distant landscapes. It is your best means of creating the illusion of three-dimensional space on a flat piece of paper or canvas. Generally, it is advisable to start your painting from the farthest distance, gradually strengthening the tones and colors as you progress toward the foreground. This applies particularly to watercolor, which is a medium that requires that you always paint from light to dark.

# FIELDS

WHEN PAINTING OPEN FIELDS AND
MEADOWS, MAKE SURE TO INTRODUCE
A VARIETY OF COLORS, SHAPES, AND
CONTOURS TO AVOID A MONOTONOUS
"BILLIARD TABLE" EFFECT.

**LEADING THE EYE**
The converging lines of the field serve several
purposes: they establish this area as slightly
undulating, they lead the eye from the middle
ground to the distance, and they make a link that
ties all three areas of the picture together.

Rather than painting the field in one flat,
even tone, it is far better to brush several
different greens onto the paper or canvas
and mix them very loosely. The different
shades and tones will suggest the rolling
contours of the land. In addition, take the
opportunity to introduce cloud shadows and
shadows cast by nearby trees. Vary the
style and the direction of your brushstrokes
to indicate how the grass is ruffled by the
breeze, much like the wind ruffles water.
There are many ways of introducing variety
into an apparently flat piece of land.

In winter, the linear patterns of plowed
fields can be used as a strong design
element in your paintings. Their converging
lines lend a sense of space and perspective
to the composition.

Another means of lending depth and
space to a landscape with fields is by
keeping crisp detail to the foreground and
treating the background more loosely.

**SUMMER CORNFIELDS**
**1** The artist begins by applying a transparent
imprimatura over the entire canvas, using yellow
ocher heavily diluted to a wash-like consistency
that allows the white of the canvas to shine
through. This color will in turn shine through the
succeeding layers of thin color, tying the whole
composition together and imbuing the scene with
warmth and light.

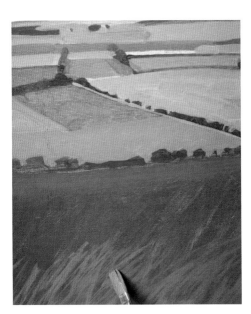

**2** The artist gradually builds up a patchwork of
fields in the distance with flat washes of yellow
ocher, Turner's yellow, and cadmium oxide green,
lightened with titanium white in places. The paint
is applied thinly, allowing the imprimatura to
show through. The field in the foreground is
painted with a mixture of cadmium oxide green
and titanium white, applied with diagonal
scumbled strokes which do not completely cover
the yellow underlayer. The artist then loads a flat
No. 4 brush with a light mixture of cadmium oxide
green and titanium white and suggests long
blades of grass in the immediate foreground with
sweeping diagonal strokes.

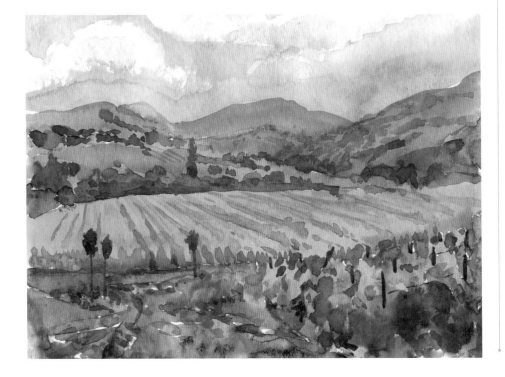

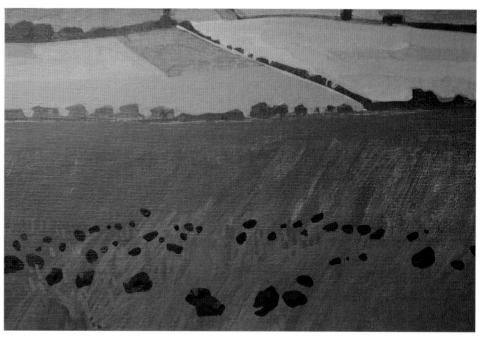

3 Finally, the bright-colored heads of the poppies are painted using various tones of cadmium red dabbed on thickly. The red flowers take on a particular brilliance because they are surrounded by their complementary color, green.

4 In the completed picture the artist has captured the atmosphere of brightness and warmth that pervades a summer landscape, with wheatfields stretching as far as the eye can see. The sense of distance is enhanced by the warm colors of the poppies in the foreground and the lively brushstrokes which contrast with the flat areas of color in the distance.

### SUMMER FIELDS

Inexperienced painters sometimes make the mistake of painting landscape subjects in colors that are too bright and look unnatural. In temperate regions, landscape greens tend to be on the cool side, and even in hot, sunny climates the colors are not always as brilliant as is sometimes supposed.

Make a point of looking for other colors besides green when you are painting a landscape with trees and grass. In this oil painting, a range of yellows, browns, pinks, grays, and gray-greens has been used to create a composition that is harmonious, yet full of variety and interest.

2 This detail shows the artist using a chisel brush to model the lights and shadows of the furrows. He does this by dragging the brush on the still-wet lines in short, scrubby strokes between the furrows. The underwash is a pale mixture of burnt sienna and ivory black, applied with loosely scumbled strokes to give a suitably rugged texture to the field. In some climates, fields in winter are darker in color than at other times of the year, because they are wet most of the time. The artist has added plenty of ivory black to his paint mixture for painting the straight lines of the furrows.

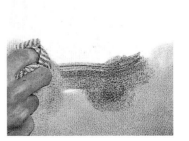

## WINTER FIELDS

1 This deceptively simple watercolor conveys the atmosphere of a stark, chilly day in winter. The way in which the picture is composed creates stresses and tensions which amplify the mood. The converging lines of the plowed furrows in the foreground lead the eye forcefully back in the picture plane to where the furrows of the distant fields suddenly change to a diagonal direction. This regular, repeated pattern of the plowed fields is contrasted with the organic forms of the clouds and trees, both painted in cool grays.

## DENSE FOLIAGE

1 Staining a canvas is a good way of establishing the background color. It is better to use a primed canvas and to select colors with a strong tinting power such as chrome green, Prussian blue, sap green, and viridian, as used in this example.

2 The colors were gradated over the whole canvas and in some areas were wiped with a turpentine-soaked rag to lighten the tone.

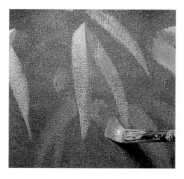

3 Using a No. 7 flat brush, the artist paints in the leaves using tones of cadmium yellow, sap green, viridian, and white.

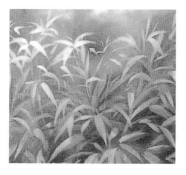

4 He has carried the patterns of spiky leaves throughout most of the canvas, not copying exactly what he sees but exaggerating the motifs to create a decorative effect.

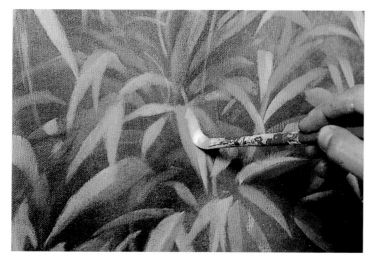

5 Reflected sunlight is implied by the addition of streaks of white to some of the leaves.

### GRASS

This is a detail from an oil painting of a summer meadow that shows the variety of subtle greens, yellows, grays, and earth colors that make up "green" grass. The artist began by covering the canvas with soft umbers and ochers, scumbled together wet-in-wet to suggest areas of light and shadow. Then, with a small pointed brush and lighter colors, he worked back into the wet color to suggest individual stems and blades of grass.

The underpainting provides a soft-focus background for the precise strokes of grass in the foreground and helps to give a sense of depth and volume. Notice how the curving, rhythmical strokes of the grass lead the eye back into the picture plane, where the tones become cooler and bluer, thus creating a sense of receding space.

# HILLS

WITH THE SOFT CONTOURS OF ROLLING HILLS IT IS MORE DIFFICULT TO DISTINGUISH THE MAIN MASSES OF LIGHT AND SHADE WHICH EMPHASIZE SOLIDITY. IT HELPS TO LOOK AT THE SUBJECT THROUGH HALF-CLOSED EYES, THEREBY REDUCING THE COLORS AND MAKING THE LIGHTS AND DARKS MORE APPARENT. WATCH OUT FOR FLEETING CLOUD SHADOWS AND USE THEM TO ENLIVEN THE FORMS OF THE HILLS.

In contrast to the sharp angularity of mountains, most hills have soft, slightly blurred edges, because they are covered with trees and vegetation. Use rapid, fluid brushstrokes that follow the undulations of the hills and allow a variety of greens and earth colors to blur into each other wet-in-wet.

If the hills are covered by trees, it is enough to merely suggest the texture of the foliage with short, scrubby strokes, rather than trying to paint each individual tree.

**SEE ALSO**

WET-IN-WET, pages 52–53

### HILLS • WATERCOLOR I
The artist has used aerial perspective to create a marvellous sense of distance in this landscape. The overlapping planes of the hills recede to the hazy, blue horizon. The color range is limited and the tones have been built up from washes laid over each other. Where the washes are thin, the white paper gives a luminous quality to the paint.

### HILLS • ACRYLIC
The artist was attracted by the wild, lonely atmosphere surrounding these ancient Welsh hills which brooded under a blustery sky. To convey their ruggedness, he applied acrylic paint in the direct, alla prima manner.

**1** The artist begins by applying a toned ground of Hooker's green over the entire canvas with a 1" (2.5 cm) flat decorator's brush, leaving obvious brushstrokes that will soon be covered with opaque color. When the toned ground is completely dry, a No. 8 bristle brush is used to paint the sky with cobalt blue.

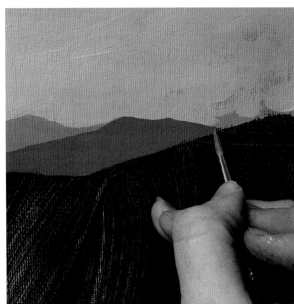

**2** A mixture of titanium white and a touch of cobalt blue is scumbled over most of the sky area, leaving a small patch of blue sky on the right. When this is dry the artist begins to block in the far distant hills with a No. 2 sable brush. The farthest range is a pale tone of Hooker's green, cobalt blue, and titanium white. This mixture is darkened slightly with more Hooker's green, and a second, closer range of hills is painted in front of the first one.

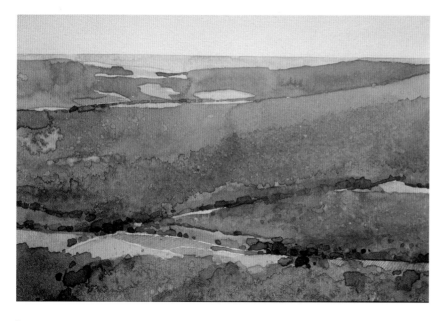

**HILLS • WATERCOLOR II**

In this detail from a hilly landscape in Italy the artist has created a subtle range of textures to suggest foliage and vegetation. He has added gum arabic to the paint to make the color denser and give it a slight sheen. He has then spattered clear water onto dry areas of paint and lifted off the color to create light patches that suggest the play of sunlight on the leaves.

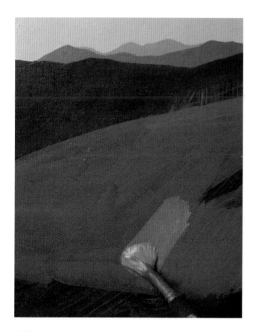

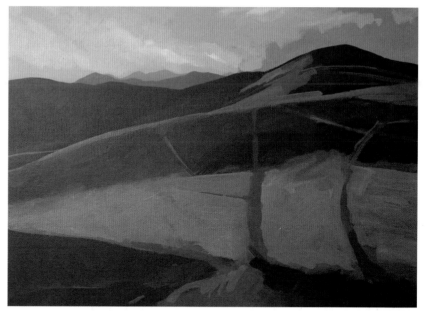

**3** The peak of the hill in the middle ground is now painted in a dark green made by adding a little ivory black to the mixture. The distinct range of tones, becoming paler in the distance, gives a feeling of atmosphere and deep space. The artist now starts working on the immediate foreground, brushing in a light tone, mixed from sap green and yellow ocher, to indicate patches of grass lit by the sun.

**4** The bumps and curves of the hillside are broadly modeled with warm and cool greens applied with vigorous strokes that move in different directions. The footpaths that criss-cross the hillside are indicated with thin paint. These pathways accentuate the contours of the hills and help to lead the eye into the picture. In the completed picture, the rugged quality of the handled paint is in perfect keeping with the nature of the subject. The opposition of warm and cool greens gives an impression of how the cloud shadows travel across the landscape as the clouds are blown by the wind.

# MOUNTAINS

WHEN YOU'RE PAINTING MOUNTAINS,
THE TRICK IS TO LOOK FOR THE BASIC
GEOMETRIC FORMS AND EMPHASIZE THE
LIGHTS AND SHADOWS.

Mountains are always impressive, but they
look particularly dramatic under certain
lighting conditions. Notice, for example,
how late afternoon sunlight emphasizes the
three-dimensional quality of the form. The
light strikes some of the planes of jagged
rock, leaving others in shadow. Solidity is
achieved in your painting by building up the
planes of light and shadow, using warm
colors in the lights and cool colors for the
shadows. It is a good idea, when painting
outdoors, to block in quickly the light and
shadow planes with a neutral underpainting
before you add color, to insure that there is
consistency in the lighting.

The amount of textural detail you give to
a mountain depends on its distance. The
blocklike forms of foreground rocks can be
painted with bold horizontal or vertical
strokes, using a knife or a flat bristle brush.
The rock forms appear less distinct on
more distant mountains, so use soft,
scrubby brushstrokes to describe them.

The effects of aerial perspective are often
strongly apparent in mountain scenes.
Begin by painting the most distant
mountains with soft, indistinct strokes and
cool blues. Gradually work forward to the
foreground, adding more detail, stronger
color, and darker tones.

## MOUNTAINS • ACRYLIC
Used straight from the tube or
diluted with medium to a creamy
consistency, acrylic paint has
enormous covering power,
strength, and directness which is
ideally suited to a scene such as
this one. Acrylic also dries quickly.
The artist uses this quality to his
advantage in building up a strong
pattern of light and dark shapes,
which gives form and solidity to
the subject.

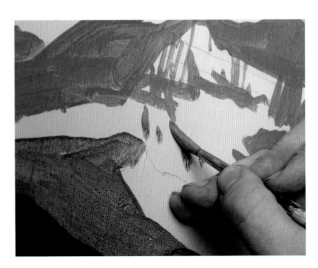

1 Working on a sheet of illustration board, the artist begins by
defining the main shapes with simple pencil outlines. He also
records the intricate pattern of light and shadow shapes so that
it can easily be followed by the brush. The main shadow planes
are then blocked in with a mixture of cerulean blue and
titanium white, diluted with water to a thin consistency. Note
how the direction of the brushstrokes helps to establish a
feeling of form. Between these strokes, patches of bare canvas
are left to suggest the light-struck areas. Switching to a No. 7
sable brush, the artist then indicates smaller shadows within
these light areas.

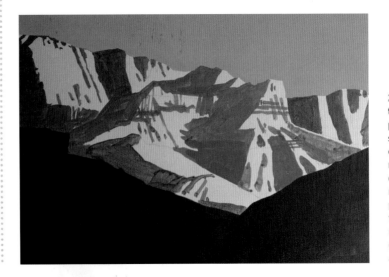

2 The artist continues
to build up the shadow
planes with broad
strokes that follow the
contours of the
mountainside. The
dark shape of a
mountain ridge is
painted in the
foreground, using a
mixture of Payne's
gray, cerulean blue,
and titanium white.

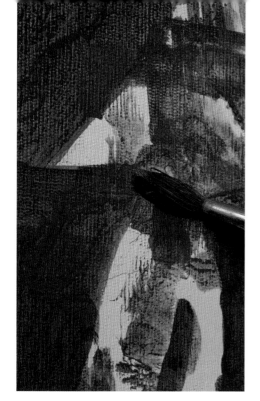

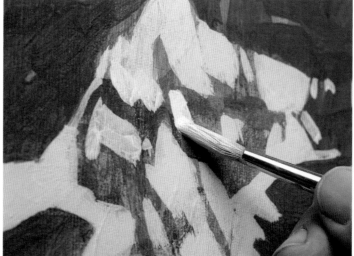

**4** Finally, the sunlit patches of snow are filled in with titanium white, which is applied with a round sable brush.

**3** With the main shapes and forms roughly established, the artist now sets about consolidating them with thicker, darker paint. The pigment is diluted with water, mixed with a little gloss medium to a creamy consistency, and applied with a flat brush in smooth strokes. In this detail, paint is being applied by "rolling" the brush to create strokes similar to drybrush. This gives a suitably craggy texture to the mountainside.

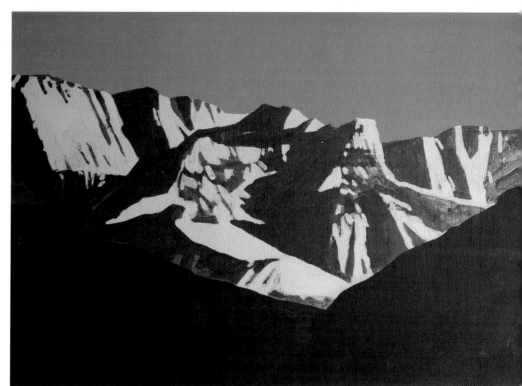

**5** In the completed painting, the shadowy foreground heightens the impact of the dramatic lights and darks on the distant mountain, rather like throwing a spotlight on a stage.

# ROCKS

THE MOST COMMON MISTAKE WHEN PAINTING ROCKS IS TO MAKE THEM APPEAR TOO SOFT AND FORMLESS. ROCKS ARE SOLID, THREE-DIMENSIONAL, AND HEAVY. THE WAY TO PORTRAY THESE QUALITIES IS BY EMPHASIZING THE CONTRASTS OF LIGHT AND SHADE THAT PLAY ON THEM.

The first thing to consider is the overall structure of the rocks. Some rocks are rounded in shape, some are jagged, and some are a combination of both. Begin by picking out the broadest areas of tone and color and brushing them in freely. Next, look for smaller planes of tone and color within the large planes and indicate them with short, stabbing strokes. For angular rocks, leave the edges between these planes quite sharp and distinct. For rounded forms, you could produce a graded effect by softening and blending the edges of the different planes.

Finally, when the overall structure is completed, indicate the main cracks and fissures on the rock surface. These act as contour lines which move across and around the form and strengthen its three-dimensional appearance.

Rocks are a fascinating subject whatever medium you use, because they offer an ideal opportunity to try out different kinds of brushwork. In oil and acrylic, short strokes of impasto, applied with a knife, will describe the jagged edges of rocks. In watercolor, too, a blunt knife can be used to scrape out wet paint to create jagged highlights. In egg tempera, highly realistic effects are achieved by using tiny strokes, hatched and crosshatched to describe every minute change of color and tone.

In most media, rough surfaces can be implied by dragging and scumbling with fairly dry paint or by spattering with wet paint. Mottled patterns caused by the presence of lichen or moss can be described very effectively by dabbing color on with a sponge. The possibilities are endless, but take care not to get carried away with a technique.

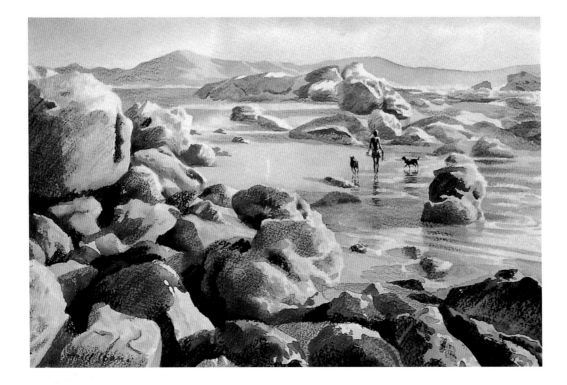

**SEE ALSO**

IMPASTO, pages 48–49
SCUMBLING, page 69
SPATTERING, pages 74–75

**EXPRESSING FORM**
Strong contrasts of tone have been employed in Hazel Soan's painting to build up the different forms and give a sense of solidity to the rocks. Notice how she has used cast shadows to give more depth to the foreground and establish the strong light source coming from above right.

## ROCKS • OIL

**1** In a painting of a rocky headland with crumbling cliffs and striated patterns, the artist used a variety of techniques to depict the different textures. He first drew on a fine-textured board with a pencil and then applied several washes of diluted oil paint. Each diluted layer was applied after the one before it had dried; liquid was added to the paint to speed up its drying time. The striations in the rock were painted in with vertical strokes.

**2** To emphasize the vertical fissures in the rock, the artist used a soft (3B) pencil sharpened to a point to draw into the paint. He also used a scalpel to scratch back into it.

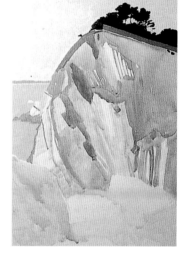

**3** The painting was allowed to dry before the next layer of color was applied. The pale washy nature of the rock and grass is balanced by the starkness of the trees at the top of the headland.

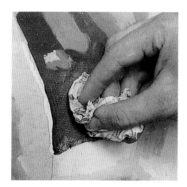

**4** Wet paint on crumpled tissue paper was dabbed onto the grassy area to create texture and deepen the color.

**5** The artist then used a stiff brush to splatter diluted paint onto the rock to enhance the textural effect further.

**6** An art knife was used to scratch the paint surface to reveal the underlying white of the canvas.

*SEQUENCE CONTINUED OVERLEAF* ▶

**7** Highlights were applied with a brush, using a mixture of Payne's gray and white.

**8** In the final stage of the painting, the artist smudged the highlights with his finger to blend them in slightly.

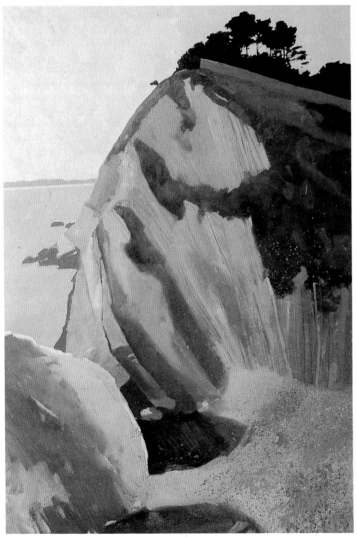

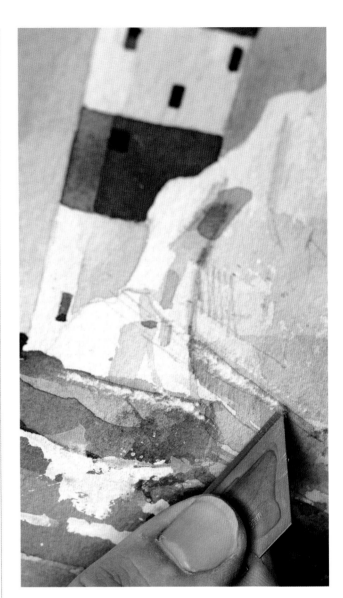

**ROCKS • WATERCOLOR**
In this detail from a coastal landscape in watercolor, the artist is scratching out paint with a sharp blade to create an impression of the cracks and striations in the face of the sunlit rock. This technique is known as sgraffito.

# TREES

TREES ARE AN IMPORTANT THEME OF MANY LANDSCAPES, AND THE SERIOUS ARTIST SHOULD STUDY THEM AS CLOSELY AS A PORTRAIT PAINTER STUDIES THE HUMAN FACE AND FIGURE.

Observation is the key to painting trees convincingly. Each species has a particular shape and growth pattern, and each tree within this species has a unique character. An oak tree, for example, has a squat, rounded silhouette, with a heavy trunk and gnarled branches. The elm, on the other hand, has a tall, slender, and graceful silhouette. Deciduous trees lose their leaves in winter, which is a good time to study their characteristic "skeletons" without the distraction of their leaves.

Don't allow yourself to become overwhelmed by the apparent complexity of branches, twigs, and leaves. It is impossible and ineffective to try to paint every leaf. However, making do with a generalized version of a tree is equally undesirable. The best approach is to look for the large shapes and masses, which characterize that particular tree and give it volume, and to paint them as broadly and directly as possible.

Begin by reducing the outline or silhouette of the tree to its simplest form and blocking in the shape as a solid mass of tone. Remember to leave gaps between the branches, particularly around the outer edges. Next, indicate the main masses of foliage within this overall shape.

Notice how each mass is modeled by light and shade and how each casts its own shadow on nearby masses of foliage. Finally, use a smaller brush to add the most important branches and twigs and a suggestion of foliage.

Pay attention to the limbs of the tree also. A common mistake is to make all the branches grow sideways, ignoring the fact that some will extend toward and away from you. Notice how the limbs taper gradually from thick to thin as they reach outward and become lighter in tone near the top of the tree, where they receive more light.

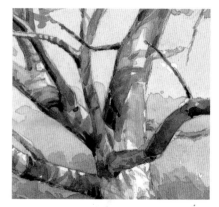

**3** After painting in the shadow on the grass, the tones on the branches and trunk are adjusted to suggest some branches thrusting forward and others curving away.

**TREES • PERSPECTIVE**
**1** The artist begins by observing the perspective; how some of the branches recede, some shoot forward and are foreshortened, and some are seen sideways on. A wash of raw umber and green-gold is laid over the whole area and color lifted out on the light side of the trunk and some of the branches.

**2** When dry, a mix of green-gold and raw sienna is brushed into parts of the branches and trunk. Attention is paid to the fall of light, which creates shading that models the forms and describes the spatial relationships.

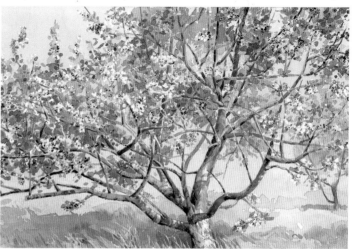

**4** The final piece has realistically captured the tangle of branches of the apple tree as well as the spring sunlight and pretty pink blossoms.

**FALL TREES • VIBRANT COLORS**

**1** The large branch is drawn in and and the smaller branches and leaf masses are indicated. A No. 12 round brush is loaded with watery, though not too pale, quinacridone gold and painted around the large branch, worked loosely into the leaf masses. It is allowed to dry.

**2** The top of the leaf clumps are painted in with alizarin crimson. While still damp, a darker tone of Windsor red is added with angular brushstrokes. After leaving to dry, the yellow background is worked into with a mix of quinacridone gold and Windsor red.

**3** Once the orange color is dry, a mix of sap green and indigo is painted around the red leaves. Once this is dry, the main branch is indicated with a mix of burnt umber and indigo, giving structure to the foliage.

**4** To capture the considerable variations of tone and color in the leaf masses, the artist builds up the darkest tone on the lower edges with a mix of brown madder and Windsor red, then further accents of Windsor red are added.

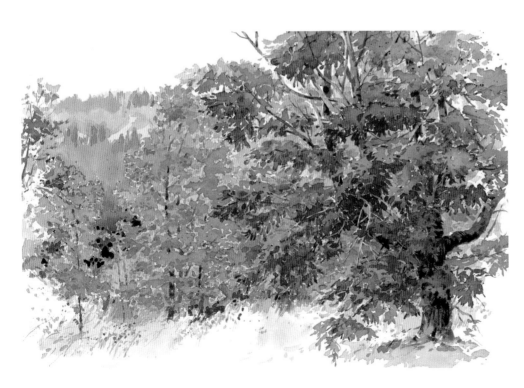

**5** In the final painting the bright reds of the foliage glow out against the dull green of the background; the dark tones give form and structure, and the profusion of twigs and branches add texture and interest.

## TREES • DEFINING FORM

**1** The artist starts with a wash of green-gold and Hooker's green. After allowing this to dry, a slightly darker tone is added. The size of the strokes are varied and patches of the first color are reserved. Hard edges form as the paint dries.

**2** While still damp, a third tone is added and worked wet-in-wet to strengthen the shadows. The softer blends contrast effectively with the crisp edges of the light areas. The branches are painted in with a strong mix of burnt umber and olive green, and a little of this is also dotted into the shaded areas to suggest darker leaves.

## SUMMER TREES • SPONGE PAINTING

**1** The soft, irregular texture of a sponge makes it particularly well suited to rendering the texture of tree foliage. The artist applies increasingly dark washes of sap green and Payne's gray.

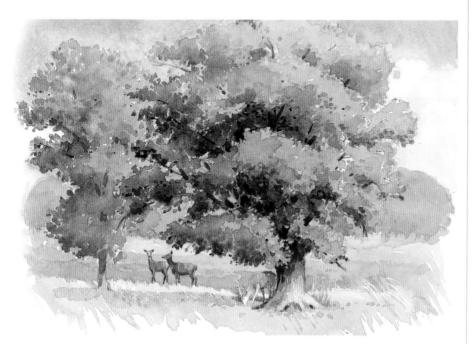

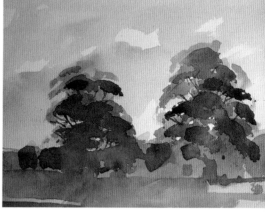

**2** The completed painting has a refreshing spontaneity and feeling of light, and the sponged texture gives a convincing interpretation of heavy summer foliage.

**3** The finished painting captures the forms, colors, and textures of the scene without engaging in too much detail.

## WINTER TREES • WATERCOLOR

When painting the bare trees of winter, don't make the mistake of trying to portray every twig and branch, because this can look rather stilted. It is far better to convey an impression of massed twigs and branches, particularly where trees are grouped together. In this impression of a winter landscape the artist depicts the distant trees as a soft blurred tone against the sky, accented by a brief suggestion of branches.

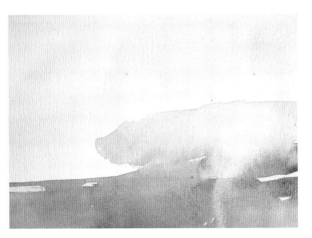

**1** The artist dispenses with an underdrawing, preferring to allow the spontaneity of watercolor to have free rein. A pale wash of cerulean blue is washed in for the sky, followed by a loose wash of diluted sap green for the foreground. While the paint is still damp, the artist creates a deliberate backrun on the right of the painting by flooding the area with clear water applied with a soft brush. The loosened color is allowed to bleed into the foreground. This shape will eventually be developed into a small group of trees enveloped in mist.

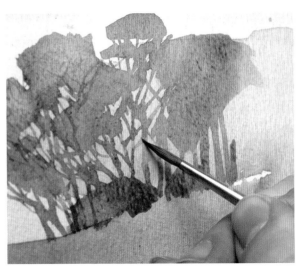

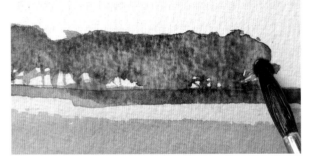

**3** The trees farther back in the distance are painted loosely with a wash of sap green darkened with a touch of Payne's gray.

**2** The artist uses a No. 2 sable brush and a mixture of Payne's gray and raw umber to draw in the delicate shapes of the trees on the right. A small soft brush is used to lift out color here and there to suggest swirls of mist.

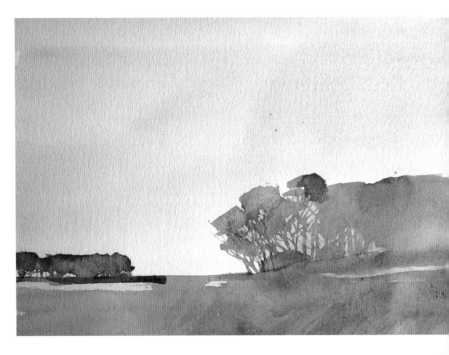

**4** The completed picture perfectly captures the cold stillness of a frosty morning in the country. This mood is conveyed by the way the artist has composed the picture: the low horizon line emphasizes the calm, open sky.

## PALM TREES

Palm trees are always a favorite painting subject, with their tall, graceful trunks topped with luxuriant foliage.

### PALM TREE • WATERCOLOR I

Here the artist has used watercolor, an excellent medium for rendering the crisp, clean outlines of a palm tree. Using a No. 4 sable brush, he painted the trunk with a pale underwash of raw umber, graduating to Payne's gray near the base. When this was dry the shaded half of the trunk was strengthened with ivory black and Payne's gray. What is particularly interesting here is the use of lively, scribbled marks to indicate the jagged texture of the trunk, caused by palm fronds breaking off.

### PALM TREE • WATERCOLOR II

This picture shows a different species of palm tree, with softer, more feathery foliage. The secret is to capture the essential characteristics of the foliage without overworking the painting. Sap green and Payne's gray were used here to create a few simple tones, laid down in overlapping washes and blotted with a tissue to create texture. Darker washes were used for the "inner core" of the foliage, while the lightest tones are found at the outer edges, painted with feathery drybrush strokes.

# FIGURES IN THE LANDSCAPE

THE QUESTION OF WHETHER OR NOT TO INCLUDE FIGURES AND ANIMALS IN A LANDSCAPE DEPENDS ON THE MOOD YOU ARE TRYING TO CONVEY. IF YOU WISH TO PROJECT A FEELING OF PEACE AND SECLUSION, THE ADDITION OF FIGURES MAY BE INAPPROPRIATE. BUT IN MANY CASES AN ELEMENT OF ACTIVE INVOLVEMENT IN THE SCENE HELPS TO BRING IT TO LIFE.

A group of cows in a distant field, a fisherman by a riverbank, or an old man strolling down a country lane all provide a narrative element, as well as giving life, movement, and scale to the scene. A tiny figure on the shore helps to convey the vastness of the sea; a grand doorway becomes even more imposing with a small figure standing before it.

Having said all this, it is most important that figures be included in the scene for a purpose and not just to fill up a space. Generally, they should be placed in the middle or far distance, acting as a supporting feature of the landscape. If a figure is placed too centrally, the picture is in danger of becoming a portrait with a landscape in the background.

It is also essential that animals and people be rendered in correct proportion to their surroundings. Otherwise, a perfectly good painting may be ruined. One way to overcome this problem is to draw the figure on a small piece of tracing paper and lay it on the painting, so long as the painting is dry. This way you can check that the relative scale of the figure is correct, and you can try the figure out in different positions in the composition.

## FIGURE SKETCHES

Here are a few examples of simple figure sketches drawn with a small brush and ink. Take every opportunity to make rapid sketches of people in parks, cafés, railroad stations, etc. Keep the sketches small so that they can be drawn rapidly, and look for interesting shapes that convey a sense of movement. These sketches can be used later as reference when you are painting a landscape in the studio; having been drawn from real life, your figures will have a greater sense of authenticity.

## TELLING A STORY

Bringing figures into a landscape introduces a narrative element, as we always identify with our fellow beings. Denise Burns's oil painting is more about the people than the seascape, which plays a minor role.

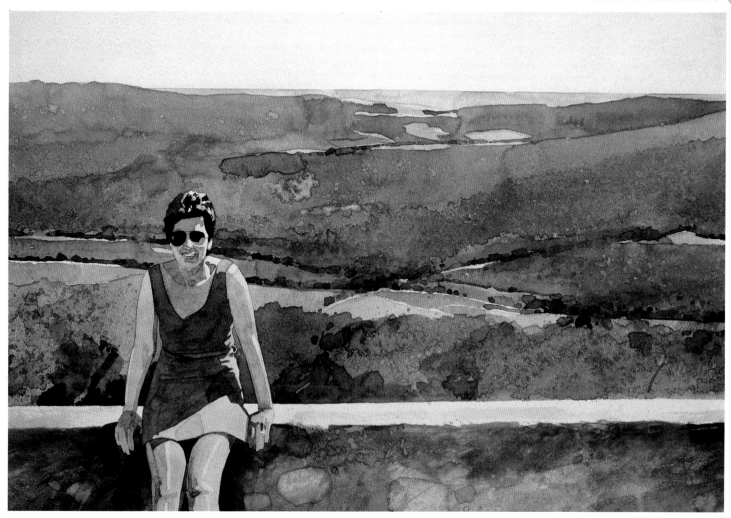

## HAVE CONFIDENCE AND PRACTICE

Many amateur artists exclude figures from their landscapes because they feel that they are not competent enough at figure painting. But for the purposes of a landscape painting, a detailed figure study is less important than the attitude and activity of the figure. In fact, the less detail you include the better, because it allows the figure to blend naturally with the surroundings. For tiny figures in the distance, a well-placed stroke for the body and a dot for the head may be all that is required. For figures in the middle distance, the best technique is to start with a silhouette of the figures and gradually introduce lights and shadows into them to lend weight and solidity to the forms. The most important thing is to get an interesting shape and a sense of movement. Make sure the figure is engaged in some sort of activity and not just hanging around aimlessly!

The best way to practice figures in landscapes is to make rapid sketches in soft pencil each time you go out on a sketching or painting trip. Keep the sketches small, and aim to capture the gesture and silhouette of the figure or animal. These sketches will be an invaluable source of reference to you when painting landscapes in the studio.

### CREATING SCALE

The inclusion of a figure or figures can provide a focal point in a landscape and give an indication of the scale of the other features. In this painting, the figure of the girl in the foreground accentuates the vastness of the mountainous landscape behind her. Think carefully about the positioning of figures in your landscapes. They should be an integral part of the overall design. For example, they can be used to stress the importance of the center of interest or be used to lead the eye into the picture.

### FIGURES FROM A DISTANCE

**1** In painting the figures in the landscape, the artist has decided that they are too small to be painted in detail. With simple broad brushstrokes he applies the basic skin tones, laid on top of the background color.

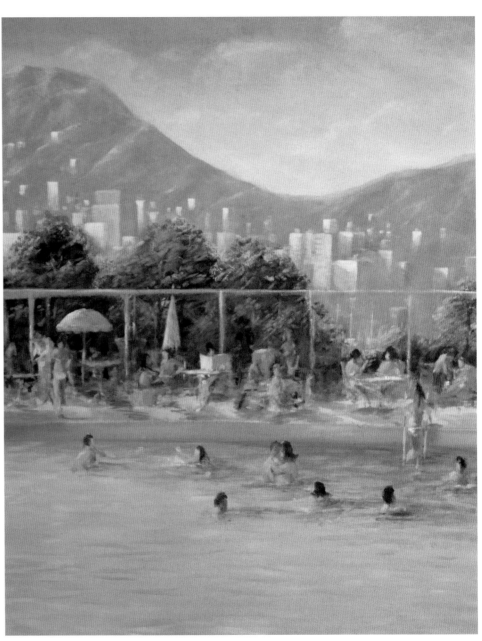

**2** Then he adds the darker tones for the hair and the modeling of the figures.

**3** In the final picture everything falls into place. The figures, which looked like blobs of paint close up, now look very life-like.

## FIGURES IN ACTION

No matter how simple your rendering of the figure is, it is important to get the proportions right. The most common mistake is making the head too big in relation to the body. It is useful to remember that the length of the head is roughly one seventh of the figure's total height. Generally the legs are a little longer than the trunk, and the arms extend to roughly halfway down the thighs.

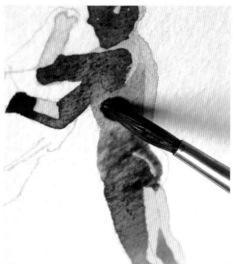

**2** The form of the figure is modeled very simply, using raw umber and burnt umber for the areas in shadow. The bathing suit is then painted with ultramarine.

**3** Even though this figure is rendered freely and with very little detail, there is a marvelous sense of the way strong sunlight falls on the figure, from the right. The impression of movement and action is reinforced by the way the towel is caught by the wind.

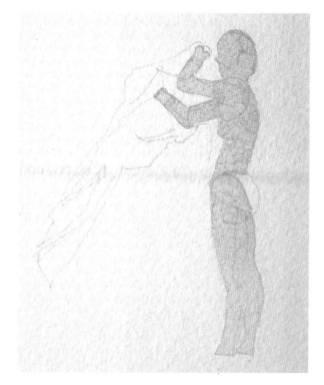

**1** Here the artist is making a rapid watercolor sketch of a woman on a beach, shaking out a towel. After making an initial pencil sketch to get the proportions right, the artist blocks in the lightest tone on the figure with a pale wash of cadmium red light.

# PORTRAITS

Of all the painting subjects, the human face is without doubt the most challenging. The main difficulty faced by the artist is in making the head not only look solid and three-dimensional but also recognizable as the person who is the subject of the painting. Before attempting your first portrait, you will find it helpful to make sketches of faces at every opportunity. Sitting on a train or bus, you can sketch faces and individual features, such as eyes and mouths. Studying your own face in the mirror is also a good idea; you might also paint a self-portrait before you begin on other people.

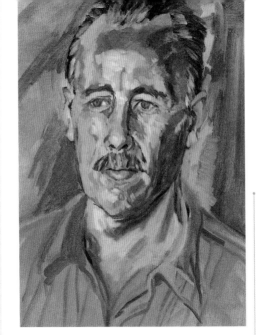

**CHARACTER**
A successful portrait goes beyond merely recording facial features. This oil portrait by Rima Bray gives a strong impression of the sitter's character and typical expressions.

Assuming that you have found a model and are ready to begin painting the portrait, there are some preliminary steps to consider before you actually put brush to canvas. The first step is to establish a rapport with your sitter and help them to relax. Make conversation as you paint, and provide some background music if you like.

The other important factor is the pose. This needs to look natural, as well as be comfortable for the sitter: if he or she feels ill at ease, their tense expression will come through in the painting. In general, a sitting pose is better than a standing one, because it allows the model to relax and hold the pose without moving too much. Even so, you must allow your model frequent breaks.

## BACKGROUNDS AND LIGHTING
Backgrounds play a secondary role in most portraits, but they nevertheless require thought and attention. You may choose to paint the setting in which the sitter is placed, or to treat the background as a simple color area with no detail. In either case, try to choose colors that provide pleasing contrasts with the face or figure.

In most cases, portraits are painted indoors, which gives you a choice of using natural or artificial light. Natural daylight is preferable, especially when it comes from a fixed source such as a window or skylight. If you are

working with artificial lighting, choose "warm white" fluorescent tubes if possible.

Whether working with natural or artificial light, it is best to illuminate the subject from a single source only. Soft, diffused light coming from one side of the head is flattering to the model and brings out the form of the features. Light falling just in front and to one side of the model, referred to as "three-quarter lighting," is probably the easiest to paint. The light illuminates one side of the face and part of the front, throwing the other side into shadow. This makes the lights, half-tones, and shadows readily distinguishable and helps to solidify the form.

## WORKING METHODS
Begin by resolving everything down to basic shapes and tones, and build up gradually from there. Don't make the mistake of drawing a detailed outline of the face and then filling it in with color. By all means indicate the overall shape with loose strokes as a rough guideline, but a hard, rigid outline inhibits and stultifies the painting process. You should always be free to alter the painting as it progresses.

Begin by using large brushes to indicate the main masses, lights, and shadows, and once you have established the three-dimensionality of the form, proceed in a natural sequence from broad, sweeping strokes to smaller, more precise ones. Even at this stage, don't become too involved with details such as the eyes and mouth. The form of the face as a whole is what's important. Getting a good likeness is not simply a matter of accurately painting the eyes, mouth, and nose. The shapes, sizes, and relative proportions of the face differ from one individual to another. Observe these surface shapes closely, because these are what give your sitter his or her particular identity.

# EYES

THE EYES ARE OFTEN REFERRED TO AS
"THE WINDOWS OF THE SOUL," BECAUSE
THEY CONVEY SO MUCH ABOUT A
PERSON'S CHARACTER AND MOOD. AS
SUCH, THEY ARE A VITAL ELEMENT OF
ANY PORTRAIT, AND IT IS IMPORTANT
TO GET THEM RIGHT.

In shape, size, and character, eyes may differ
enormously from one person to another, but
the basic anatomical structure remains the
same. The eye is a convex form in a concave
socket, but all too often it is rendered in a
schematic way, as an almond shape with a
circle in it. The upper and lower lids are never
the same shape; the lower lid is much flatter.
In addition, the upper lid covers a third to half
of the iris, depending on the individual, and the
iris "sits" inside the lower lid—not on its edge.

Conveying the illusion of the spherical nature
of the eye, as with any rounded object, involves
working with light-dark modulations of tone, as
demonstrated here. Notice how the lights and
shadows emphasize the curving shape of the
eye: even the white of the eye can be brighter
on one side of the iris, curving gradually into
shadow on the other side. The band of shadow
below the eyelid helps to give the effect of the
lid curving over the ball of the eye.

When light coming from one side strikes the
glassy, moist surface of the cornea, a bright
highlight is produced which gives light and
sparkle to the eyes. Keep this in mind when
lighting your sitter. The transparency of the eye
allows some light to travel on inside the
eyeball, creating a softer reflection on the
opposite side which gives a wonderful glow and
luminosity to the eye. Paint the main highlight
crisply and the secondary one softly, paying
attention to their subtle coloring; highlights are
not always white. Glazing also helps to convey
the reflectivity of eyes.

Generally, the eyes should have a soft,
"melting" appearance. This is achieved by

avoiding too many crisp hard edges and painting
wet-in-wet. Even the blackness of the pupil
should be softened at the edges where it meets
the iris, to avoid an unnatural, staring look.

Finally, never paint individual eyelashes;
nothing looks more amateurish. Use a curving,
irregular dark line to give an impression of
the eyelashes.

### EYES • OIL

**1** Having drawn the face in pencil, the artist starts
to lay in the paint, working down from the hair. He
interrupts his method to paint in the irises and
eyelids separately, relating them to the skin color
already painted and working outward from the
eyes toward the broader areas of skin tone.

SEE ALSO

WET-IN-WET, pages 52-53
GLAZING, pages 58-59

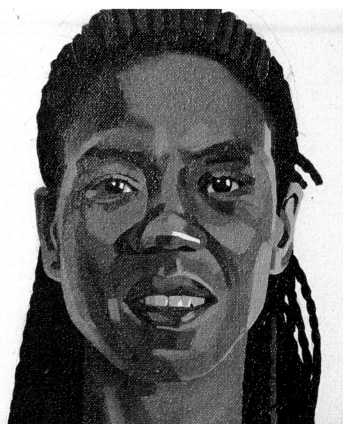

**2** The eyes have been
integrated into the
completed face with a
subtle blend of colors
around the lids. The
eyes also reflect the
direction of the light
source; the white of the
left eye is brighter than
that of the right.

## EYES • WATERCOLOR

Of all the facial features, eyes are the most complex and difficult to paint, and watercolor can be a particularly tricky medium to use. The fluid nature of the medium is not easily controlled. However, this is more than compensated for by watercolor's unique transparency and delicacy. In this demonstration, the artist shows how to build up a series of subtle washes and glazes which emphasize the form and three-dimensionality of the eye, as well as the "glassy" surface appearance.

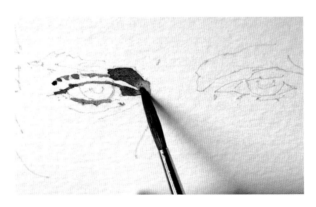

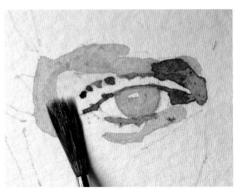

**1** After making an outline sketch of the eyes in pencil, the artist defines the shape of the eye rim and the shadow on the inside corner of the eye with a mixture of ivory black and brown madder alizarin and with a No. 2 sable brush.

**2** When the first wash is completely dry, a thin, transparent wash of burnt sienna is used to block in the middle tones around the eye. Then, with a delicate wash of cobalt blue and Payne's gray, he paints in the iris, leaving a tiny dot of untouched white paper for the main highlight.

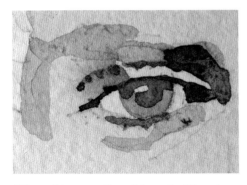

**3** The artist now applies a thin wash of Payne's gray to the eye. In one stroke he delineates the pupil and the shadow cast by the upper lid, being careful to work around the white shape of the highlight. With a clean, damp brush, he then carries a little of this color up toward the outer corner of the eye to create a subtle shadow which emphasizes the curve of the eyeball. Checking first that the flesh tones around the eye are dry, the artist now paints the lightest tones of the face with a heavily diluted wash of burnt sienna.

**4** When this wash is dry, the flesh tones are now strengthened with further washes mixed from cadmium orange, brown madder alizarin, and burnt sienna, and the artist begins to paint the various tones of the hair with burnt umber and cadmium orange. The shape of the eyebrow is then strengthened with a mixture of burnt sienna and cobalt blue. When these washes are dry, the color of the iris is developed further with strokes of cobalt blue, leaving some subtle highlights of paler blue. Then the pupil is darkened with a wash of ivory black. Notice how the two colors bleed into each other very slightly where they meet, creating a soft, "watery" feel which is much more lifelike than a hard, unsympathetic edge. Next the "white" of the eyeball is toned down with a very pale mix of yellow ocher and Payne's gray, which is slightly darker in the inner corner of the eye where there is more shadow.

It is important to work continually back and forth between the eye and the surrounding features, so that the eye becomes an integral part of the face.

5 With the basic tones and shapes now established, all that remains is to sharpen up the details in the eye to strengthen its "glassy" appearance. Finally, tiny upward strokes of paint are lifted out just above the eyelid; viewed from a distance these pale shapes give an impression of blond eyelashes.

6 Below is the completed painting. Delicate washes and glazes have been used throughout to create a subtle and lifelike portrait of a young girl.

**CLOSED EYES • ACRYLIC**

1 Having sketched in the head and the features of the face, the artist works on the eyes.

2 In this detail you can see the various skin tones. The lightest areas are made up of yellows, pinks, and oranges, whereas the shadows contain tinges of blue, green, and purple.

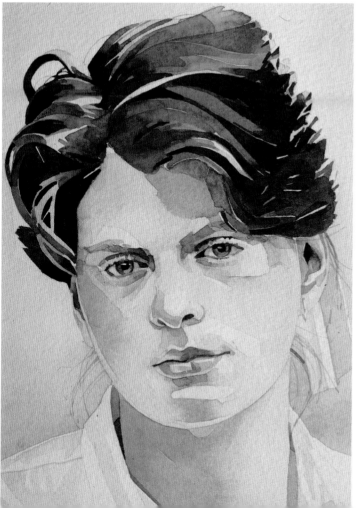

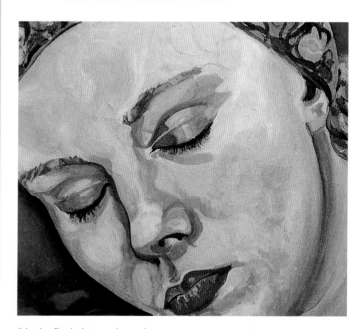

3 In the final picture, the various tones merge together. The tones of the eyelids are purple in comparison with the golden colors of the cheeks.

# MOUTHS

THE MOUTH IS THE MOST MOBILE PART OF THE FACE, AND CAPABLE OF MANY EXPRESSIONS. LEONARDO'S *MONA LISA* IS THE MOST ELOQUENT EXAMPLE OF THE SUBTLETY OF EXPRESSION THAT THE MOUTH CAN LEND TO A PORTRAIT.

The most common mistake when painting mouths is to draw the final outline first and then fill it in with color. This linear approach is inappropriate for a painting and gives the mouth a flat, pasted-on appearance. The correct technique is to model the mouth in a sculptural way, in terms of light and dark tones and hard and soft edges.

Assuming that we are looking at a closed mouth in repose, there are various points to be noted. First, the mouth is not flat but stretches around the sphere of the head, swelling out toward the middle of the face and narrowing again toward the corners. The upper and lower lips have distinct features: the upper lip may be thin, well defined, and dark in tone when compared to the lower lip, which is usually fuller and softer, and lighter in tone because, being more prominent, it catches more light.

To emphasize the curvature of the lips, begin at the corners and work inward. Put in the darkest tones first—the underside of the upper lip, and the shadow beneath the lower lip. Then apply the middle tones, blending them softly into the darks. Finally, add the highlights.

So that the mouth appears integrated with the surrounding skin, introduce a variety of hard areas and soft areas into it. The top line of the upper lip, for example, may be much crisper than that of the soft, lower lip.

Finally, don't make the mistake of painting the lips too red. Use the same color mixtures as you would for the skin, with the addition of just a touch more red.

**MOUTHS • ACRYLIC**

**1** A mouth is not a flat shape but rounded, requiring different shades to describe its form. Begin by painting the middle tones with a No. 2 brush. The basic mix of colors is white, cadmium red, cadmium orange, and cobalt blue.

**2** Add the highlights where the light catches the moisture and the raised muscles on the lips.

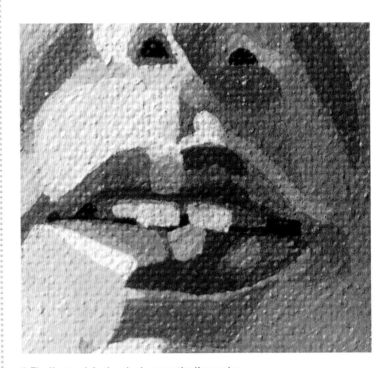

**3** Finally, touch in the shadows on the lips and on the surrounding skin.

## MOUTHS • OIL

Painting a portrait from a three-quarter view can often yield more interesting results than the conventional full-face portrait, but care must be taken to get the shape and positioning of the features right. Here the artist uses oils to paint a mouth from a three-quarter view. The slow drying time of oils allows for the soft blending of colors in a way that is not possible with other media, and any necessary alterations can easily be made while the paint is still wet.

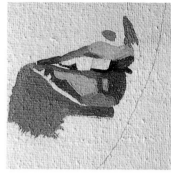

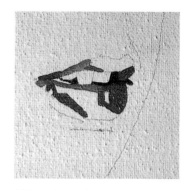

**1** The artist begins with a brief sketch to outline the shape of the mouth, and then blocks in the darkest tones with burnt and raw sienna and a No. 4 sable brush.

**2** Here the lighter tones have been blocked with cadmium red, burnt sienna, and titanium white. A mixture of burnt umber and white is used to define the darkest shadows around the mouth.

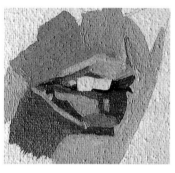

**3** The artist now blocks in the lights and middle tones around the mouth, blending them smoothly together. With a touch of cadmium yellow and ivory black, the tones of the teeth are darkened very slightly.

**4** Using a very limited palette, the artist has succeeded in rendering a bold, direct impression of the mouth.

**5** In the finished painting, the slightly open mouth is echoed by the animated look of the eyes; the sitter appears to be engaged in conversation or interested in something we cannot see.

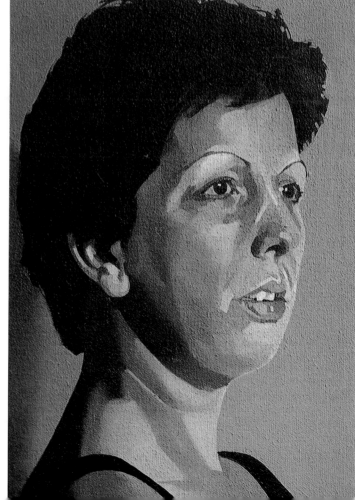

## MOUTHS • WATERCOLOR

A smiling mouth is more difficult to paint than a mouth in repose, since any undue exaggeration of the smile results in a caricature rather than a portrait. The essential thing to remember is that we smile not only with our mouths but with our entire faces. Cover up the mouth in this portrait and you will see that the girl is still smiling. This is valuable proof that all the features of the head are interlinked and supportive of one another.

Obviously it would be difficult for a sitter to hold a smiling pose for a long period without the smile becoming somewhat "fixed." In this case, it might be helpful to take snapshots of your sitter and use these as references during the painting of the portrait.

**1** In this sequence, the artist demonstrates how he uses simple watercolor washes to render the important shadow patterns formed by the creases around a smiling mouth. After sketching in light pencil lines to establish the facial features and main shadow patterns, the artist begins painting the mouth. The dark line between the upper and lower teeth is painted with a light wash of ivory black, using the tip of a No. 2 sable brush. Then the upper gums are painted with a delicate tone of brown madder alizarin and cadmium orange. The same color is used on the lips, except for a small section of untouched paper on the lower lip, which serves as a highlight.

**2** When the first washes have dried, the artist blocks in the lightest tones around the mouth with a delicate wash of cadmium orange. A large area of white paper is left to indicate the light-struck area on the left side of the chin.

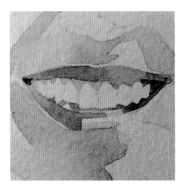

**3** Next, the darker tones of the upper lip and the right side of the lower lip are painted with brown madder alizarin. When the light skin tone around the mouth has dried, the artist indicates the middle toned shadow shapes with cadmium orange and a touch of burnt sienna. Already we can see the smile beginning to form.

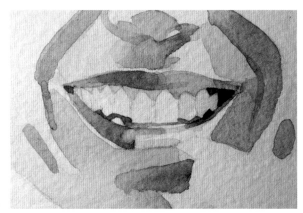

**4** When the middle tones are completely dry, the artist continues to build up the darker shadows by glazing with a mixture of cadmium orange and burnt sienna. The darkest shadows, under the nose and in the cleft of the chin, are painted with a mixture of burnt sienna and Payne's gray. It is important that each layer of color be perfectly dry before the next one is applied, so the shadows remain clear and luminous.

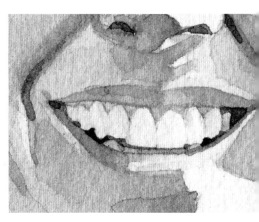

**5** The color on the shadow side of the face is darkened with further washes which accentuate the light-struck planes of the left side of the face. Finally a light mix of ivory black and yellow ocher is brushed onto most of the upper teeth, leaving one or two white highlights. This is another important point about painting mouths; always make teeth slightly darker than the white of the paper in tone.

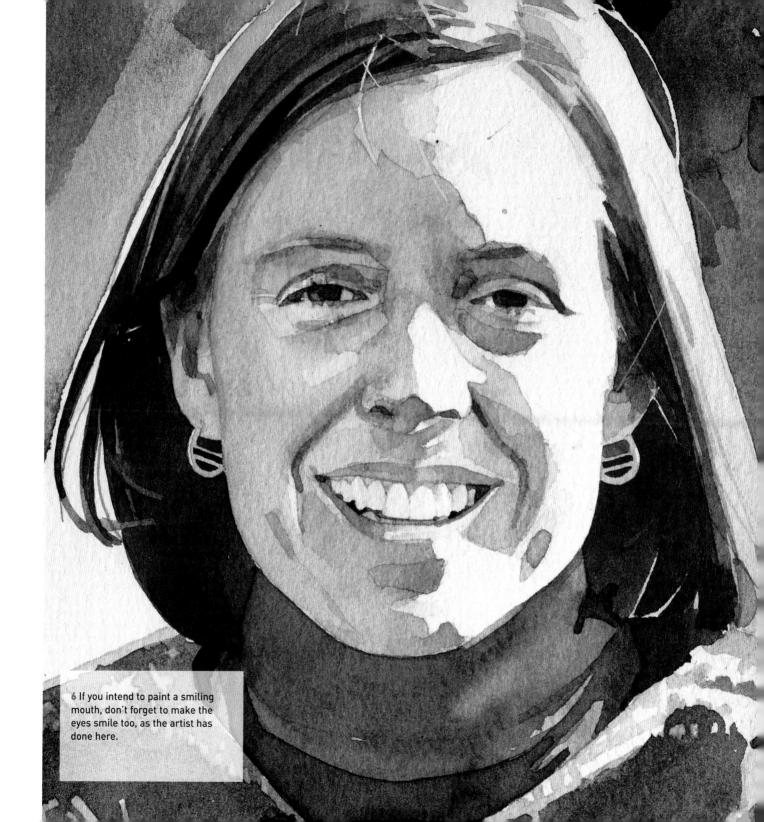

6 If you intend to paint a smiling mouth, don't forget to make the eyes smile too, as the artist has done here.

# FLESH TONES

IT IS POSSIBLE TO BUY TUBES OF
PIGMENT LABELED "FLESH TINT"
(INTENDED FOR CAUCASIAN SKIN), BUT,
IN FACT, THERE IS NO SUCH COLOR.

Human skin contains an infinite variety of
hues, and flesh tones vary in color from
person to person. In addition, skin is
affected by the quality of the prevailing light
and by the colors of nearby objects. And
yet, so often, one sees portraits in which
the skin of the unfortunate sitter looks
more like that of a porcelain doll than a
human being.

## PRACTICE AND OBSERVATION

The best way to practice painting flesh
tones is to make studies of your own hand
under different lighting conditions. At first
you may see pinks and reds only, but closer
observation will soon reveal touches of
yellow, gray, blue, brown, and even green.

To render flesh tones well, you must
discard all preconceived notions about the
color of flesh and paint what you actually
see. For example, you will notice how skin
looks lighter and warmer in the prominent,
light-struck parts than it does in the
receding or shadowy areas. In a painting,
warm colors appear to advance, while cool
colors appear to recede. By juxtaposing
warm and cool colors, the artist is able to
define the shape and volume of the face,
creating a visual "push-pull" sensation.

Thus, you will find cool blues and yellow-
grays used in the receding parts of the
face: the eye, under the chin, behind the
ear, and at the corners of the mouth.
Advancing parts, such as the forehead,
nose, chin, and cheeks, will contain more
warm reds and yellows.

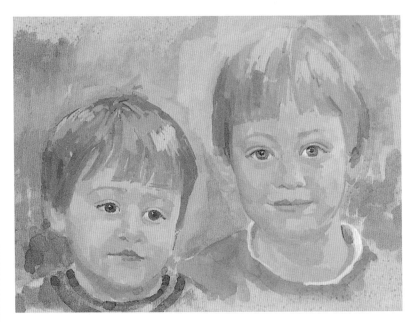

**FLESH TONES • GOUACHE**
The creaminess and opacity of gouache was well suited to the subject, because it can create
extremely fresh and pure color mixes. The painting was begun with paint diluted to a
watercolor consistency and drawn freely with a brush; the paint was gradually thickened as
the picture progresses. Although the artist has conveyed the smooth texture of the skin very
successfully, the treatment is quite vigorous.

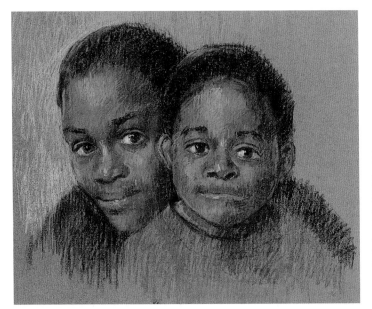

**FLESH TONES • PASTEL**
The paper chosen for this
portrait was dark, in
keeping with the overall
tonalities. This also had
the advantage of allowing
highlights to be added at
any stage, because they
could be immediately
assessed against the
paper. Colors were mixed
on the paper surface
by crosshatching.

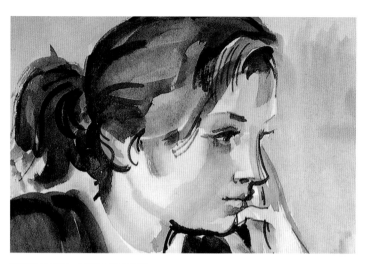

**FLESH TONES • LINE AND WASH**

This portrait study in watercolor and ink demonstrates how washes and lines can work beautifully in tandem to produce an image that is strong yet subtle. The artist has used bold calligraphic lines with brush and ink, which give definition to the profile and rhythm of the hair. The skin, in contrast, is rendered with soft washes of delicate color applied wet-in-wet. The resulting portrait has an immediacy and a lifelike quality that are special to the watercolor medium.

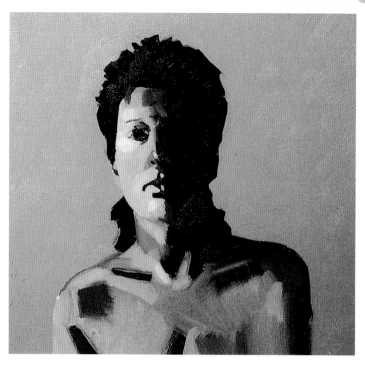

**FLESH TONES • OIL**

In complete contrast to the delicate transparency of watercolor, oil paints can be laid on with thick impasto to produce a heavily textured result. In this striking portrait, the artist worked alla prima, applying all the paint in the same stage and working wet-in-wet over a beige ground. The paint was applied rapidly in large blocks of color which describe the planes of the figure in a bold, uncompromising manner. The painting has an almost sculptural form, accentuated by the strong side light which throws the figure into distinct planes of light and shadow.

## THE PALETTES

Basically, the overall color of white flesh is comprised of various mixtures of the three primary colors—red, yellow, and blue. So the "core" of your palette should consist of six colors—a warm and a cool version of each of the three primaries. Bearing in mind that warm flesh tones tend toward yellow, and cool ones toward blue, a suggested palette might be as follows: cadmium red light or vermilion (warm); alizarin crimson (cool); cadmium yellow (warm); lemon yellow (cool); cobalt blue (warm); ultramarine (cool).

Of course, this is only a starting point. You will also need white (except in watercolor), some black, and touches of other colors, depending on the particular skin type of your sitter. Other useful colors include burnt sienna, burnt umber, yellow ocher, Venetian red, and viridian. For the pastellist, additional colors might include burnt umber, burnt sienna, yellow ocher, blue violet, gray blue and olive green.

There is no single, all-embracing formula for painting flesh tones, and almost every artist has his or her own favorite palette of colors. The combinations given here are intended only as suggestions. You are advised to try these out alongside other mixtures and decide for yourself which colors are best suited to your painting style.

## COLOR CLARITY

Some artists prefer a fairly restricted palette. But if you wish to use more colors, feel free to do so. The main rule is that not more than three or four colors should be used in any one mixture. Any more than this and the colors begin to cancel each other out and turn muddy.

Clarity of color is vitally important if you wish to convey delicate, translucent skin tones. Use a palette with a large mixing area which won't become clogged with color too quickly, and arrange your colors systematically.

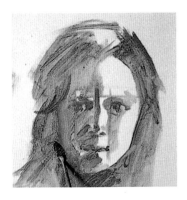

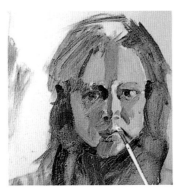

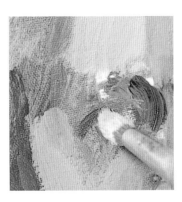

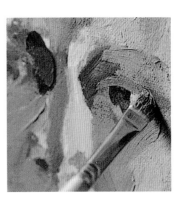

**FLESH TONES • OIL**
1 The artist starts the portrait with an underpainting of ultramarine oil paint, thinned with turpentine. The strong lights and darks of the model's face, created by shining a light onto it from one direction, can be portrayed easily with one color.

2 The warm flesh tones are laid on in a thick impasto. Their warmth is heightened by their contrast with the cool color of the underpainting.

3 A thin layer of color is scumbled over the impasto and, by blending with it, modifies the underlying color slightly to create an exciting effect.

4 In painting the eye, the artist brushes in only tone and color of the reflected light that he sees, rather than the form of an eye.

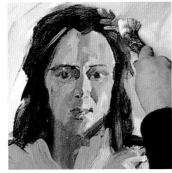

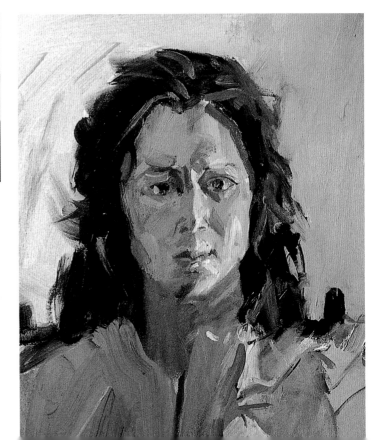

5 Using color only again, he paints the mouth, using light tones where the lower lip is struck by light and darker tones where the lips are in shadow.

6 With a decorator's brush, the artist applies white with touches of other colors for the background and the blouse. His scrubbing brushstrokes suggest the folds and ruffles of the blouse.

7 A sense of vitality comes across in the final painting, conveyed by the vigorous brushstrokes and the marvelous balance between the warm and cool tones.

## FLESH TONES • ACRYLIC

Because acrylic is such a versatile medium, many artists choose it over others for portraits and figure work. It is easy to make corrections and you have a wealth of different techniques at your disposal. You can work in any way that suits both your style and the subject.

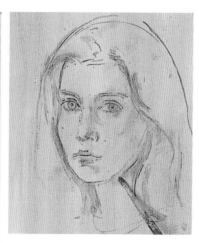

### WORKING ON A WARM GROUND

**1** To contrast with the overall cool colors and help them show up well, a warm ground color is used—a diluted sienna. The drawing is made with a blue-black mixture, and the artist begins to build up the forms immediately in tone.

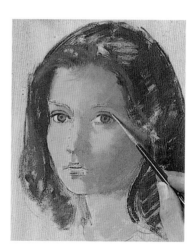

**2** The artist achieves a remarkably realistic mix for the skin colors. The hair is painted with mixtures of black and crimson with a little blue and yellow, giving a good impression of a natural red color.

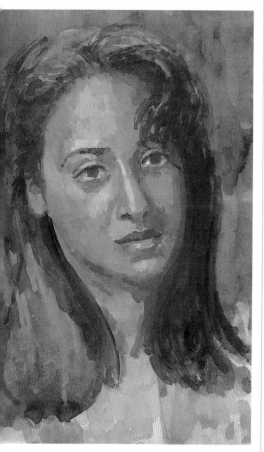

### ACRYLIC GLAZES

This painting has been built up gradually, first with layers of water-thinned paint and then with rich glazes that achieve a luminous effect.

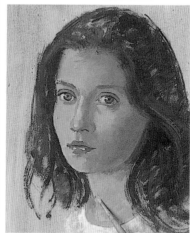

**3** Highlights were added in the final stages, when the tones and colors were well established.

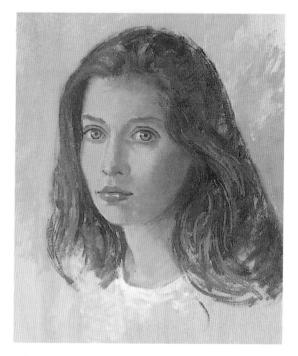

**4** The clothing is only lightly suggested, so that all attention is focused on the face.

## FLESH TONES • PASTEL

Pastel is the perfect medium with which to express the appealing sensitivity of a child's face. A pastel stick is easy to manipulate, allowing you to catch even the most fleeting expression. The fresh, clear colors are well suited to the delicate luminosity of a child's complexion.

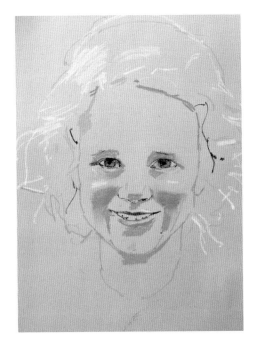

2 This detail shows the artist modeling the forehead with light, feathered strokes of madder brown, allowing the neutral undertone of the paper to shine through. Seen from the appropriate viewing distance, these tones blend together in the viewer's eye without losing any of their sparkle or freshness.

3 In contrast to the thinner skin on the forehead, the cheeks are plump and soft. Here the artist uses a torchon to blend the skin tones together, creating a smooth, velvety texture.

1 The artist begins by establishing the outline of the girl's face and hair, using hard pastels in shades of pink, brown, and yellow. The strokes are kept deliberately loose and sketchy, serving only as a guide to proportion and color. Next the artist begins to block in the eyes, nose, mouth, and cheeks, making sure that the proportions are correct and trying to get a feel for the girl's likeness. The broad, friendly grin of the child is an important feature of the portrait, so the artist makes sure the area around the cheeks and mouth is well established in the early stages.

4 Movement and texture in the hair are represented by scribbled strokes of cadmium lemon, lightly blended here and there with a torchon.

5 The portrait is now nearing completion, requiring only a few final white highlights to bring out the youthful shine on the child's skin. Here, the artist is using the sharpened point of a white pastel to flick in a highlight on the lower lip. Notice how the teeth are indicated with just a couple of strokes of white: the viewer visually "fills in" the rest of the teeth quite easily.

6 Finally, some background color is indicated with loose strokes of Hooker's green and cadmium yellow. This cool dark tone emphasizes the warmth and brightness of the skin tones.

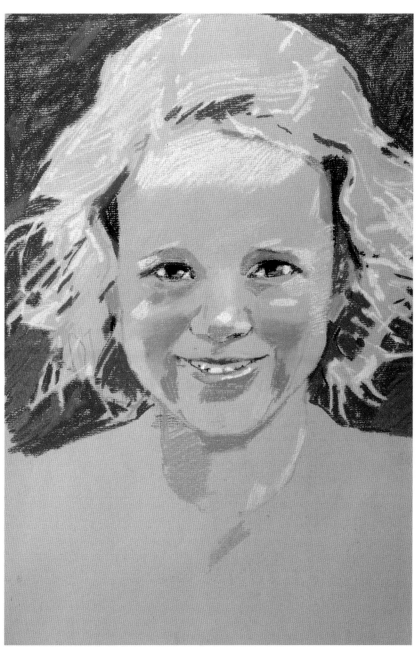

7 In this portrait, the artist has used strokes of pure color in a loose, sketchy style which perfectly complements the engaging warmth of the child's expression. The artist has chosen to work on a flesh-tinted Canson Mi-Teintes paper. The neutral color of the paper is used freely as an underlying tone, helping to emphasize the fresh colors of the child's face.

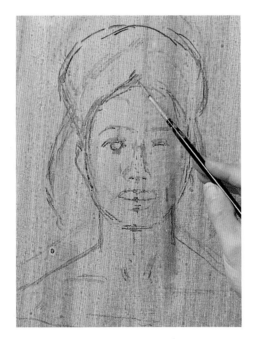

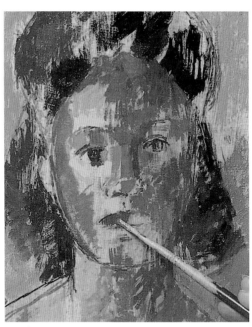

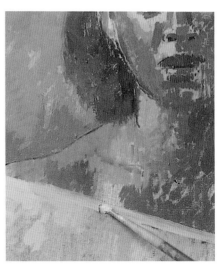

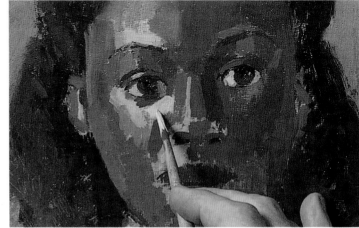

**3** The yellow dress is painted in before the rest of the picture becomes established.

## FLESH TONES • ACRYLIC

**1** The board has been given a relatively dark overall tone, in keeping with the subject, and the drawing is made with diluted burnt sienna.

**2** The artist works mainly in mid-toned color, but brings in one or two highlights so that they can get a feel for the contrasts.

**4** The junction of the forehead and hair is very indistinct because of the overall darkness of the tone, so the colors are gently blended by laying one over the other.

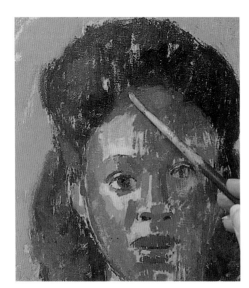

**5** The highlights around the eye socket are strengthened with thick, juicy paint, giving a feeling of solidity to the forms. The area of neutral, unpainted board beneath the other eye still works well.

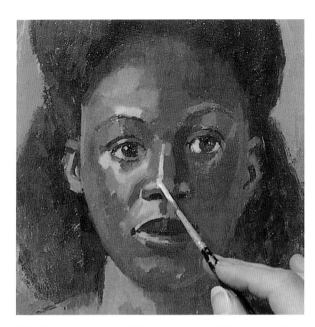

6 Moving from one area of the picture, the artist continues the process of refining the tones and colors. The highlight on the nose is first modified and then sharpened to achieve the strong contrast that defines the shape.

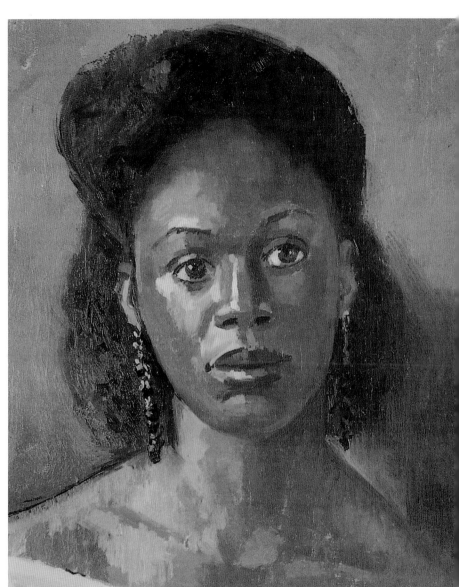

7 Some attention is now needed on the chest and neck to prevent this part of the painting from getting left behind. A dab of slightly lighter color describes the collarbone.

8 In the final painting you can see the importance of the other colors James Horton has chosen for the composition. The blue background and yellow dress provide a counterbalance to the rich skin colors.

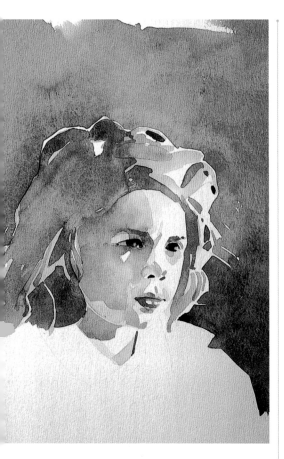

**FLESH TONES • WATERCOLOR**

When it comes to painting delicate skin tones, no other medium can quite match watercolor. In this portrait, the white of the paper plays a vital role in creating an impression of bright sunlight shining on the model's face. The essence of this technique is to use a limited palette of fresh, bright colors and to keep the shapes and color washes as simple and uncluttered as possible.

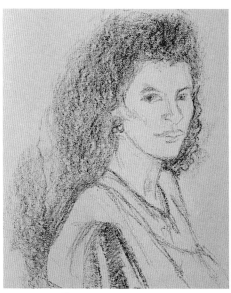

**FLESH TONES • PASTEL**

1 The artist begins with a charcoal drawing. Because the charcoal will mix with the overlaid pastel colors and darken them, the artist has only used shading for dark areas, such as the hair.

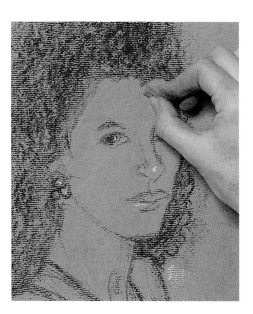

2 There is already enough indication of tone on the hair to assess the tonal values and color needed for the face. Light strokes are made with the side of the pastel stick.

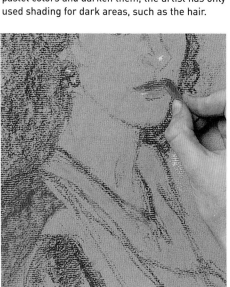

3 A broad stroke of crimson establishes the color of the model's wrap. The same crimson is now used for the lips, with the tip of the pastel stick employed to give precise definition.

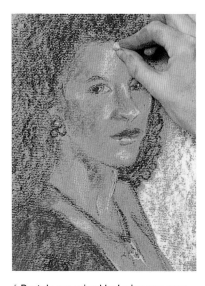

4 Pastels are mixed by laying one over another on the paper. A purplish red has been applied on the cheek and neck and highlights added with pale yellow.

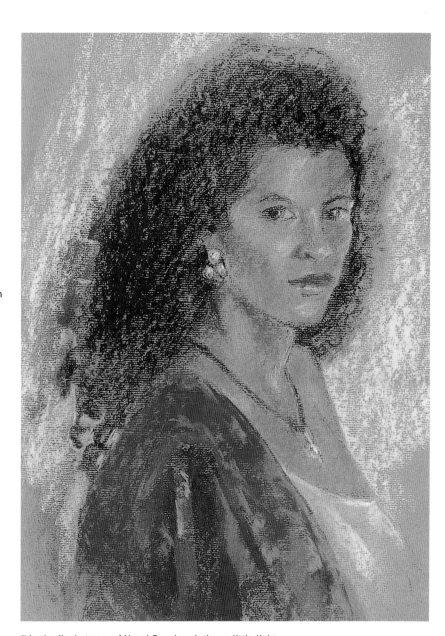

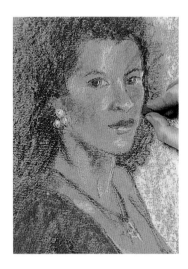

**5** To make the edge of the cheek and brow stand out more strongly, the artist adds black around the face. The stick is used on its edge, with a firm pressure that yields a crisp line.

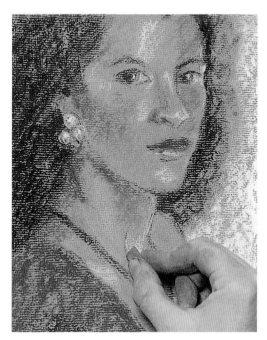

**6** There is always a danger of smudging pastel paintings as you work, so fine details are left until the end. Here a linear touch of mid-brown is applied.

**7** In the final stages of Hazel Soan's painting, a little light blending was done to soften the tonal gradations of the skin. Notice how the black of the hair has been applied lightly so that the gray paper shows through, suggesting small highlights.

# HAIR

THE AVERAGE HEAD CONTAINS AROUND 100,000 SEPARATE HAIRS, BUT, AS FAR AS THE ARTIST IS CONCERNED, HAIR SHOULD BE RENDERED AS ONE SOLID FORM, WITH PLANES OF LIGHT AND SHADOW.

The volume of the head is defined by the hair, so it is important to begin by defining the hair in terms of shape and mass before thinking about texture. Search out those areas that catch the light and those that are in shadow, describing them with broad washes of color. Having established the underlying form, indicate the direction of the hair growth: long, flowing strokes for long hair, short, scumbled strokes for curly hair. Again, think in terms of mass—don't paint individual strands.

To portray the essentially soft, pliant nature of hair, it is best to work wet-in-wet, so the edges between the hair and the face and the hair and the background flow into one another. One of the most common errors made by beginners is to make the hairline too hard. The hair and face should flow together as one entity; this is achieved by running some of the skin color into the hairline to soften the division between hair and face. Similarly, the outer edge of the hair should melt into the background color. Soft edges here will give an impression of air and atmosphere around the sitter.

The color of hair should also look soft and natural, and should not attract attention away from the face. Even if your sitter has raven black hair, do not paint it black. Hair picks up reflected color from its surroundings. Look for subtle hints of blue and brown in black hair, blond and red in brown hair, and brown, gold, and gray in blond hair.

**HAIR • WATERCOLOR**

**1** Working on a sheet of pre-stretched 200lb Bockingford paper, the artist begins by making a light outline sketch of the head in pencil. The facial tones are established first; this makes it easier to assess the relationship between the tones of the hair and the face. Notice how the artist has carefully worked around the thin strands of hair blowing across the face. Using a No. 2 sable brush, the artist now blocks in the overall shape of the hair with a dilute wash of yellow ocher.

**2** When the first wash is dry, a slightly stronger wash of yellow ocher and raw umber is brushed on, leaving a few strands of pale hair untouched.

**HAIR • ACRYLIC**
The fine, wispy hair of this baby was captured by Michael Warr using sgraffito; the dry paint was scratched back with a craft knife and then re-tinted with a very dilute color.

**3** With a still darker mixture of raw umber and yellow ocher, the artist begins to block in the middle tones of the hair, working around the highlighted areas. Here you can see how the patient build-up of transparent glazes, from light to dark, gives a fresh, translucent appearance to the skin and hair.

**4** With a mixture of raw umber, ivory black, and gum arabic, the artist now blocks in the dark tones and shadows within the hair, carefully working around the lighter strands.

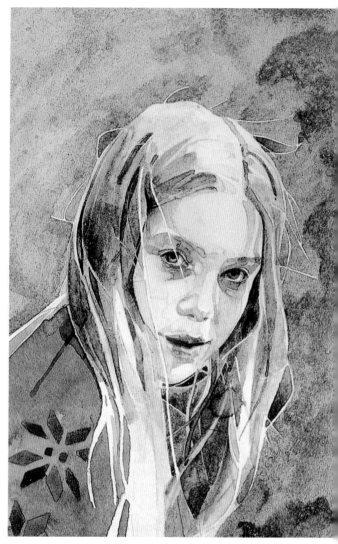

**5** When the hair is dry the background color is washed in, again working carefully around the loose strands of hair blowing around the head. The artist uses a mixture of sap green, ivory black, and gum arabic, working with loose strokes so as to create interesting tonal variations within the color.

**7** In this outdoor portrait, the artist achieves a lively impression of light and movement in the girl's hair. The essence of this technique is to keep the tonal masses strong and simple, allowing a few telling highlights to describe the movement in the hair.

**6** Finally, a few further highlights are created by lifting out color with the tip of a No. 2 sable brush dampened with clear water.

# SKIES AND CLOUDS

The sky is one of the most challenging and exhilarating subjects to paint. Indeed, many artists have made a special study of skies, among them two of the greatest landscape painters, John Constable and J.M.W. Turner. Throughout their lives, both artists made literally hundreds of studies, in oil and watercolor, which capture the sky in all its moods.

## ACHIEVING UNITY

In most landscapes and seascapes, it is the sky that determines the overall mood. In Constable's own words, "The sky is the source of light and governs everything." It is important to think of the sky as an integral part of the landscape, and not merely as a backdrop. Rather than painting the sky and the land separately, work continuously on all areas of the picture. This will make you more aware of how sky and land are integrated. On a sunny day, for instance, clouds cast shadows on the land, and, where there are gaps in the clouds, the fields below are sometimes lit as if by a spotlight. When details like this are overlooked, the finished painting lacks credibility.

Another way to achieve a sense of unity is to harmonize the colors used in the sky and the ground. Include touches of the blues used in the sky when mixing your shadow colors, for example, and hints of the reds, yellows, and ochers of the landscape in the darker clouds. It also helps if you begin with a colored ground of a very light gray or earth color; when small patches of this undercolor are allowed to "grin through" the overpainting, they serve to unify the scene.

## LEARNING SKIES

In order to paint skies convincingly, you need a working knowledge of the various cloud types and their characteristics. Take every opportunity to observe cloud patterns and fill your sketchbook with rapid, on-the-spot sketches. These sketches will help you to paint skies quickly and decisively. They are an important asset, because skies and clouds are constantly moving. In addition, they will form valuable reference material, which you can use in future paintings.

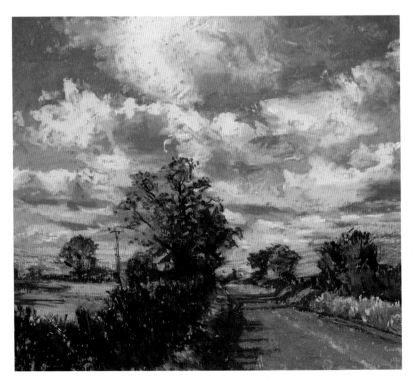

**THE HORIZON LINE • PASTEL**
When the sky is an important part of the painting, it makes sense to give it more space than the land beneath, and in Margaret Glass's pastel painting it occupies about two-thirds of the composition if you discount the tall tree reaching upward from land to sky. The pastel has been used thickly, with small highlights added as a final stage.

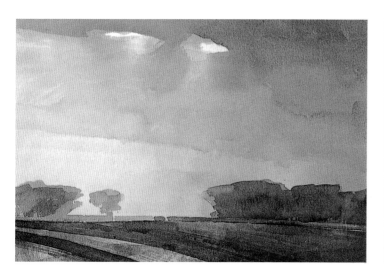

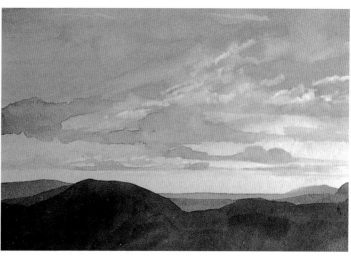

## CLOUD COMPOSITION • WATERCOLOR

In a landscape where the sky plays a dominant role, it is important to create a main center of interest within it—somewhere for the eye to focus on. In this watercolor, the center of interest is created by the breaks in the clouds near the top of the painting through which shafts of sunlight pour down on the landscape. The eye is drawn to this spot because it is here the lightest and darkest tones in the sky meet in dramatic opposition. To create the effect of the pale, misty shafts of sunlight, the artist lifted out the sky color with a soft, moist brush and gently blotted the area with a tissue.

## CLOUD PERSPECTIVE • WATERCOLOR

The laws of perspective apply to the sky just as much as they do to the landscape. On a cloudy day, you will notice that clouds seem to get smaller and closer together as they recede toward the horizon. They also become cooler and grayer in color, due to the presence of dust particles in the air. Taking note of these points will enable you to create an exciting impression of the vastness of the sky.

In this painting, notice how the tonal gradation from light to dark in the landscape is echoed in the sky. The warm background blue of the sky becomes a pale, cool tone close to the horizon, and the streaks of cloud appear thinner, paler, and closer together. To heighten the sense of deep space even further, the artist has introduced clouds subtly placed on the diagonal, near the top of the picture.

## CREATING ECHOES • ACRYLIC

An excellent method of unifying a landscape composition is to create echoes, either of shape or color, from sky to land. Here the rocks are quite softly treated and are less hard-edged than the clouds, yet have similar shapes to the clouds.

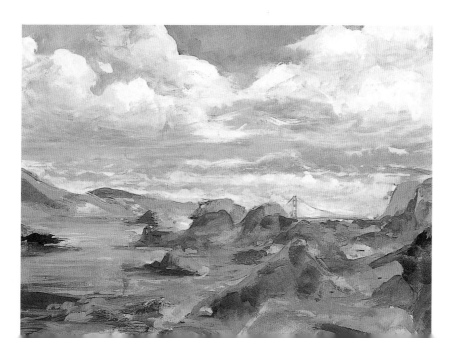

# CIRRUS CLOUDS

FEATHERY STREAKS OF WHITE CLOUD HIGH IN THE SKY ARE ASSOCIATED WITH HOT SUMMER DAYS. HANDLE THESE CLOUDS WITH RESTRAINT, BLENDING THEM SLIGHTLY INTO THE SKY COLOR SO THAT THEY DON'T APPEAR TO BE "PASTED ON." SCUMBLING AND DRYBRUSH ARE PERFECT TECHNIQUES FOR RENDERING THIS TYPE OF CLOUD.

**CIRRUS • OIL**
Oil paint is an excellent medium for rendering skies and atmospheric effects. If you are working outdoors, the drying time of oil paints can be reduced by mixing alkyd white or gel medium with your colors.

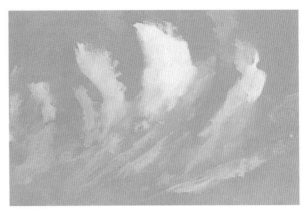

1 The artist begins by laying in the sky color with a mixture of cerulean blue and titanium white. When this is almost dry, the shapes of the cirrus clouds are blocked in roughly with a lighter version of the sky color, diluted to a thin consistency. Following the upward sweep of the clouds, the artist applies rapid drybrush strokes with a flat bristle brush. To create these semi-opaque veils of color, the artist keeps the brush starved of paint and works with a very light touch. The larger sunlit areas of cloud are then painted with titanium white, applied a little more thickly.

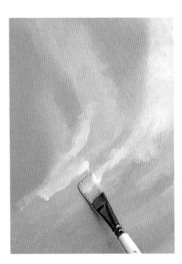

2 The artist now refines the shapes he has created. With a brush dipped in turpentine, he softens and blends the feathery clouds so that they merge with the sky tone to create a hazy appearance. Then the thicker, brighter areas of cloud are painted with opaque layers of titanium white.

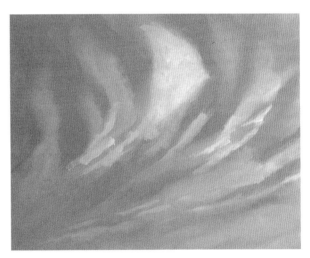

3 The completed study shows how softly blended passages create the effect of thin, vaporous clouds, whereas thicker strokes of color bring some clouds forward. The clouds appear as part of the sky, rather than painted on it. Cirrus clouds often have a powerful diagonal pattern which can be exploited to great effect in a painting.

# CUMULUS CLOUDS

THOSE HEAPED, WHITE CLOUDS THAT OFTEN HERALD RAIN ARE CALLED CUMULUS. SUCH CLOUDS ARE WONDERFUL TO LOOK AT, AND MUCH CAN BE LEARNED BY OBSERVING THEM CLOSELY AND MAKING SKETCHES BEFORE ATTEMPTING TO PAINT THEM.

Cumulus cloud formations are usually well defined, with distinct planes of light and shadow. During the day, the upper part of the cloud is bright and luminous, with a definite scalloped edge, whereas the underside is flatter and darker. At sunset, the clouds are lit from below, so they glow underneath while being dark on top.

The three-dimensional appearance of clouds can be emphasized by modeling them with warm and cool colors. The lit planes of clouds are rarely a stark white; they may contain subtle hints of yellow, pink, and blue, depending on the weather and the time of day. Similarly, the shadows on clouds are not battleship gray, but contain a variety of blues, reds, browns, and violets.

Pay careful attention to the edges of the clouds, making sure that they appear to blend naturally into the atmosphere. This can be achieved by blending wet-in-wet, or by scumbling the cloud colors over the sky color so they melt softly together. Do, however, include a few hard edges for definition; otherwise the clouds tend to look like balls of absorbent cotton.

Another important point to remember is that the laws of perspective apply to clouds just as they do to landscapes. Clouds appear to become smaller and closer together as they disappear toward the horizon; they also become cooler and more neutral in color, and their forms soften.

## CUMULUS • PASTEL

Soft pastels are excellent for making quick sketches of fleeting cloud effects, thanks to their speed and readiness of handling. They also come in a wide range of delicate colors which need no pre-mixing. In addition, tinted pastel paper serves as a useful middle tone; only the shadows and highlights are needed to create a full range of tones.

SEE ALSO

WET-IN-WET, pages 52-53
SCUMBLING, page 69

1 For this rapid study of rain clouds, the artist works on a dark-toned paper which provides a suitable undertone. The sky tone is blocked in first with cobalt blue. Next the clouds are rendered in white, leaving the dark paper showing through in places.

2 The sky area is blended with a soft rag to set the color, then some of the sky color is blended roughly into the clouds.

3 Streaks of cadmium yellow are drawn into the undersides of the clouds and blended with the fingertips to create a hazy effect.

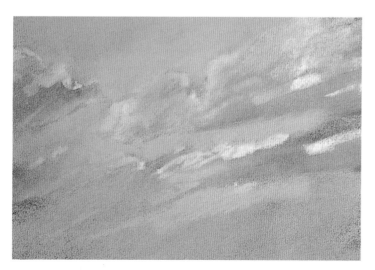

4 The sunlit areas of the clouds are now highlighted with thick strokes of white, and the sketch is complete. Positive marks contrast with softer passages in this picture to create a feeling of movement and light.

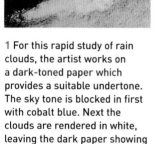

**CUMULUS • OIL**
This close-up shows the subtle range of hues found in "white" clouds. The sky contains delicate hints of mauve, while the clouds are modeled with colorful grays mixed from pale blues, reds, and yellows.

**CUMULUS • WATERCOLOR**
Cloud shapes can change very quickly; the fluidity of watercolor allows you to work with great spontaneity and achieve delightful, rapid effects.

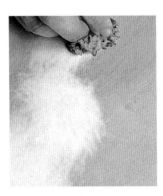

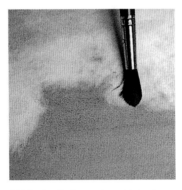

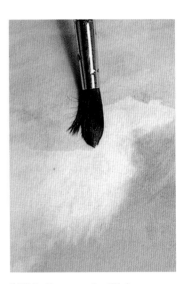

**1** The artist works on a stretched sheet of 200lb Bockingford paper, dampened with a sponge and clear water. He first lays a flat wash of cobalt blue for the sky, using a No. 8 Dalon brush. While the wash is still wet, a small natural sponge is used to lift out the cloud shapes.

**2** This detail shows the artist using a soft round brush to make scumbled strokes at the edges of the clouds, giving a soft, ragged effect.

**3** While the paper is still damp, a pale wash of Payne's gray and cadmium yellow is brushed into the lower, shadowed edge of the cloud, then softened and blended with clear water. The brush is rolled over the surface of the paper, suggesting the rhythm of the clouds and their heaped texture. When mixing the shadow color, remember that it will dry much lighter in tone than when wet. Only the brightest, sunlit tops of the clouds are left as bare white paper.

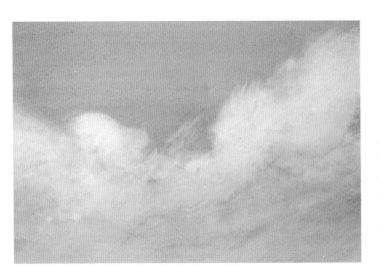

**4** The finished effect. The upper part of the cloud is brighter and better defined than the lower part, which is darker and more ragged. The combination of warm and cool colors gives a rounded, three-dimensional feel to the clouds. Note how the smaller clouds beneath give a suggestion of depth and perspective and how the light scumbled strokes convey a sense of movement.

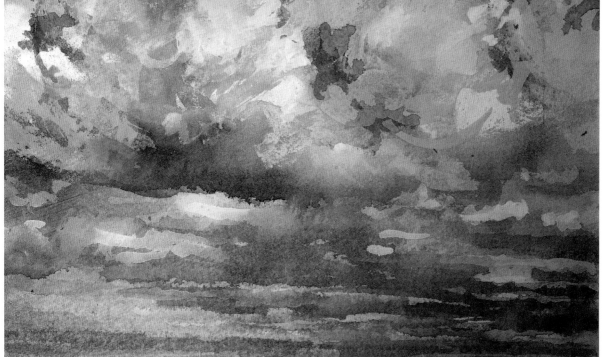

**DIRECTIONAL STROKES**
In this painting the artist uses vigorous diagonal and horizontal strokes to reflect the violent movement of the clouds as they are pushed by the wind. The impact of the clouds rushing toward us is accentuated by the strong perspective, which gives further depth to the scene.

## STORM CLOUDS • WATERCOLOR

For maximum dramatic effect, a stormy sky should take up roughly two-thirds of the picture space, with the land occupying the lower third. This allows you to give full rein to the swirling shapes of the clouds, which should be painted progressively smaller toward the horizon to heighten the feeling of tension.

Storm clouds give the artist plenty of scope for creative interpretation. Use a large brush, work wet-in-wet, letting your brushstrokes follow the sweep of the windblown clouds. Model the cloudforms with warm and cool grays mixed from various blues, yellows, and earth colors—not black and white.

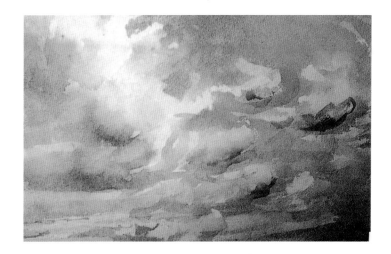

## FAST-MOVING CLOUDS • WATERCOLOR

A fluid, expressive medium such as watercolor is invaluable for making on-the-spot cloud studies, particularly on a breezy day when the clouds are moving fast. It is impossible to paint moving clouds with great accuracy, but that doesn't matter. The important thing is to use expressive brushstrokes which follow the clouds' movements and gestures.

**LOOSE STROKES**
The artist brushed the distinctive shapes and tones of these cumulus clouds as quickly as possible with loose, curving strokes. With watercolor you can push the color around while it is still wet, flooding the paint in and lifting it out until you achieve the desired effect.

# SUNSETS

WHEN PAINTING SUNSETS AND SUNRISES, THE MOST COMMON MISTAKE IS TO PILE ON TOO MANY PINKS, ORANGES, AND REDS. THIS ONLY RESULTS IN THE CLICHÉD IMAGE OFTEN FOUND ON CHEAP POSTCARDS. THE SECRET OF SUCCESS IS TO USE YOUR HOT COLORS SPARINGLY. INTERWOVEN WITH THE COOL BLUES, GRAYS, AND VIOLETS IN THE REST OF THE SKY, OFFSET BY A SHADOWY LANDSCAPE, THE WARM HUES WILL TAKE ON A SUBTLE, TRANSLUCENT GLOW.

Be sparing with your colors, and don't try to use too many. Also, exercise restraint with your brushwork. The temptation is to put in every tiny variation, and this may result in a fussy and overworked painting. With either oils or watercolors, try working wet-in-wet so that the colors blend gently, and with pastels lay one color lightly over another.

Look for the best effects, and take photos if you need to. A cloudy sky at sunset is particularly striking. Because the sun is lower than the clouds, the undersides of the clouds are brilliantly lit while their tops are thrown into shadow. For the same reason, the brightest clouds are low in the sky, becoming darker farther away from the sun.

**SUNSET • MIXED MEDIA**
In this Turner-esque sky study, the artist has used watercolor and gouache—the former for its transparency and the latter for its brilliance of color. The background sky colors were brushed in wet-in-wet with watercolor, after which small strokes and dabs of opaque gouache were touched in for the clouds and allowed to blend softly into the still-damp colors beneath. The appearance of bright, luminous color was achieved by layering warm yellows, oranges, and pinks with cool blues and grays which, by contrast, accentuate the warm colors.

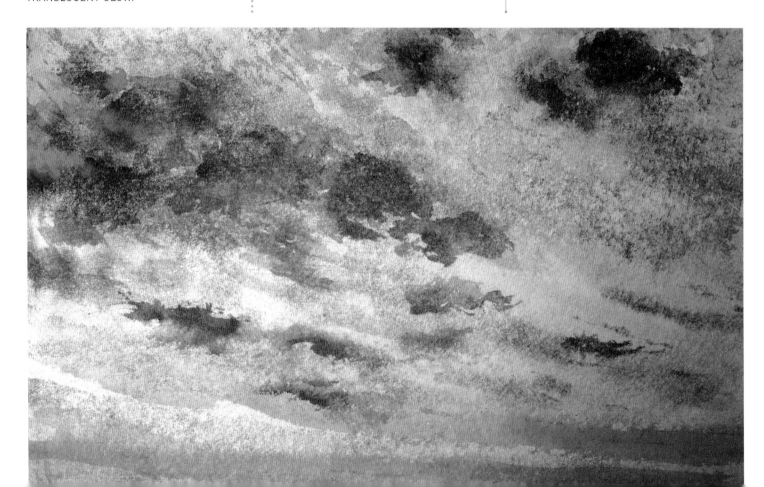

## SUNSET • WATERCOLOR

1 In this painting, the artist has used watercolor washes to describe the glowing, translucent quality of the sky at the point just before the sun sinks below the horizon. The dark silhouette of the landscape and trees helps to heighten the warm glow of the sky's colors. He began by establishing the position of the horizon and the setting sun with very light pencil marks. He then used masking fluid to block out the shape of the sun before painting the sky.

When the masking fluid had dried, he dampened the paper and painted a variegated wash of first ultramarine, then lemon yellow, and finally a mixture of alizarin crimson and lemon yellow near the horizon. When the sky wash was completely dry, he brushed in a loose wash of ivory black for the foreground, lifting out color here and there to create texture and tonal variety. Using the tip of a No. 2 brush, he then painted the delicate silhouettes of the trees against the sky.

2 This detail shows how the artist achieved the glowing effect of the sun sinking behind trees. When the painting was dry, the artist rubbed off the masking fluid from the sun, revealing a circle of untouched white paper. He then painted the outer rim of the sun with cadmium yellow, making the color paler toward the middle and leaving the center as white paper. After this, dry calligraphic strokes of cadmium red and orange were used to describe the delicate tracery of branches against the sun.

# STILL LIFE

Unlike landscape and figure painting, still life allows the artist to be in complete control. You have a virtually limitless choice of subject matter to begin with, and provided you can set up your arrangement where it won't be disturbed, you can spend as much time as you like on composing the arrangement and getting the lighting right.

**SIMPLICITY**
Still life can be as complex or simple as you choose. The Dutch still lifes of the seventeenth and eighteenth centuries were laden with luscious objects, from silver and flowers to the spoils of the hunt, but Spanish still lifes often simply featured one or two fruits or vegetables. This artist works very much in the latter tradition, making a meaningful statement from nothing more than two pears.

When setting up a still life arrangement, don't be tempted to include too much. A simple, carefully organized group will have far more impact than a motley assortment of objects in ill-matched colors. Choose just a few objects that you find visually pleasing and that have something in common: a collection of kitchen crockery with some vegetables, fruit, and bread, for example. Above all, look for a variety of shapes, forms, colors, and textures. Your choice of background is important, too. Generally, a fairly neutral color is best because it helps to throw the subject forward in the picture plane. But if the overall tone of the group is light, then use a contrasting dark color for the background.

Having chosen your objects, the next step is to arrange them in a pleasing and harmonious way. Cézanne spent many hours on making his arrangements, and it is worthwhile taking the same time. Try to place objects so that some of them overlap, forming connections that lead the eye naturally into and around the whole composition.

## LIGHTING
Another aspect that should be carefully considered is lighting. The way in which light moves through the picture helps to give it a feeling of depth and three-dimensional space. A single source of light, preferably coming from the side, creates a clear pattern of lights and darks that help to explain forms. In addition, the light casts shadows, the shapes of which serve to link up and unify the elements in the group.

Whether you choose natural daylight or artificial light is a matter of preference. Daylight will give you more realistic colors than artificial light, but it is constantly changing. Artificial light is constant, but does tend to affect the colors of objects, giving them a slightly yellow cast. Artificial light also gives you the advantage of being able to alter its position or make the light hard or soft, depending on your requirements.

# FLOWERS

WHEN PAINTING FLOWERS IN A STILL LIFE ARRANGEMENT, DO NOT GO FOR PHOTOGRAPHIC REALISM. TRY TO CAPTURE THE ESSENTIAL CHARACTERISTICS OF THE VARIOUS BLOOMS: THE RICH, VELVETY TEXTURE OF ROSES, THE SIMPLE, CLASSICAL GRACE OF TULIPS, AND THE INTENSE COLORS OF ANEMONES.

Because flowers are so lovely to look at, it is hard to restrain the urge to paint every detail lovingly. This is a dangerous trap to fall into, because the resultant painting begins to look like a botanical study. Your concern, as an artist, is to create a living picture and to convey an impression of depth, mystery, and transience, emphasizing the subtle effects of light on the subject. Detailed over-emphasis of every leaf, bud, and blossom leads to confusion, making the flowers look hard and brittle instead of soft and graceful. In addition, the three-dimensional appearance of the image is lost.

When we look at a profusion of flowers, our eyes can only focus on one area at a time; the outer edges of our vision are comparatively blurred. Aim to convey this effect in your painting through the interplay of hard and soft edges, bright and muted colors, and dark and light tones. Observe the group carefully and pick out the one or two flowers that receive the most light and emphasize these with bright, clear colors and crisp edges. Allow the rest of the flowers to fade gradually into the background by softening their edges and muting their colors, particularly in those that are near the back of the group. These soft colors and tones make the bright spots appear even more vibrant by contrast. In addition, the flower group will have a feeling of roundness and three-dimensionality, rather than appearing as a flat pattern.

## ARRANGEMENT AND COMPOSITION

When arranging flowers in a still life painting, remember that they should look fresh and natural. Keep the arrangement natural and avoid symmetry. Formal and stylized floral arrangements do have their place but not in a painting. Somehow, they strike a false note. A simple, even haphazard, grouping looks more natural and spontaneous.

A well-thought-out composition is important. Arrange the blooms so that they overlap each other and face in different directions. Include profile views of flowers and add variety by introducing some flowers in the bud stage.

Greenery is important, too, in enhancing the colors of the blooms and providing dark, shadowy tones that give a three-dimensional feel.

Unless you specifically want the container that holds the flowers to be an integral part of the still life arrangement, it is best to underplay it by partially obscuring it with overhanging blooms and foliage. If the vase is on display, it should complement the flowers in color, shape, and pattern. Ideally, it should contrast tonally with the overall color of the flowers, and be smaller in size than the floral arrangement.

## FLOWERS • ACRYLIC

Tulips make an excellent painting subject, because their simple forms are rendered easily in terms of light and dark tones. Here the artist uses acrylic paint, which can be applied to the canvas like oil paint but dries much more quickly, allowing layers of color to be built up one on top of the other.

**1** This picture shows how the artist has outlined the main elements of the composition with blocks of flat color. The neutral grays and blacks of the background are painted first, and allowed to dry. Then the vase is painted with a dark mixture of ultramarine, cobalt blue, and ivory black, with touches of ultramarine and titanium white for the highlights. The stems and leaves are painted in three tones of green, mixed from chromium oxide, ultramarine, and white. Finally the tulip heads are painted in various tones of yellow, mixed from cadmium yellow pale, yellow oxide, and titanium white. The paint is well diluted with medium, and the flowers are developed from light to dark, each tone being completed in flat patches of color.

*SEQUENCE CONTINUED OVERLEAF* ▶

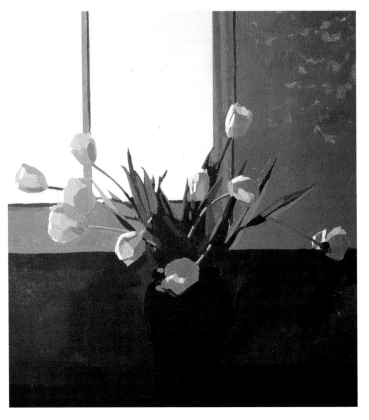

2 This close-up shows how the clear "blocks" of color and tone create a sense of three-dimensional form and establish the direction of the light source. With the main shapes and tones in place, the artist now begins to add the bright highlights that make the picture "sing."

3 The lightest tones in the leaves and stems are painted with chromium oxide, titanium white, and a touch of cadmium yellow pale, and the warm, bright highlights on the flowers are painted with cadmium yellow pale and white.

Notice how the artist has paid careful attention to the composition of this picture. The background is divided into the straight geometric shapes of the wall and window, which provide a contrasting setting for the organic forms of the flowers. The cool, neutral color of the background also helps to emphasize the brilliant yellows of the flowers. The window provides a strong light source, from above and slightly to the right, which creates interesting patterns of light and shadow on the flowers and highlights the luminosity and transparency of the flowers.

## FLOWERS • DIFFERENT APPROACHES

There are many different ways of starting a painting; three of the most useful ones are demonstrated here.

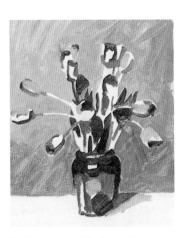

Having sketched in the outline, use a neutral tone to fill in the areas of dark and light before adding any color.

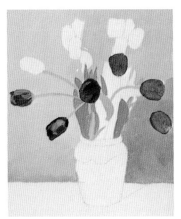

Simplify the colors in the subject so that you use three basic tones in each pigment. Here you can see that the tulips were painted in a light, medium, and dark red.

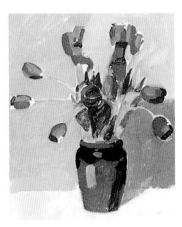

Begin by filling in the main areas of local color, leaving the finer details until later.

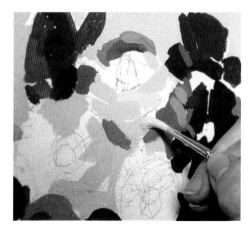

**FLOWERS • OIL**

**1** The artist began painting with two layers of acrylic and then developed the subject further in oils. To begin, the basic tones of the flowers were blocked in, and then the details were added. The paint is thicker on the flowers because more work was involved. Remember to begin by painting thin layers. If the first layer is too thick it will be difficult to add subsequent layers because they will take a long time to dry.

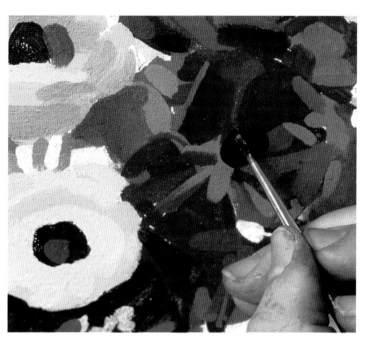

**2** Here the artist is adding the details of the petals. With diluted white paint he paints the design on the vase.

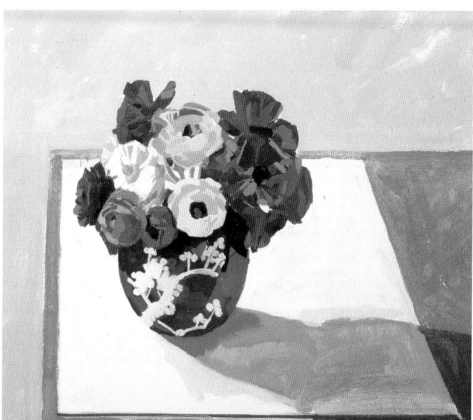

**3** The artist continues to work on the flowers, defining and redefining the different forms. The whole composition is unified by means of the overlapping layers of color.

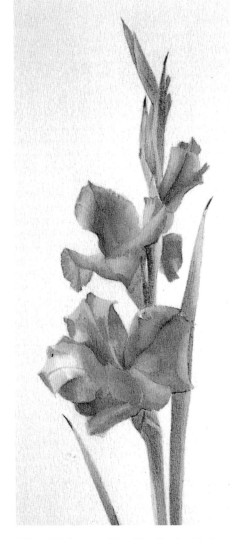

## FLOWERS • WATERCOLOR

**1** After a pale lemon yellow wash has been laid on the petals, a stronger yellow wash is added to the flower centers. Because the first wash is not completely dry, the yellow bleeds outward and into the petals.

**2** Always mix watercolor in a white palette so that you can judge the true color before using it.

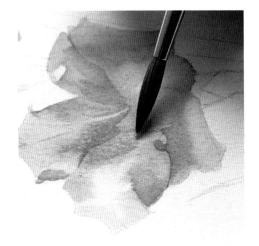

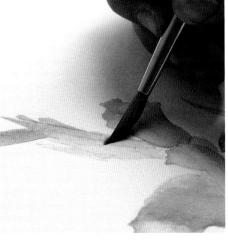

**3** Building up washes in watercolor requires skill. The most successful way is to allow the first wash to dry slightly, and then add the second; the two colors should then blend. If you let the first wash dry completely, you will be left with hard edges; if you apply the paint wet-into-wet, you don't have as much control over the result.

**4** The artist laid a wash of olive green on the leaves and stem, and then added Hooker's green to the dark areas.

**5** Fine details are put in with a No. 6 sable brush once the washes are absolutely dry.

   The finished picture is exceptionally delicate in tone and texture. The artist used a No. 5 sable for all the work and limited his palette to four pigments.

# FRUIT AND VEGETABLES

FRUITS AND VEGETABLES ARE ALWAYS POPULAR IN STILL LIFE ARRANGEMENTS. NOT ONLY DO THEY HAVE FASCINATING SURFACE TEXTURES, BUT THEIR COLORS AND SHAPES CAN ALSO BE ALL-IMPORTANT IN LENDING BALANCE TO THE COMPOSITION.

For example, a painting that is light in tone overall can be given just the right amount of contrast by the addition of a bunch of black grapes. Alternatively, dramatic chiaroscuro effects can be achieved by introducing pale, luminous green grapes or pieces of lemon into a dark painting. As with flowers, fruits and vegetables look best when they are not forced into a rigid arrangement. Try to place them so that they appear to have just spilled out of a basket, and introduce variety by including pieces of cut fruit or vegetables, such as onions and cabbages chopped in half to reveal their inner patterns.

Beginners often make the mistake of rendering shadows by adding black to make a darker version of the local color of the object. In fact, colors become cooler as they turn into shadow, and contain elements of their complementary color. For example, the shadow side of an orange will contain a hint of its complementary color, blue. In addition, shadows often contain subtle nuances of reflected light picked up from nearby objects.

Highlights, too, are worth close scrutiny. Even the brightest highlight on a shiny apple is rarely pure white. If the prevailing light is cool, the highlight might contain a hint of blue; if the light is warm, the highlight may have a faint tinge of yellow. By paying attention to such details, you will give your paintings a greater feeling of light and form.

## APPLES • WATERCOLOR

Here is another simple watercolor study in which the artist uses transparent washes and glazes to model the form of the apples and bring out their luscious texture.

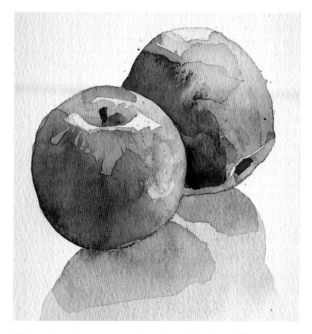

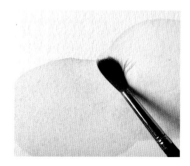

**1** With a mixture of sap green and cadmium yellow, the artist blocks in the overall shapes of the apples on damp paper. This is allowed to dry before moving on to the next stage.

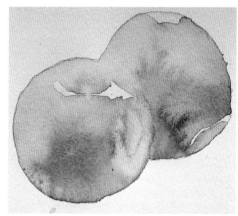

**2** Working wet-in-wet, the artist brushes in mixtures of sap green and brown madder alizarin to build up form and color, leaving small areas of the pale underwash to create highlights.

**3** The reds and greens are strengthened further with transparent glazes, and the artist follows the contours of the apples with his brushstrokes. In places the color dries with a hard edge. This gives the impression of the crisply modeled form of an apple. When the apples are complete, the stalks are painted with raw sienna and a touch of ultramarine.

Finally, the cast shadows of the apples are painted with washes and glazes of indigo and purple madder alizarin. A clean damp brush is used to soften the shadows.

## LEMONS • WATERCOLOR

A still life set-up does not have to be elaborate. Try making a simple study of fruits that have attracted you because of their shape, color, or texture, as the artist has done here.

2 Using a round No. 4 brush, the artist paints the lemons with a diluted wash of cadmium yellow; this color should be mixed to quite a strong tone, because it dries much paler. The waxed areas resist most of the paint, which settles into the dents of the paper's surface. When dry, the result is a texture which resembles the pitted texture of lemon skin. Notice how the artist has chosen not to use a pencil outline, which would show through the pale color of the fruit and spoil the delicacy of the finished effect.

1 Working on a sheet of 140lb cold pressed paper, the artist begins by rubbing the highlighted areas of the lemons with a wax candle. This is done lightly, so that the wax settles on the high points only of the paper.

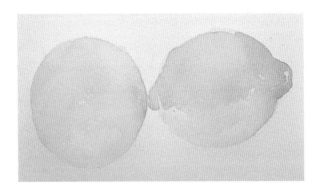

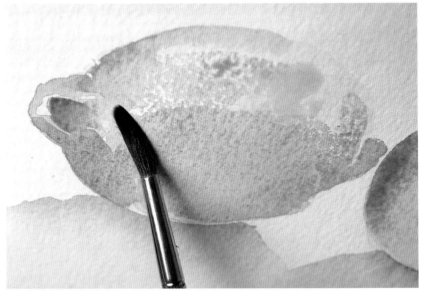

3 When the first wash is dry, the artist applies the middle tones with a wash of cadmium yellow, cadmium orange, and a touch of ivory black, leaving the highlighted areas pale. The middle color tone is applied loosely and blotted lightly in places with a tissue to give an interesting variety of tone and texture.

4 A little more cadmium orange and ivory black is added to the middle tone mixture and used to block in the darkest tones.

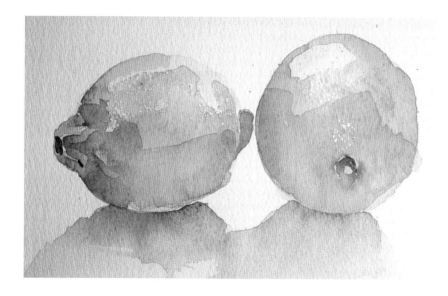

**5** The cast shadows are painted with washes and glazes of Payne's gray and indigo. Notice how the shadows are darker and sharper close to the subject, becoming paler and more diffused as they move outward. This is achieved by fading out the color with a clean damp brush.

The finished painting has a clarity and freshness that is entirely appropriate to the subject. The wax resist technique has perfectly created the texture of the lemon skins, which would be very difficult to achieve by any other means.

## MELON • PASTEL

In some cases, a far more interesting result is achieved by cutting a fruit or a vegetable into segments to reveal the fascinating textures and patterns of the flesh and seeds inside. The artist uses pastel and graphite pencil in this study of a cut segment of melon.

**3** This close-up shows the artist using a graphite pencil to create dark accents around the melon pips.

**1** Working on a smooth paper, the artist blocks in the overall shape of the melon using lizard green, lemon yellow, and cadmium red. The colors are applied thickly and blended quite smoothly.

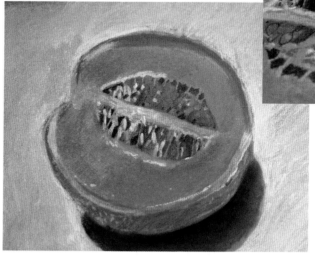

**2** Next, the colors of the flesh and skin are consolidated with light scumbles of color to bring out the three-dimensional form, and the cast shadow is strengthened with lizard green and black. Then the artist uses orange, red, white, and yellow pastels, sharpened to a point, to indicate the melon seeds.

## ONIONS • ACRYLIC

Onions, with their glowing colors and papery-textured skins, are a favorite element of still life paintings.

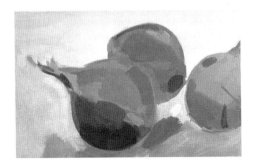

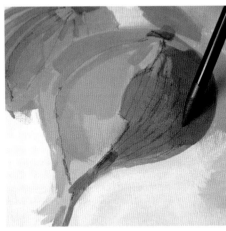

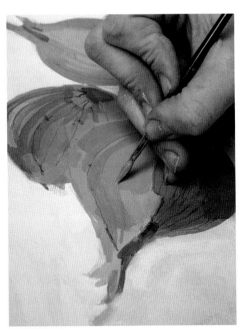

1 Working on a fine canvas board, the artist begins to render the form of the onions with simple blocks of color. The colors used are raw umber, naphthol red, yellow ocher, and titanium white. More raw umber is used for the dark tones, and more titanium white is used for the light tones.

2 When the colors are dry, the artist uses a graphite pencil to draw in the dark veins of the onion skins, which also emphasizes the bulbous forms of the onions.

3 With a No. 4 sable brush, the artist now paints in the green parts of the onions with a mix of chromium oxide green and titanium white.

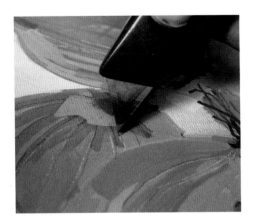

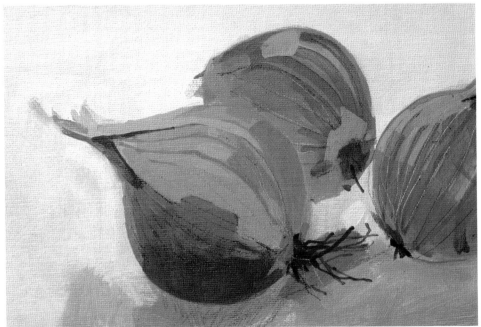

4 When the painting is dry, the artist uses a sharp craft knife to scratch out a few silvery lines in the onion skins.

5 Finally, a few dark accents are added with raw umber and ivory black.

# GLASS OBJECTS

CLEAR GLASS TAKES ON THE COLORS OF OBJECTS SURROUNDING IT. WHEN PAINTING GLASS VASES, BOTTLES, OR OTHER REFLECTIVE OBJECTS IN A STILL LIFE, ALWAYS INDICATE THE BACKGROUND COLORS FIRST, BEING CAREFUL TO RECORD ANY DISTORTIONS OF SHAPE REFLECTED IN THE OBJECT. THE GLASS OBJECT CAN THEN BE PAINTED OVER THE BACKGROUND.

When painting glass, take time to observe the subtle tonal variations between the highlights, middle tones and shadows, their colors, and their shapes, which follow the form of the glass object. Then record them faithfully, but not too mechanically. Painting clear glass is much like painting water; less detail says more. Under certain lighting conditions, a clear bottle or glass will contain myriads of reflections and highlights, but painting them all would detract from the transparent appearance of the subject. Paint only those tones and highlights that matter, and keep your lines sharp and crisp, with a minimal blending and refinements.

On the subject of highlights, remember that it is very rare to find a highlight that is pure white: always modify your white paint with a hint of the local color of the object that is reflected.

## GLASS • ACRYLIC

**1** Because glass is clear, the artist must begin with the background tones, rather than painting the object and background together. The artist uses ivory black and titanium white with a touch of cobalt blue for the background, varying the tones by adding more white in the lower section of the canvas.

Next, he draws in the shape of the glass clearly but lightly, using a light mixture of ultramarine painted with a No. 2 sable brush. The lines and the ellipse of the mouth of the glass must be accurate.

The dark, middle, and light tones of the glass are blocked in next, keeping some edges crisp and others soft. The colors used are cobalt blue, titanium white, and Payne's gray. It is important not to overwork this stage; just a hint of tone is all that is required to separate the glass from the background.

**2** The next step is to add small touches of highlight, which make the glass appear to sparkle. Using a No. 6 sable brush, the artist picks up a small amount of titanium white and paints vertical lines down the side of the glass as well as on the rim. These are the brightest highlights. The lesser highlights are painted with mixtures of titanium white and raw umber in brushstrokes that follow the curves of the glass and stem.

**3** The artist adds a cast shadow to the background tone with a mixture of titanium white and ivory black. The feeling of transparency in the glass is achieved by keeping the details strong and simple, while allowing just a few shimmering highlights to tell the story.

# EARTHENWARE

EARTHENWARE BOWLS, JUGS, AND VASES OFTEN COME IN DELIGHTFUL SHAPES AND LEND GRACE TO ANY STILL LIFE PAINTING. AS WITH GLASS, PAINTING GLAZED EARTHENWARE IS A MATTER OF RECORDING TONAL VARIATIONS AND KNOWING HOW TO RENDER DISCREET HIGHLIGHTS.

Unglazed earthenware pots are equally attractive, their warm terracotta color blending harmoniously with any plants and flowers included in the still life.

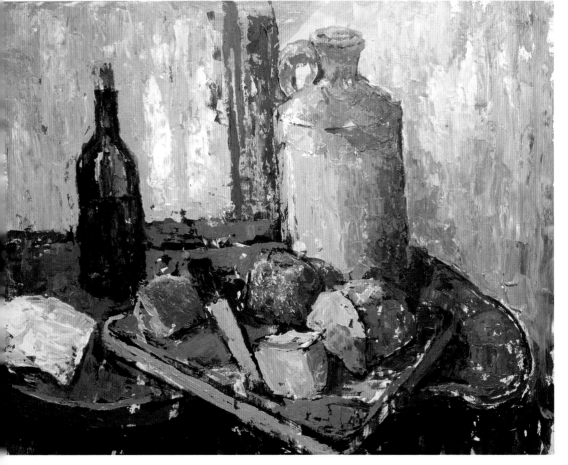

### EARTHENWARE • ACRYLIC

**1** In this painting the artist decided to re-use an old canvas and painted over it by laying in the main colors with a painting knife. This method of application creates a rough texture in the paint, reminiscent of earthenware.

**2** The paint was laid on thickly with brown and sap green scraped over yellow ocher for the shaded part of the jug.

**3** The unfinished roughness of the painting provides wonderful textures, which are ideal for such subject matter.

## EARTHENWARE • OIL

The smooth, glossy finish of glazed earthenware and shiny metal gives tones that graduate from light to dark with very subtle changes. The artist chose to use oil paint for this study of earthenware pots: the creamy consistency and slow drying time of oils allow you to manipulate the paint on the surface as much as you like in order to achieve smooth gradations of tone. However, it is best to avoid overblending, because this creates a somewhat static effect. Notice how the artist has used lively brushwork to animate the picture's surface here, without losing the illusion of roundness of form.

1 This detail shows the artist painting the mouth of the large pot with a mixture of burnt umber and ivory black. The paint is kept thin with a subtle variety of tone, so the shadow appears luminous and full of reflected light.

2 Here the lightest tone is applied in a thicker impasto which makes the bright highlight stand out.

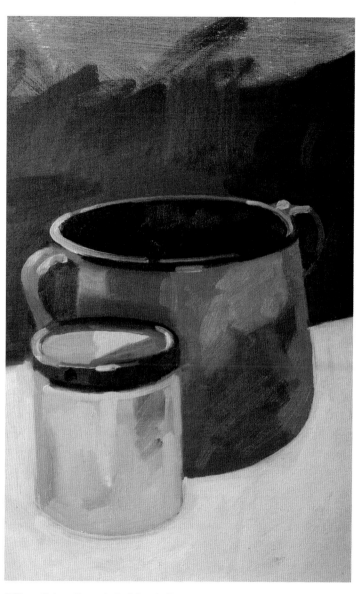

3 The artist continues to build up both the pot and the background. The red ground under the background makes the black appear more vibrant.

# CLOTH

CONTRARY TO WHAT SOME BEGINNER PAINTERS THINK, FOLDED DRAPERY IS NOT AN OBLIGATORY ELEMENT OF EVERY STILL LIFE. NEVERTHELESS, A SOFTLY DRAPED PIECE OF CLOTH DOES SERVE MANY USEFUL PURPOSES. IT OFFERS AN INTERESTING TEXTURAL CONTRAST TO THE OTHER OBJECTS INCLUDED IN THE STILL LIFE; THE LINES AND FOLDS CAN ALSO BE AN IMPORTANT COMPOSITIONAL ELEMENT, CREATING VISUAL DIRECTION WITHIN THE PICTURE.

A solid-colored fabric can be chosen to contrast with the busy patterns of flowers, vases, and other objects in the still life, providing a welcome "breathing space" for the viewer's eye. Alternatively, choose a patterned fabric if you wish to add interest to a more simple arrangement.

If you do include drapery in your still life, try to make the folds look natural and uncontrived. The lines of the folds should help to guide the viewer through the composition without looking like busy streetcar lines.

If the background drapery takes up a large area, give careful consideration to its color, because this will affect the overall color harmony of the arrangement. Tone is important, too: if the tone of the drapery is too similar to that of the objects in front of it, the finished painting will look monotonous and lack "punch." It is useful to have several lengths of fabric on hand in both light and dark colors, so you can try out different ones with your still life in order to compare their effects.

Some artists enjoy painting fabric folds and find it absorbing. Others find it frustrating, because the forms are difficult to define. Before you start painting, it is often a good idea to make a sketch of the fabric, blocking in the dark tones and middle tones with charcoal or soft pencil, leaving the white of the paper for highlights. This will give you a clearer idea of the pattern of the folds, making them easier to cope with when you come to paint them.

## PATTERNED CLOTH

Patterned fabrics may at first glance seem even more complicated, but in fact the pattern is usually helpful in describing the way the fabric lies; stripes and checks are especially effective.

The best way to paint complicated folds in patterned fabric is to take small sections at a time and describe how the pattern runs in different directions within each section. Observe how the light falls on the fabric, painting the highlighted areas in a lighter tone than those in shadow. In addition, vary the pressure of your brushstrokes to create a combination of hard and soft lines that convey a sense of movement.

## FOLDED CLOTH

When painting complicated folds in a piece of white cloth, the secret is to exaggerate the warm and cool shadow tones slightly so that the white highlights sing out more clearly. For the sake of clarity, adopt a systematic approach. Before you begin painting, look at the subject through half-closed eyes and pick out just four or five main tones; making a monochrome sketch will also help. Next mix up colors on your palette to correspond with these tones. Now you are ready to begin.

**CLOTH • OIL**

1 In this oil study, the artist begins by toning the canvas with a thin layer of raw sienna so that the tones of white can be judged more easily. When the toned ground is dry, the artist draws in the main folds and areas of tone in the cloth with a flat No. 6 brush and well-diluted raw umber. He then makes a loose underpainting to establish the darks, middle tones and lights: raw umber is used for the dark tones, ultramarine and titanium white for the middle tones, and titanium white alone for the light tones. The underpainting helps the artist to see how the overall picture will look. At this point, any corrections or alterations can be easily made because the paint is thin.

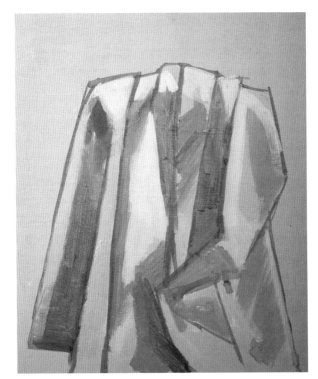

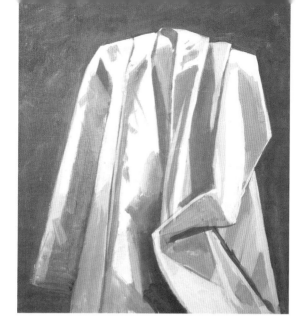

2 The artist now applies a loose wash of ultramarine and titanium white in the background, allowing the neutral tone of the underpainting to show through. Using the underpainting as a guide, he now begins building up the tones in the cloth with thicker paint.

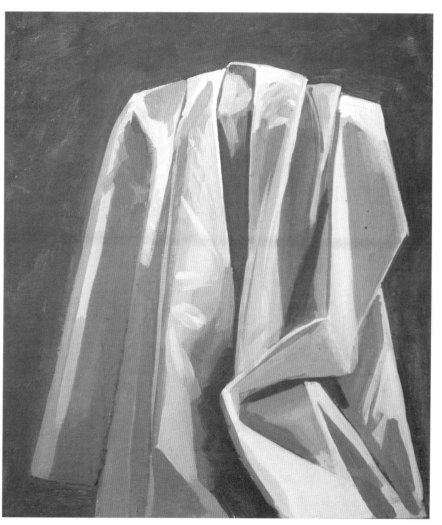

3 This detail shows how the artist has used crisply defined strokes and thick paint for the highlighted parts of the folds to make them stand out, while the shadows are thinner and less well defined to make them recede.

4 Here is the finished painting. By working in a methodical way, starting with an underpainting and gradually refining and sharpening the details, the artist has arrived at a clear, uncluttered statement.

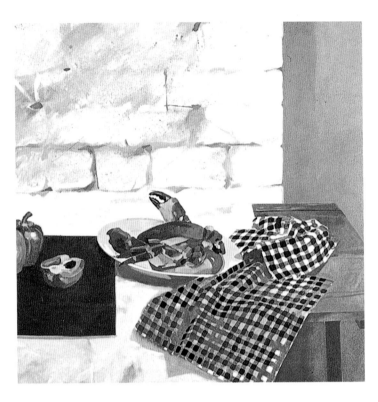

## PATTERNED CLOTH • WATERCOLOR

In this painting the artist uses thin glazes of watercolor to give form and substance to the folds of the fabric.

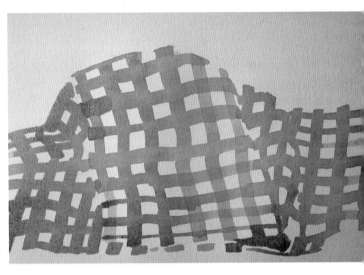

**1** Using a chisel brush and a pale wash of ivory black, the artist begins to define the checked pattern of the cloth. The folds and twists in the fabric are indicated by the direction of the lines in the pattern.

## FOLDED CLOTH • OIL

**1** Use masking tape for making clean lines for the edge of the cloth. Allow the paint to dry and then peel away the tape carefully.

**2** When painting a checked cloth like this, use a small sable brush to block in the areas of black carefully. For the shadows, use a light gray and for the white checks, just let the canvas show through.

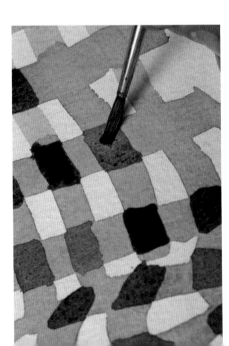

**2** When the first washes are dry, the artist blocks in the darker squares with a small sable brush and a darker tone of ivory black.

**3** When the painting is completely dry, the artist works back into the cloth with a transparent middle tone of ivory black, creating shadows in the cloth and strengthening the light and dark contrasts.

**4** Here is the completed painting. Notice how the black squares in the pattern of the cloth are darker in the shadowed areas than in the lighter areas.

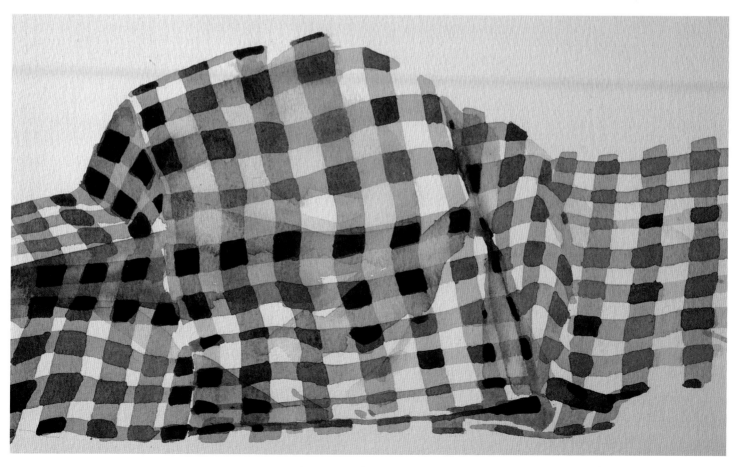

# WATER

Water holds an endless fascination for almost everyone, artists and non-artists alike. It can be calm and still, like lakes and quiet rivers with their smooth, mirror-like reflections, inviting contemplation. It can also be exciting and dramatic, like crashing waves or white-water rapids.

## MOVING WATER

Like the sky, moving water is an elusive subject: highlights and shadows appear and disappear; colors change; waves break and re-form before you even have a chance to put brush to canvas. The basic problem is how to pin down all this action and create a convincing image without losing the inherent sense of movement and spontaneity that makes water such an attractive subject in the first place. Don't try to "freeze" the motion, or render it with photographic precision. Instead allow a few carefully placed brushstrokes to convey a general impression of movement and fluidity.

Learn to harness the particular qualities of your chosen medium to depict the character of your subject. Oil and acrylic paints, for example, have a certain strength which suits the ruggedness of a stormy seascape. Watercolor and pastel, on the other hand, allow for a swift, spontaneous response to the feeling of light and running water.

## WATER COLOR

Water is usually thought of as being blue, but in fact it is virtually colorless in itself, acquiring its colors from the prevailing light in the sky and from its surroundings. Thus, the sea on a calm day will reflect the blue of the sky, whereas on a stormy day it may look brown-green. Seen at a distance, a river might reflect the cool gray of the sky, but seen at close range in the depths of a wood, it will reflect the dark greens of the nearby trees that obscure much of the light in the sky. In addition, algae, weeds, and sediment present in the water itself can add unexpected touches of greens, browns, and ochers.

## REFLECTIONS

Perfect reflections in still water make a lovely subject, but take care with these; if they are too perfect they will be no more than an upside-down copy of the objects reflected. You want to give an impression of the water surface, whether by slightly blurring the reflections, a few light ripples, or pieces of flowing weed here and there.

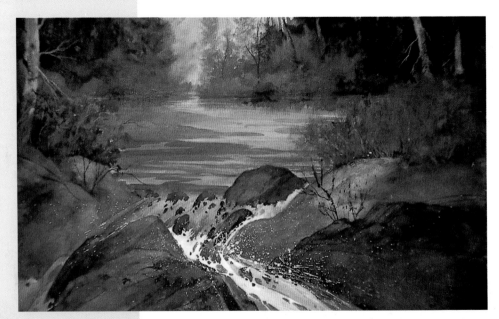

**CALM AND FAST WATER**
The contrast between the calm pool above and the rush of water over the rocks is beautifully expressed in Shirley McKay's watercolor. The splash of the froth was achieved by flicking opaque white across the rocks.

# MOVING WATER

PAINTING FAST-FLOWING WATER DEMANDS A KEEN EYE AND A SURE HAND. ONCE AGAIN, THE TRICK IS NOT TO BE OVERWHELMED BY THE APPARENT COMPLEXITY OF SHADOWS AND HIGHLIGHTS. LOOK AT THE WATER THROUGH HALF-CLOSED EYES AND PICK OUT THE MOST OBVIOUS RIPPLES AND WAVELETS. PAINT ONLY THESE, WITH SWIFT, DECISIVE STROKES.

To paint the rushing, white water of rapids and waterfalls, let the action of your brush suggest detail and movement. A few curving drybrush strokes, not too labored, are all that is needed to create an impression of water falling downward. Using a rough-textured paper or canvas helps, because the raised tooth of the surface catches and drags at the paint.

## MOVING WATER • OILS

The patterns of waves, ripples, and reflections in water are a never-ending subject for study. It is a good idea to carry a sketchbook with you so that you can make on-the-spot studies of the form, direction, and movement of water in different situations and weather conditions.

Here the artist is making a rapid oil sketch of the surface of a lake on a breezy day, when the water is ruffled by the wind and breaks up into tiny wavelets.

1 Using a No. 4 flat bristle brush, the artist paints the dark ripples with curving strokes of Payne's gray and ultramarine.

2 With a mixture of ultramarine and white, criss-cross strokes are now blocked in for the lighter ripples, and the ruffled white highlights are put in last.

3 The paint is allowed to dry for about 15 minutes, then the artist blends the colors a little by brushing over the surface very lightly with a 1" (2.5 cm) decorator's brush.

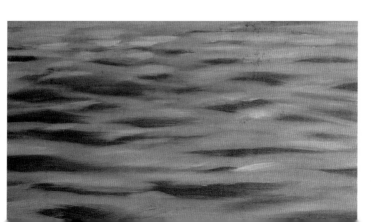

4 The finished study captures the impression of moving water that reflects the gray sky above.

## MOVING WATER • WATERCOLOR

A river view that includes a weir or a waterfall offers the artist an opportunity to practice rendering different types of water: the smooth, glassy surface of the calm water upstream, the tumbling white water of the waterfall itself, and the complex ripples and eddies of the water churned up beneath the waterfall. With a subject like this, the main pitfall is including too much detail, letting the painting become fussy and losing the fresh, moist feeling. It is essential to select the most significant lines of motion and leave out the rest.

For this painting of a woodland river, the artist has chosen watercolor as his medium. Watercolor has a unique transparency and freshness which is ideally suited to painting water.

Painting rushing water in watercolor is especially challenging, however, because you can't pile on thick layers of paint to represent churning foam as you can in oil or acrylics. In this respect, watercolor is an excellent medium with which to practice developing a simple, restrained approach to painting water.

**1** Working on a sheet of 200lb Bockingford paper, the artist begins by indicating the dark tones in the water with a pale wash of ultramarine applied with a No. 6 sable brush. The strokes are made smoothly and decisively, leaving areas of white paper for the highlights on the water.

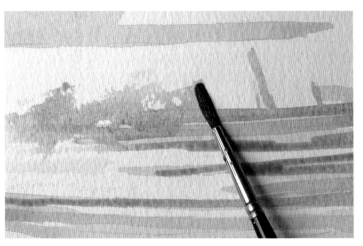

**2** At the base of the waterfall, the color is applied thinly in loose, scumbled strokes with the side of the brush to create the effect of churning water.

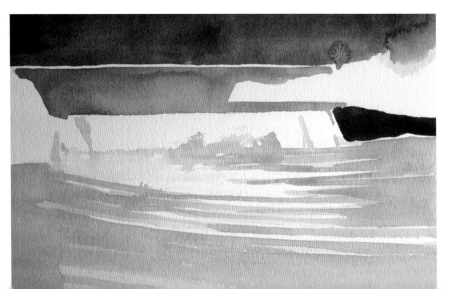

**3** A dark wash of Hooker's green is now brushed in to establish the trees on the bank of the river in the background. Beneath this, a thin strip of white paper is left to indicate a sparkling highlight on the distant water. Then the smooth expanse of water above the waterfall is painted with ultramarine and Hooker's green, mixed wet-in-wet.

5 Moving toward the foreground now, the artist strengthens the color of the ripples in the water, which reflect some of the dark greens of the foliage overhanging the river bank. The ripples are painted with Payne's gray, Hooker's green, and ultramarine, with the tones becoming progressively lighter toward the foreground.

6 Taking a soft brush moistened with clean water, the artist softens and blurs the colors in the foreground to show how the ripples dissipate as they move out from the waterfall. Finally, the background trees are developed with mixtures of sap green, Hooker's green, and ivory black. A little gum arabic is added to stiffen the paint, allowing the artist to push the color around with scumbled strokes. When dry, they leave an impression of dappled sunlight filtering through the trees.

The cool, clear water has been rendered very simply, yet it looks real enough to touch!

4 Using a stiff bristle brush, the artist spatters a pale mixture of ivory black and Hooker's green across the base of the waterfall to give the effect of spray and foam being tossed in the air.

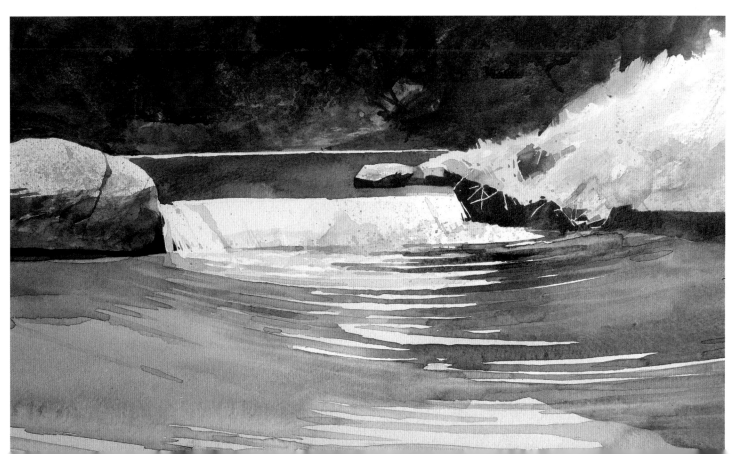

# REFLECTIONS

THERE IS SOMETHING PICTORIALLY SATISFYING ABOUT A SMOOTH BODY OF WATER REFLECTING THE LANDSCAPE LINING ITS BANKS. SOFT REFLECTIONS OF TREES, BUILDINGS, BRIDGES, AND MOUNTAINS PRESENT A BALANCED AND UNIFIED IMAGE THAT IS ALWAYS PLEASING TO THE EYE.

The best way to understand reflections in order to paint them convincingly is to find a stretch of calm water and observe the differences and similarities between an object and its image in the water. For example, you will notice that the reflection of a light object is always slightly darker than the object itself. Similarly, dark objects appear lighter when reflected because of the water's light-reflecting properties.

Anything which leans at an angle, whether in the water or at its edge, will cast a reflection at the same angle. However, objects which are slanted away from you cast a reflection that appears shorter than the object, while objects slanted toward you appear to have a longer reflection.

The real complications set in when the water's surface is broken up by undercurrents, or ruffled by a breeze. These ripples have the effect of breaking up the image so that it wavers and appears distorted. Broken reflections appear longer than reflections in calm water. Indeed, the reflections of tall buildings and trees sometimes appear many times longer than the height of the actual object.

## THE LOGIC OF REFLECTIONS
Broken reflections often look complicated, but rather than trying to copy every detail, it is better to simplify the patterns. A few well-placed wiggly strokes, painted with a soft, round brush, are all that is needed to convey the smooth, undulating surface of the water.

Even the calmest water can be disturbed by ripples or swells or the movement of boats on the surface. When this happens, reflections become elongated and distorted and form fascinating abstract patterns which are worth studying. This is one area where a camera can be useful for "freezing" the pattern of moving reflections, enabling you to study them more closely.

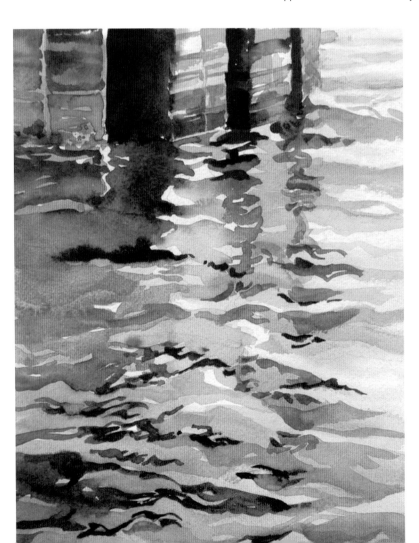

**REFLECTIONS • WATERCOLOR**
The reflections are beautifully described through varied brushwork and strong contrasts of tone, both of which create a powerful visual impact. Each shape has been painted boldly with just one stroke of the brush so that the paint remains clean and pure.

# SEA

THE ROUGH SEA CRASHING AGAINST A ROCK-STREWN SHORE IS AN EXHILARATING SIGHT TO WITNESS, BUT TRYING TO CAPTURE ITS POWER AND ENERGY ON A SMALL PIECE OF PAPER OR CANVAS DOES REPRESENT A VERY REAL CHALLENGE. HOWEVER, IF YOU CAN RID YOURSELF OF THE IDEA OF TRYING TO "COPY" NATURE AND AIM INSTEAD TO CAPTURE AN OVERALL IMPRESSION OF THE SCENE, YOU WILL FIND IT LESS FRUSTRATING AND MORE REWARDING.

**SEA • OIL**
The artist has created a lively landscape; the shimmering water contrasts dramatically with the dark tones of the land.

An energetic subject like the sea is best painted on location. Before you begin painting, take the time to sit down and watch the waves. Although they are constantly moving and changing, you will be able to see a definite pattern of movement emerging. If you look long enough and hard enough, you will recognize the essential shapes and be able to paint them virtually from memory.

## WAVES

To paint waves convincingly, it helps if you understand how they are formed. On a calm day, a wave travels through the open sea with a smooth, undulating motion. As it gets nearer to the coast, the lower part of the wave is slowed down by the land rising underneath it, but the top part of the wave continues at its original speed, eventually falling over itself and crashing down onto the shore. The white foam is caused by the aeration of the water. The action of the wave is finally stopped by the shore and reverses direction. Where this water meets the next incoming wave head-on, the churning action causes further aeration, resulting in a swirling mass of foam.

## DESCRIPTIVE STROKES

When painting the action of the sea, imitate the movements with your brushstrokes. For example, hold the brush loosely and far back on the handle to create loose, casual strokes that suggest liquid movement; use long, horizontal strokes of fluid paint for the distant waves which appear less and less distinct as they approach the horizon. To suggest choppy waves far out at sea you could use a soft, round brush to make curving, arc-like strokes. In the foreground, where all the action is taking place, use vigorous brushwork. Downward strokes convey the power of a wave crashing down; upward strokes indicate flying spray.

## SPECIAL TECHNIQUES

In opaque media, scumbling, drybrush, and impasto are very effective in portraying white foam, as are stippling and spattering. Watercolor is a little more difficult to use for this subject because you first have to leave white shapes for the foam and then model the tones within the foam afterward.

## COLOR

Pay careful attention to colors when painting the sea. The foam of breakers, for instance, may look white at first glance, but it may in fact contain subtle hints of gold and pink reflected from the evening sunlight; it may also appear quite gray in stormy weather.

Depending on the weather and the prevailing light, the overall color of the sea may be blue, blue-green, gray, or even brown. Whatever the color, do not paint it with an even monotone. Introduce subtle variations of color and alternate dark and light tones to suggest the movement of the water's surface.

**SEE ALSO**

IMPASTO, pages 48–49
DRYBRUSH, page 68
SCUMBLING, page 69
SPATTERING, pages 74–75

## SEA • OIL

The drama of foam crashing and bursting against a rock is a fascinating subject, and is the theme of this oil study. When painting a subject like moving water, it is often helpful to use a viewfinder cut from a piece of gray cardboard to isolate the main action. Using a camera also helps, though photographs should be used only as an adjunct to your studies.

**1** Working quickly in the alla prima style, the artist covers the entire canvas with a toned ground of titanium white mixed with a trace of Prussian blue. Using a ½" (1.25 cm) decorator's brush, he applies the paint thinly in curving, arc-like sweeps, which will later help to accentuate the sense of dynamic movement in the foam burst.

The sea is quickly painted with mixtures of Prussian blue, Hooker's green, and cadmium yellow applied with vigorous, broken strokes, suggesting the choppy movement of the waves.

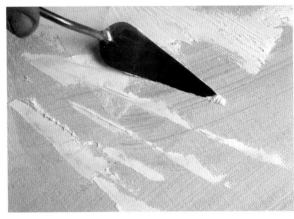

**2** The shape and form of the foam burst are now developed. Titanium white is mixed with a little medium to a thick, creamy consistency and applied with heavy impasto strokes, particularly at the base of the wave. Using the ½" (1.25 cm) decorator's brush, the artist scumbles the color quickly so that it blends partially with the cool undertone. This gives a sense of volume to the foam burst by indicating areas of light and shade.

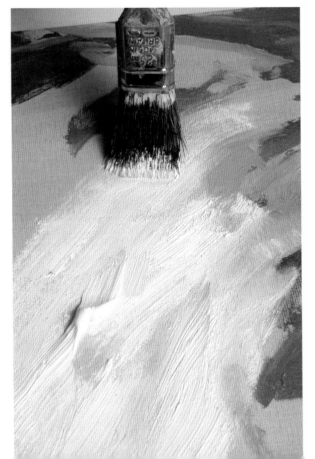

**3** Now the artist uses the edge of a painting knife to lay in long, broken strokes of titanium white at the upper edge of the foam burst. These strokes of solid, creamy color create a dramatic outline against the sky and heighten the impression of the great forces with which the foam splashes upward.

**4** The decorator's brush is used to spatter titanium white across the shape of the foam burst to imply broken flecks of foam and further emphasize the directional movement of the wave.

**5** The completed picture gives a thrilling impression of the explosive forces of nature. Heavy impasto and bold, vigorous brushstrokes are used in the point of impact. The outer edges of the foam are dispersed by the wind and become more translucent, blending into the surrounding atmosphere. This contrast of sharp and blurred passages gives movement and atmosphere to the painting.

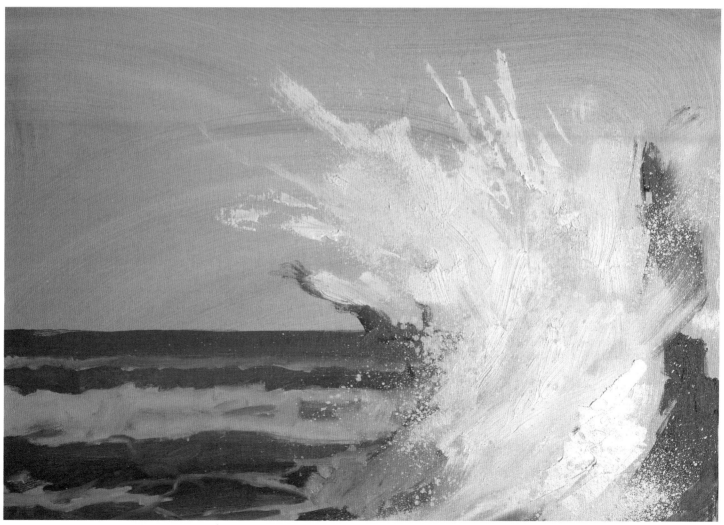

# WAVES

WAVES ARE ONE OF THE MANY SUBJECTS THAT ARE BEST TACKLED AFTER A LONG PERIOD OF OBSERVATION. YOU WILL SEE THAT THEY FOLLOW A DISTINCT PATTERN, WITH THE WATER SWELLING UPWARD TO FORM A CREST THEN BREAKING TO FORM WHITE SHAPES AND OFTEN FINE SPRAY.

It is often necessary to simplify waves, especially if you are working in watercolor. If you attempt to describe every tiny detail, your work will become fussy and tired, and you may muddy the colors as well as lose the built-in impact of the subject.

Conveying the force and energy of an incoming wave may seem a daunting prospect, but it is really just a question of using your brushstrokes to capture the essential gesture of the water.

**WATERCOLOR AND OPAQUE WHITE**
The artist painted this watercolor picture very rapidly in order to maintain the spirit of the subject. Working on damp paper, he quickly brushed in various tones of Payne's gray, ultramarine, and burnt umber, pushing the colors together on the surface and letting them mix wet-in-wet. A clean wet brush was used to lift out some patches of color, and the picture was spattered with opaque white to give the impression of splashing foam.

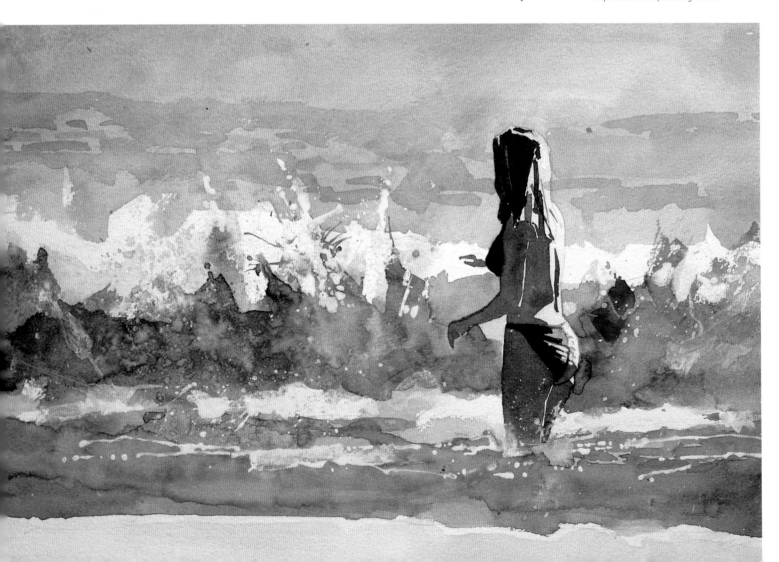

# CALM WATER

WATER, ESPECIALLY WHEN UNRUFFLED BY WIND, MAKES A LOVELY SUBJECT AND IMPARTS A SENSE OF PEACE. BUT DO TAKE CARE NOT TO PAINT IT EXACTLY THE SAME COLOR AND TONE ALL OVER, OR IT WILL LOOK LIKE A WALL RATHER THAN A RECEDING HORIZONTAL EXPANSE.

The smooth surface of a lake or river on a calm day is best depicted with broad, flat washes applied wet-in-wet. Use minimal brushstrokes; otherwise the illusion of the glassy surface will be lost.

**CALM WATER • ACRYLIC**

**1** The three areas of the picture are simply blocked in with base colors. The band of water in the foreground is painted in phthalocyanine blue and white.

**2** Touches of phthalocyanine blue and cobalt blue are added to the water's surface to convey the reflection of the sky in the water.

**CALM WATER • PASTEL**

**1** Soft pastel has many advantages when it comes to making sketches and studies outdoors. It is easy and quick to use and capable of producing a wide range of expression. In this sketch of a riverside scene, softly blended tones and rough hatching are combined to capture the sparkle of a bright summer's day. The artist has chosen to work on a smooth, tinted paper in a light shade of green, which provides a sympathetic background for the landscape greens and harmonizes the composition.

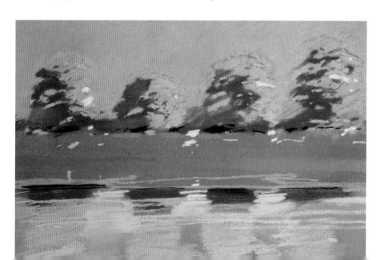

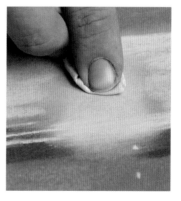

**2** To give an impression of still, calm water, the artist blends the tones of the reflections together smoothly using a clean rag, bringing the color down in vertical strokes.

**3** The picture is sprayed with fixative to prevent smudging and allow further layers of color to be added without muddying those beneath. Bright highlights dancing on the surface of the water are applied more thickly and blended with a torchon to set the color into the wave of the paper.

# WEATHER EFFECTS

The ability to generate a feeling of atmosphere in a landscape painting is one of the hallmarks of a skilled artist. The prevailing light and weather conditions play an important part in establishing such a mood, and will often turn a perfectly ordinary scene into a memorable one.

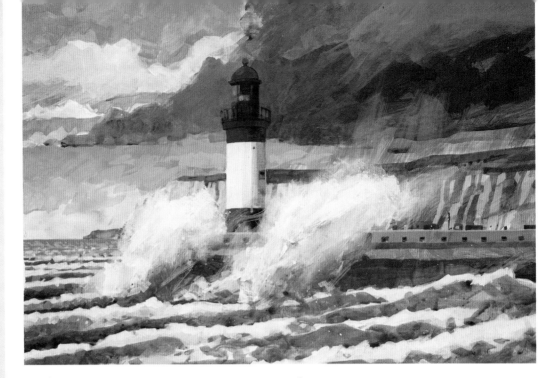

Strong sunlight makes the very air vibrate with color and gives rise to deep, dark shadows. Fog and mist act like a veil upon the landscape, turning hills and trees into eerie shapes that seem to float above the land. Storm clouds are particularly dramatic, especially when strong shafts of sunlight break through and spotlight the distant landscape. Lashing wind and rain set the landscape in motion as trees bend and leaves fly. And after a fall of snow, the whole landscape seems hushed and still, the dark shapes of trees and buildings looming in stark contrast to the whiteness of the land.

## FIRST-HAND EXPERIENCE

Though it may sometimes be possible to recreate atmospheric effects from photographs, there is no substitute for actually getting out there among the elements. Other senses, apart from sight, have a part to play in painting. If you can smell the sun on the grass, hear the whistle of the wind, or feel the sharpness of a frosty day, these qualities will come through in your painting. Even in a blizzard or a downpour, it is possible to work directly from nature by viewing the scene from your car window or finding some other shelter. And apart from this, many weather conditions

### CONNECTING TO THE LANDSCAPE
Heavy cloud's fill Ian Sidaway's painting with a powerful sense of foreboding. It is built up with final thin washes, making it more three-dimensional. The hard horizontal line of the cloud's base is softened with shafts of falling rain, connecting it to the landscape.

simply cannot be photographed satisfactorily; mist and fog, for example, don't allow enough light for the camera to record the image.

When painting the weather, it is important to switch off the analytical side of your brain and be responsive to the feelings generated by a sparkling spring day or a crashing thunderstorm. Because atmospheric conditions are transitory and difficult to "pin down," the creative artist turns this to his or her advantage by letting the paint itself suggest the power and drama of nature. The watercolorist has a distinct advantage here, since the medium's fluidity and spontaneity have often been compared to the behavior of nature itself. But every medium has its own special qualities, and it is worthwhile to experiment with unusual techniques which express the ever-changing moods of nature.

# FOG AND MIST

A LANDSCAPE THAT IS SHROUDED IN MIST TAKES ON A STRANGE, HAUNTING, AND UNFAMILIAR ASPECT. THESE INDEFINABLE QUALITIES HAVE ATTRACTED ARTISTS FOR CENTURIES. THE GREAT MASTERS OF TRADITIONAL CHINESE AND JAPANESE PAINTING DELIGHTED IN RENDERING, WITH A FEW EXQUISITE BRUSHSTROKES, AN IMPRESSION OF MOUNTAINS AND TREES LOOMING OUT OF THE MIST. OF THE EUROPEAN PAINTERS, TURNER IS THE UNEQUALED MASTER OF DEPICTING THE EFFECTS OF SUN, WATER, AND LIGHT ON LANDSCAPES AND SEASCAPES.

Because fog and mist are actually water vapor hanging in the air, it follows that a fluid medium such as watercolor lends itself particularly well to such a subject. Oil paints, too, can be used with great success, because their slow rate of drying allows for subtle wet-in-wet blendings. Pastel is another favorite medium, especially for on-the-spot studies. With a few rapid strokes, hastily smudged with the finger, the artist can capture a fleeting effect of hazy light before it disappears forever.

## TECHNIQUES

Fog acts as a filter on the landscape, reducing forms to simple silhouettes, minimizing tonal contrast, and eliminating textural detail. There are many techiques that you can use to render this effect in your paintings. In oils, an excellent method is to apply a toned ground of heavily diluted raw umber and then render the muted tones and colors of the landscape with delicate scumbles which allow the ground color to show through. This technique produces a highly atmospheric, soft-focus effect.

Another interesting technique is to tonk the painting with newspaper before the paint dries.

This removes much of the color from the surface and has an overall softening effect on the painting.

Haziness is also achieved through the classic techniques of working wet-in-wet. The best way is to start with the middle tones and then work the dark and light tones into the wet color, blending the edges of the forms into each other.

In watercolor, some artists prefer to soak the entire paper and work into the wet surface to produce a soft blending of tones. Others prefer to work on a dry surface, using a small sponge to wet those areas where a hazy effect is required. This method gives you more control over hard and soft edges and is excellent for depicting subjects that are only partially enveloped in mist.

### COLOR AND TONE

In general, fog and mist reduce the intensity of colors, giving them a cold gray or gray-blue cast. The exception might be in the early morning or late afternoon, when the sun's rays

color the mist a pale yellow. To achieve this muted effect, keep to a limited palette of harmonious colors.

Fog also reduces the intensity of tones, so tone values become very important when painting a misty scene. To achieve a sense of distance in your painting, always start with the pale, indistinct forms in the background. Then paint the middle ground, with slightly deeper tones. Finally, in the foreground, include accents of dark tone and sharp detail. This contrast makes the background look pale and more misty, lending a sense of depth and mystery to the scene.

SEE ALSO

WET-IN-WET, pages 52–53
SCUMBLING, page 69

### FOG • OIL

A landscape with rolling hills and fields stretching into the distance takes on a special atmosphere when shrouded in early morning mist. The effects of aerial perspective are heightened. The foreground, middle ground, and background become much more separate and distinct than usual; the forms of the land become flattened silhouettes, almost like stage flats stacked one in front of the other. In this oil painting, the artist uses the direct, alla prima technique, working the colors wet-in-wet to achieve the softness of tone characteristic of a misty day. He then finishes off by tonking the entire painting to soften the tones even more.

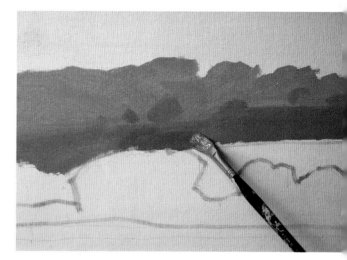

**1** The artist roughly sketches in the main outlines of the landscape with a No. 2 bristle brush. Starting with the farthest line of trees, he blocks in a pale tone. The next band of trees is blocked in with a slightly darker tone.

*SEQUENCE CONTINUED OVERLEAF* ▶

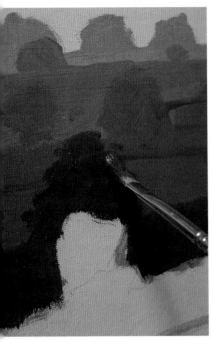

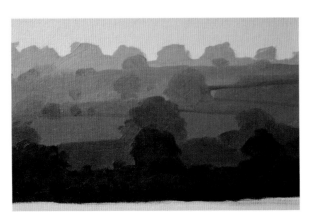

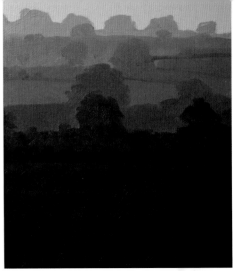

3 Here you can see the gradual change in tone from background, to middle ground, to foreground. It is important to keep each separate plane distinct, but at the same time there should be no sudden jumps from one tone to another. The overall effect should be soft and muted. Work the edges of each plane into the one before by blending wet-in-wet, particularly in the background.

4 Finally, the foreground field is painted with a large bristle brush, using vigorous scumbling strokes to give texture and movement.

2 The artist uses increasingly deeper and warmer tones as he works toward the foreground. The nearest group of trees is painted with a mixture of sap green, raw umber, and a touch of ivory black, using a No. 4 flat brush.

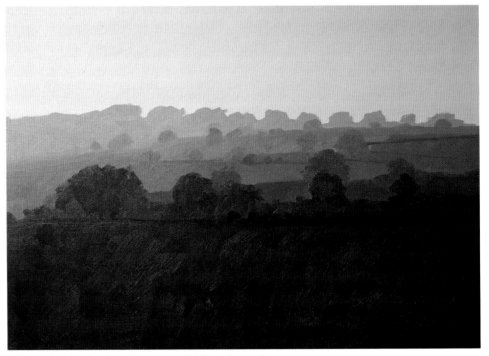

5 While the paint is still wet, the artist tonks the entire painting; a sheet of newspaper is laid over the picture and rubbed gently with the palm of the hand. The paper is then carefully peeled away.

6 The paper has absorbed the excess paint from the surface of the canvas and softened the tones overall, adding to the impression of mistiness.

## FOG • WATERCOLOR

The softness and delicacy of watercolor makes it an excellent medium for rendering impressions of fog and mist. Here the artist uses a combination of hazy, indistinct washes and sharper, crisper detail to create a misty landscape which recalls the understated beauty of a traditional Oriental ink drawing.

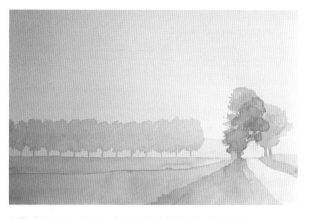

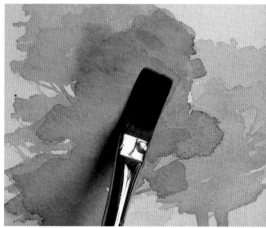

1 Working on a sheet of stretched 200lb Bockingford paper, the artist begins by painting the field and the distant trees with a mixture of ivory black and Payne's gray, heavily diluted with water. When the first wash is dry the foreground trees are further developed by adding a slightly darker wash; this deeper tone gives depth to the scene by bringing the nearer trees forward and making the pale shapes in the background seem more distant by comparison.

2 This detail shows how the washes are painted wet-over-dry to create crisp edges, which gives a suggestion of the foliage texture.

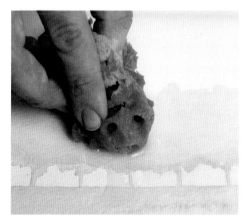

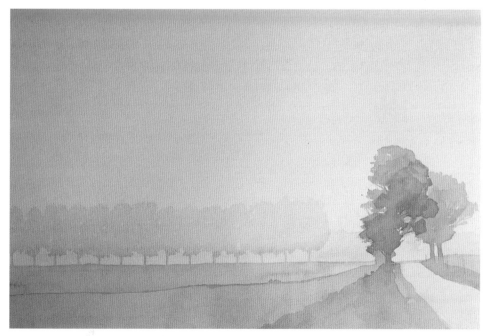

3 The painting is allowed to dry. The tops of the background trees are then flooded with clean water applied with a soft sponge and gently blotted with a tissue. This removes most of the pigment from the area, leaving just a slight hint of color. It is essential to allow the paint to dry before flooding it with water so the pigment has a chance to stain the paper.

4 The background trees now have an intriguing lost-and-found quality, blending softly into the gray distance. The beauty of the painting lies in the delicate balance between crisp forms in the foreground and soft, hazy forms in the background.

# RAIN

PAINTING AN IMPRESSION OF A RAINY DAY CAN BE TACKLED IN SEVERAL WAYS. YOU CAN INDICATE FALLING RAIN BY USING DIAGONAL OR VERTICAL BRUSHSTROKES TO BUILD UP THE PAINTING, OR YOU CAN IGNORE THE RAINDROPS AND CHOOSE TO IMPLY THE EFFECTS OF RAIN ON THE LANDSCAPE BY SOFTLY DIFFUSING THE IMAGES.

To indicate the wetness of rooftops and roads, paint them very light in tone and use a contrasting dark tone for the sky. Puddles on roads and pavements, showing reflections of trees and buildings, also add to the atmosphere of a rainy day.

The dominant color in a rainy scene is most likely gray, but make the grays interesting by mixing them from various combinations of blues, reds, and yellows, rather than just black and white.

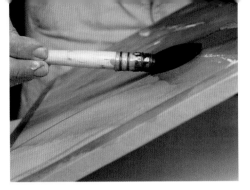

**RAIN • WATERCOLOR**

**1** A sheet of 200lb Bockingford paper is taped firmly to the drawing board and then wetted with clear water. A wash of Payne's gray is applied with broad strokes, leaving small areas of white paper, indicating bright light shining through gaps in the clouds. While this wash is still damp, a loose wash of Payne's gray and ivory black is flooded in, wet-in-wet, using a large sable brush.

**2** Tilting the board up at an angle, the artist allows the color to drift midway down the paper, using a large mop brush to guide the pigment where he wants it to go.

**3** The color is then brought down toward the horizon with diagonal strokes, using a No. 6 sable brush. The artist works quickly and with a light touch, so the color is broken up by the raised tooth of the paper.

**4** The diagonal strokes have softened slightly into the damp wash beneath, creating a subtle impression of drifting rain.

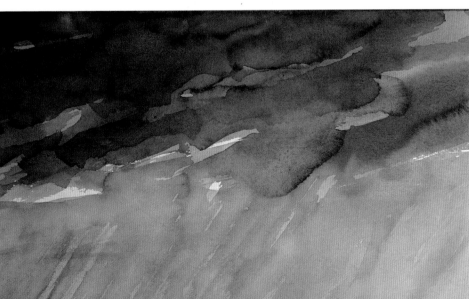

# SNOW AND ICE

SNOW AND ICE ARE GENERALLY REGARDED AS BEING WHITE, BUT THEY ARE IN FACT RARELY PURE WHITE, EXCEPT IN THE BRIGHTEST AREAS.

Snow and ice are water in solid form, and, just like water, they reflect color from the sky and nearby objects. This is especially noticeable in the early morning and late afternoon, when the sun strikes the surface of the snow at a low angle and tinges it a delicate pink or yellow. In fact, these are the best times of the day for painting snow scenes; the light is far lovelier than it is during the middle of the day, casting warm pinks and golds in the highlights, and luminous blues and violets in the shadows. In addition, the long shadows cast by the sun at these times of the day add drama to the scene and help to define the snow-covered forms of the land.

Inexperienced artists tend to think that painting a snow scene means piling on endless layers of thick white paint. On the contrary, the most atmospheric snow scenes are those that contain a lot of shadow, with only small areas of bright, sunlit snow. The bright spots look dazzling because of the contrasting shadows; if the whole picture were painted in bright white, the effect would be flat and monotonous with no feeling of light at all.

When painting a snow scene in opaque media, always begin with the light colors and gradually add the cool shadow colors. It takes less paint to darken a light color than it does to lighten a dark color. With transparent watercolor, the opposite applies. You must establish the position of the brightest highlights on the snow in advance and paint around them, working from light to dark.

After a heavy fall of snow, the objects that it covers take on soft contours and curves. The light planes blur softly into the shadow planes, with no hard edges, so model these forms with wet-in-wet.

## BLENDING

When painting shadows on snow, you will notice that they appear crisp near the object casting the shadow but more diffused farther away. This is because a lot of reflected light enters the shadows from the sky or from nearby snowdrifts. Keep the shadows airy and transparent by using thin pigment and fresh, clean color.

## FALLING SNOW

Falling snow cuts out much of the detail in background images, reducing them to faint silhouettes if the fall is heavy.

In opaque media, stippling and spattering are very effective in rendering falling snow.

In watercolor painting, you can either spatter with opaque (Chinese) white or create an impression of snowflakes with the use of salt granules, as shown below.

> SEE ALSO
> ........................
> WET-IN-WET, pages 52–53
> SPATTERING, pages 74–75

## SNOW • GOUACHE AND WATERCOLOR

In this painting, the artist tackles the problem of rendering an impression of falling snow that looks natural and uncontrived. One of the best ways of doing this is with the technique of spattering: the tiny droplets of paint fall onto the paper in a random fashion which perfectly captures the effect of swirling snowflakes.

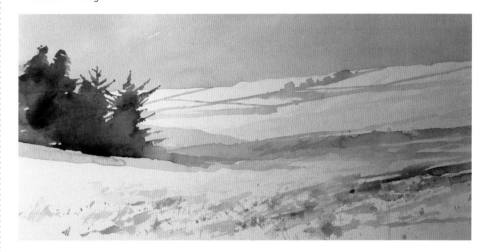

**1** Working on a stretched sheet of 200lb Bockingford paper, the artist begins by painting the sky with a pale tone of Payne's gray. Saving the white of the paper for the brightest areas of the snow, he indicates the shapes of the distant trees and hedgerows with faint gray lines. The spruce trees on the left are then painted with a dark wash of Hooker's green and Payne's gray. In the foreground, quick drybrush strokes of burnt umber indicate clumps of grass and earth uncovered by the partially melted snow. This addition of a warmer tone in the foreground accentuates the sense of depth in the painting.

*SEQUENCE CONTINUED OVERLEAF* ▶

2 The painting is left to dry naturally. Meanwhile, a thick but fluid wash of white gouache is mixed on the palette, ready for spattering to begin. This is the tricky part of the painting; the droplets of paint must be of the correct size and density, otherwise the effect could be ruined. Always do a "test run" on a piece of scrap paper before applying the technique to an actual painting. This way you will learn to gauge the fluidity of paint required and the best distance between the brush and the paper; generally this should be at least 6" (15 cm). Here the artist is using a 2" (5 cm) decorator's brush, running his finger through the bristles to create a fine spatter.

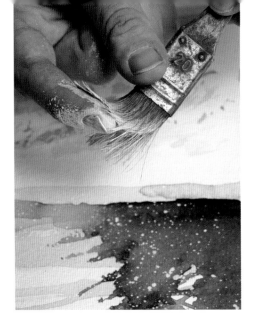

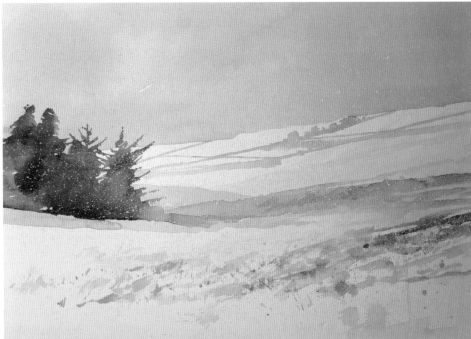

3 In the finished painting, notice how subtly the spatter has been applied to give a naturalistic effect. It is important not to overdo the spatter; too little is better than too much, unless you deliberately want to create the effect of a snowstorm. This "veil" of semi-opaque gouache also softens the forms and colors underneath, just as real snowflakes partially obscure the landscape as they fall.

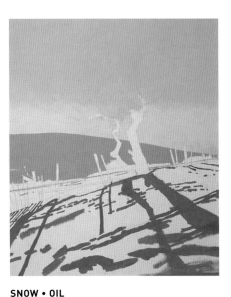

**SNOW • OIL**

1 Once the basic colors for the sky and hills have been laid in cerulean blue and white, the artist paints in the long shadows with a mixture of cerulean blue and a small amount of white and black.

2 Then he adds the middle tones of the shadows, using a pale blue mixture.

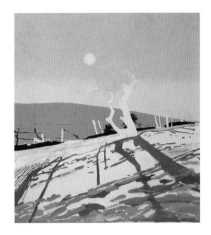

**3** As the painting develops, the artist softens the hard lines of the snow and shadows by splattering white paint in the foreground to suggest falling snow.

### SNOW • OIL

**1** The fluffiness of snow is difficult to describe in paint but using a piece of burlap can achieve marvelous results. Tape the piece of burlap over the support and press a brush well loaded with paint onto the burlap, forcing it through the fabric. The paint should not be pure white but tinged with the colors of the landscape.

**2** To create the effect of distant snow flurries, the artist splatters paint on the dark trees, using a 1" (2.5 cm) decorator's brush.

**4** In the finished picture the artist has successfully created dramatic contrasts using simple forms and a limited palette for the dark silhouetted trees against the sky and the blue shadows against the white snow.

**3** With this difficult subject of white on white, the artist has successfully built up the solid form of the white bear against the fluffy white background.

# STORMY WEATHER

THE DRAMATIC CHANGES THAT OCCUR IN THE SKY AND LAND BEFORE, DURING, AND AFTER A STORM HAVE ALWAYS FASCINATED ARTISTS. CONSTABLE OFTEN MADE MANY QUICK OIL STUDIES OF SUCH EFFECTS. YOU MAY LIKE TO HAVE A CAMERA HANDY FOR SUCH MOMENTS; EVEN IF THE PHOTOS ARE POOR, THEY MAY SERVE AS A HELPFUL VISUAL REMINDER.

**GIVING THE SKY THE STARRING ROLE**
If you wish to focus attention on a dramatic stormy sky, keep the horizon line low so that the landscape doesn't vie for attention with it. In this acrylic painting, the color of the steely gray sky has been intensified deliberately to heighten the mood; the clouds seem to be bearing down on the lonely house on the hill. The movement of the clothes drying on the clothes line also adds to the tension by implying the presence of a gusting wind.

**STORMY WEATHER • OIL PASTEL**
**1** With strong diagonal strokes, the artist roughly sketches the main areas of the sky, land, and sea in cerulean blue.

**2** He then adds diagonal strokes of gray and white pastel, which he then blends together.

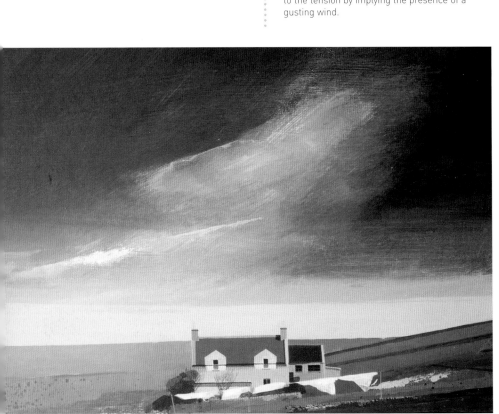

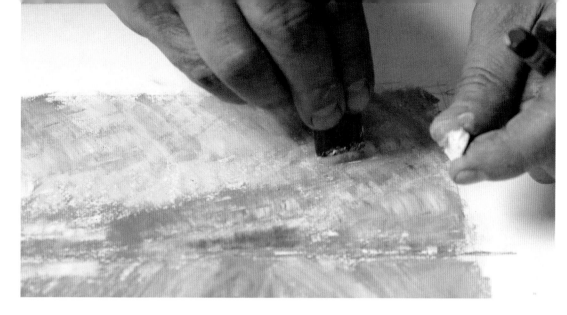

3 Oil pastel is a versatile medium, and here the artist spreads bits of broken white pastel onto the picture's surface with a palette knife. To create texture he uses the knife to scratch into the pastel.

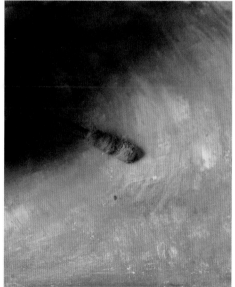

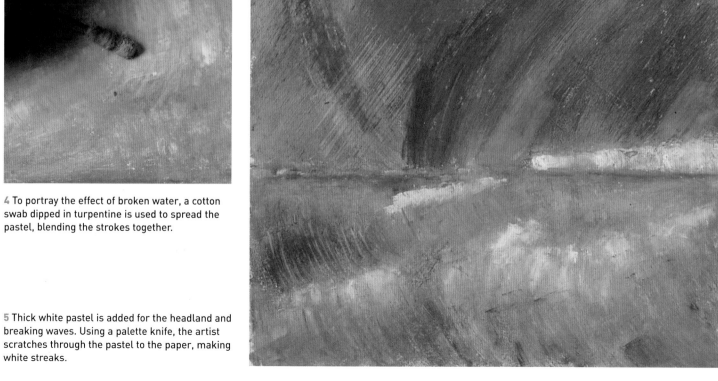

4 To portray the effect of broken water, a cotton swab dipped in turpentine is used to spread the pastel, blending the strokes together.

5 Thick white pastel is added for the headland and breaking waves. Using a palette knife, the artist scratches through the pastel to the paper, making white streaks.

# BRIGHT SUNSHINE

WHEN PAINTING A SCENE BATHED IN BRIGHT SUNSHINE, IT IS ALL TOO EASY TO BECOME "BLINDED" BY THE INTENSITY OF COLOR AND LIGHT. THE RESULTING PAINTING BECOMES TOO HIGH KEY OVERALL, LACKING TONAL CONTRAST AND GENERALLY LOOKING WASHED OUT.

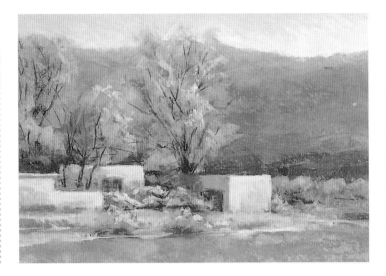

## CHOOSING THE RIGHT TIME

Bright light creates strong contrasts of tone, but under a high, overhead sun, colors can appear washed out. In this pastel painting by Bob Rohm the colors are vibrant and varied because he has chosen a time of day, probably late afternoon, when the sun is at an angle.

## BRIGHT SUNSHINE • WATERCOLOR

1 Use dry brushwork to create the background scrub and bushes. Mixtures of naples yellow, gamboge, and sap green are ideal. Using a No. 6 round brush and mixtures of burnt sienna, indian red, and ultramarine, scumble in the dark shadows.

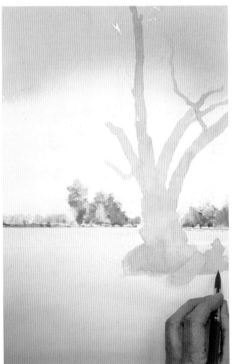

2 Begin painting the tree with a base coat of scarlet lake and a little gamboge. Keep the color light, because this will be overpainted with shapes and shadows at the next stage.

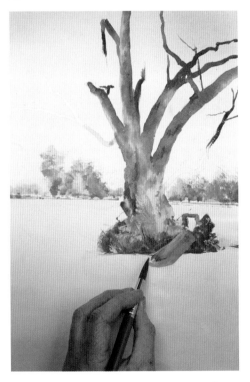

3 Continue painting the tree trunk and branches with both wet-in-wet techniques and dry brushwork to develop textures and subtle colors. Use mixtures of alizarin crimson, ultramarine, and burnt sienna.

Interestingly, the secret of creating the effect of bright sunlight lies in painting the shadows. Light looks even brighter when surrounded by darks, which is why many artists employ the compositional device of throwing a shadow across the foreground and placing a small, brightly lit area in the middle ground. The viewer's eye instinctively focuses on that spot of bright light and the scene looks sunny, even though most of it is in shadow.

When the sun is at its most intense, the color of the light itself affects the local colors of the objects it strikes, often quite dramatically. Everything the sun hits becomes lighter and warmer in tone, while shadows are correspondingly cool because they reflect the blue of the sky. Balance bright, warm colors with deep, cool shadows so that they intensify each other and create strong tonal contrasts that spell "sunshine."

Another important point to watch out for is the reflected light in shadows. On a sunny day, there is so much light that bounces from one object to another. Thus, the shadow side of a white house may look blue, reflecting the sky, or it may be tinged with green if there are trees nearby. Being aware of subtle points like this will lend greater luminosity to your painting.

Brushwork techniques also contribute to the atmosphere of the painting. In opaque media, always paint the shadows thinly and use thick impasto, which reflects a lot of light, for painting light-toned areas. In watercolor, the bleaching effect of the sun is rendered simply and effectively by leaving white shapes for highlights. Remember that intense sunlight diminishes sharp details, so use softened brushwork in some areas.

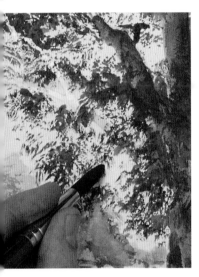

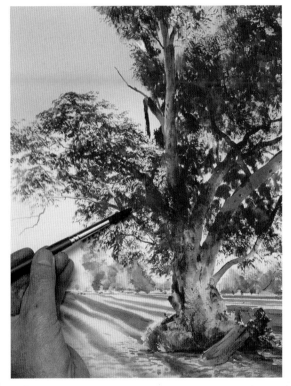

4 Now build up the foliage through "split brush" and drybrush techniques. "Split brush" requires a delicate touch and a brush that breaks up into many points; a worn, round sable is suitable. Using dark and light greens, dab the brush up and down to create the textures and tones of the leaves.

5 Brush in shadows in the sand. Make sure the surface is wet so that the brushstrokes are soft-edged. Finally, add more texture to the foliage by fine overpainting with a mixture of naples yellow and alizarin crimson, and strengthen the foreground colors.

6 The completed painting shows the effect of early-morning light. Backlighting makes the textures very apparent. The foreground textural shadows, formed by dips in the ground, seem exaggerated. This adds to the drama.

# INDEX

# CREDITS

Quarto would like to thank the following artists for kindly supplying images for inclusion in this book:

Diana Armsfield 20, 26bl; David Boys 98; Rima Bray 138t; Catherine Bernard 108t; Robert Brindley 52bl; Denise Burns 134; David Carr 159; Moira Clinch 115bl; Marjorie Collins 38; Doug Dawson 18bl; Vicky Funk 117r, 163l&r, 164; Jeremy Galton 46bl, 48bl; Margaret Glass 158; Brian Gorst 24bl, 44, 166t; Jan Hart 186; James Horton 146t&b; John Houser 65t; Brian Innes 84bl; Jane Leycester Paige 23br; Judy Linnell 53br, 68, 82bl; Shirley McKay 182; Milind Mulick 37bl; Rosalie Nadeau 30bl; John Newberry 122; Julia Rowntree 54; Ian Sidaway 112, 165; Stan Smith 114tl; Hazel Soan 126bl; Haidee-Jo Summers 62bl; Lexi Sundell 4, 32bl; Robert Tilling 36bl; Naomi Tydeman 74bl; Michael Warr 156bl; Kim Williams 22bl

We would also like to thank all the artists who took part in the demonstrations, including:

Christopher Baker, Gordon Bennett, David Carr, Jeremy Galton, Brian Gorst, Hazel Harrison, Kevin Hennessy, Jan Howell, Judy Linnell, Mike Pope, Lincoln Seligman, Ian Sidaway, Haidee-Jo Summers, Maurice Wilson, Marc Winer, Ken Wood

All step-by-step and other images are the copyright of Quarto Publishing plc. While every effort has been made to credit contributors, Quarto would like to apologize should there have been any omissions or errors—and would be pleased to make the appropriate correction for future editions of the book.

# BOOKS AND MAGAZINES FROM INTERWEAVE

Be inspired and master painting with these essential artistic guides from Interweave.

**Mastering Sketching**
A Complete course in 40 Lessons
Judy Martin
ISBN: 978-1-59668-092-0
$22.95

**600 Watercolor Mixes**
Washes, Color Recipes, and Techniques
Sharon Finmark
ISBN: 978-1-59668-265-8
$22.95

Join ArtistDaily.com, an online community that shares your passion for creating art. Here you can find online classes with top instructors, interactive artists' forums, daily blogs, product updates, and more. Sign up for Artist Daily at **ArtistDaily.com**

## AMERICAN ARTIST.

For over 70 years, American Artist has been the trusted and well-respected source for everything related to fine art. Inside you'll find expert demonstrations, in-depth artist profiles, new products, key techniques, and so much more. Subscribe now to American Artist at **ArtistDaily.com**

INTERWEAVE
interweave.com